KT-405-935

TOPICS
OF
OUR TIME

27963

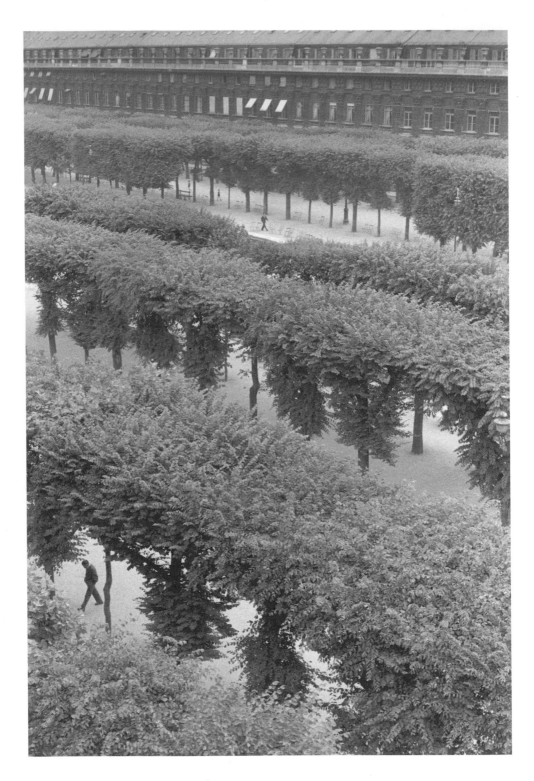

Henri Cartier-Bresson: *Le Palais Royal, Paris*, 1960

E. H. Gombrich

TOPICS
OF
OUR TIME

Twentieth-century issues
in learning and in art

Phaidon Press Limited,
2 Kensington Square, London W8 5EZ

First published in volume form 1991
Third impression (paperback) 1994
This edition ©1991 Phaidon Press Limited
Text ©1991 E.H.Gombrich

ISBN 0 7148 2791 6

A CIP catalogue record for this book
is available from the British Library

All rights reserved. No part of this publication may be reproduced,
stored in a retrieval system or transmitted, in any form or by any means,
electronic, mechanical, photocopying, recording or otherwise,
without the prior permission of Phaidon Press Limited.

Text set in 11 on 14 pt Monotype Plantin
Printed in Malaysia

Contents

Preface

In the autobiographical sketch that opens this volume I described my life as that of a 'cloistered scholar'. I should have added that in this day and age cloisters no longer offer a refuge from the mail or the telephone, let alone the fax. Even the historian who would sometimes prefer to immerse himself in the past cannot always ignore the messages requiring him to respond to the topics of his time. Some of these requests will indeed be so tempting that they cannot possibly be refused. Nearly all the papers assembled in this ninth volume of my Collected Essays published by the Phaidon Press owe their origin to such inescapable situations.

How could I have declined an invitation that arose directly from the warnings I had sounded in the Preface of an earlier volume *(Tributes)* regarding the dangers that threaten our civilization through the neglect of classical learning? Being asked to explain my anxieties at the North of England Education Conference, an annual event that is regularly addressed by the Minister of Education, I chose the title 'The Embattled Humanities', hoping against hope that some of my words would reach an official ear. It was a similar sense of obligation that prompted me to speak at the First International Congress on Architectural Conservation, held at the University of Basle in March 1983, where I attempted to rekindle the spirit that had inspired John Ruskin in his lifelong fight against vandalism.

No art historian, however cloistered, could have possibly resisted the invitation, arriving out of the blue, to deliver the opening plenary lecture at the Seventh International Congress of Germanic Studies in Göttingen in 1985, which was to be devoted to 'old and new controversies'. I accepted all the more eagerly, since many of these controversies transcend the narrow limits of one individual humanistic discipline and concern the student of art no less than the student of literature. Both these traditional branches of learning are now menaced by a tendency I described as 'Cultural Relativism'. I am not alone in my fear that this trend constitutes a very real threat to all aspects of scholarship because it denies the existence of any objective standards of truth. To be sure we must never claim the monopoly of truth, let alone look down on other cultures whose values and convictions differ from ours. But the recognition of such differences must not lead us to deny the unity of mankind. Nobody needs persuading today what havoc this denial caused when it appeared in the guise of racialism. The grotesque claims that

German physics was bound to differ from the Jewish physics of Einstein illustrate the link of this heresy with the dangers I have in mind. There are, alas, analogous absurdities to be found in Marxist writings which make the standards of truth dependent on the class situation. Unhappily this insidious corrosion has by now seeped into other academic fashions, teaching students that any belief in objective results is naïve and obsolete. It was to defend and justify my opposing convictions that I took as the starting-point of my Göttingen lecture Goethe's light-hearted pronouncement that the Greeks and Romans whom Plutarch described were just as human as we are.

Feeling so strongly about this issue, I also undertook to attack relativism in two more of its strongholds, the history of ideas and the theory of art. I spoke about the first at a symposium in Rome organized by the Lessico Intellettuale Europeo and discussed the second when I was invited by the Director of the Mauritshuis in The Hague to introduce a delightful volume of non-specialist essays about individual paintings under his care. I welcomed the opportunity of explaining my approach to the History of Art in the light of these convictions when I was invited to discuss the relation between the humanities and the sciences at a symposium in Holland organized by the Erasmus Foundation in May 1988 with the title Three Cultures.

Having sometimes been reproached for my alleged lack of interest in the art of my own century, I was doubly happy to be asked to initiate the series of annual Hilla Rebay Lectures at the Solomon R. Guggenheim Museum in New York, that citadel of modern art, in October 1980, taking as my subject 'Image and Word in Twentieth-Century Art'. My somewhat unorthodox conclusions about the origins of Picasso's cubism arose from my interest in the history of Neo-Platonism that looms so large in my volume *Symbolic Images* and which I shared with the late André Chastel, to whose Festschrift I was invited to contribute. The lecture 'Kokoschka in his Time' was given at the Tate Gallery in London in connection with the retrospective exhibition of that master. It reflects, as will be seen, a lifelong involvement with the art of this great contemporary and compatriot of mine who had asked me to lecture at his School of Seeing at Salzburg.

I was more moved than I can say by the suggestion of another great contemporary, the photographer Henri Cartier-Bresson, whom I had never met, that I should be asked to introduce the catalogue of his exhibition at the 1978 Edinburgh Festival. Being convinced that the art historian should now be more ready than ever to concern himself with creations outside the so-called mainstream of art, I have included in this volume a brief tribute to the poster artist Abram Games, written for the catalogue of his retrospective. I was also happy to testify once more, in a short essay, to my gratitude for the wit of Saul Steinberg, as I had done once before in *Art and Illusion*.

The inclusion of the most substantial paper in this volume remains to be justified. The lecture I gave in Düsseldorf at the invitation of the Gerda Henkel Foundation, 'Watching Artists at Work: Commitment and Improvisation in the History of Drawing', might indeed have fitted into my earlier volume *The Image and the Eye*, since it develops ideas first mooted in *Art and Illusion*. But it so happens that it also concerns a Topic of our Time. The role and relevance of the teaching of drawing in our schools of art is at present the subject of a lively controversy that has even reached the correspondence columns of the daily press. Maybe this survey of changing procedures, however cursory, can help to clarify some of the points at issue in this debate.

In conclusion I should like to thank Simon Haviland and Diana Davies for their help in seeing this volume through the press.

LONDON, FEBRUARY 1991 E.H.G.

An Autobiographical Sketch

Thank you for your kind invitation to talk about that particular subject I have never discussed in public in my life, that is, myself. I must warn you not to be disappointed when I talk about my life because there are no sensations, no scandals, no intrigues. The only strange and astonishing fact about my long life is that in a period which was so full of dangers, of horrors which were grim indeed, I managed by and large to lead what is known as the life of a cloistered scholar. I could not have written so much if I had been on the run, as many others had to be in those dreadful years we are talking about.

I was born in 1909. There are people who are always against teaching dates, but dates are the most important pegs on which to hang the knowledge of history. If you hear 1909 as the year of my birth, you will immediately realize that I was five when the First World War broke out and that, therefore, that period of Vienna (where I was born), which is now so much discussed, the Vienna of the *fin de siècle*, of the turn of the century, was for me a matter of history. I don't remember any of it. The Vienna in which I grew up, post-war Vienna, was a strife-torn, sad city with a great deal of economic misery. So, for me this idea of the Golden Age of Vienna, which I saw represented in an exhibition at the Centre Pompidou in Paris in 1986, and which also went to New York, is only hearsay. Even as hearsay, it is slightly stereotyped and simplified, as history tends to become when it is turned into myth. Vienna, like every other large city, consisted of many people, many different circles. It was not a monolithic society in which everybody talked about modern music or psychoanalysis. It was intellectually very lively but very different from the clichés, which you should take with a grain of salt.

On the other hand, the fact that I was born in 1909 does not yet tell you that I was born into a home where I could hear a lot about that famous period of Viennese life. My mother, who was a pianist, was born in 1873. That is to say, as a young musician she was able to hear Brahms himself. In the Vienna Conservatoire, she was a pupil of Anton Bruckner, who taught her harmony. She knew Gustav Mahler extremely well and also remembered Hugo Wolf. My father was one year younger, born in 1874. He was a classmate of Hugo von Hofmannsthal in the Akademische Gymnasium and

Transcribed from the tape-recording of an informal talk given at Rutgers University, New Jersey, in March 1987

knew him very well. But my family memory goes even further back, because my mother was a late child. My grandfather was 60 when she was born. He was, in fact, the same generation as Richard Wagner. It is strange to contemplate that history is so short. All these things are not as distant as people tend to think. They only appear to be so long ago because so many things happened in between.

I never knew my grandfather, who was born in 1813, but, again, I have some idea of the changes that occurred in his life and that of my parents. My mother remembered vividly the first exhibition of the uses of electricity, where for the first time she saw a lamp which plugged into the wall and lit up. What we today take for granted was a miracle at the time. And though, as I say, I was very young during the First World War, I still saw the Emperor Franz Joseph riding in his carriage on his way to the castle of Schönbrunn. I also remember very well his funeral cortège, which we watched from a window on the Ringstrasse. So, by now, you will see that I'm really an historical monument.

I went to school, like many middle-class children, at a Humanistisches Gymnasium, where I learned Latin and Greek. Times were grim, as I have said, but there was a great deal of intellectual life, and a lot of music, as one expects of Vienna, even though the economic situation was not easy. My father was a lawyer, and much respected, but he was not one of those who are very successful in making money.

I think that my development was at least as much influenced by the music in the home of my parents as by any other influence. We were on very intimate terms with a great musician whose name you may no longer know, Adolf Busch, the leader of the Busch Quartet, a musician dedicated to the classical tradition of Bach, Beethoven, Mozart and Schubert, and very critical of the modern movement.[1] If people have accused me of being rather distant from the modern movement, it may be that this early imprinting played a part in my life. My mother knew Schoenberg quite well when she went to the Conservatoire, but she didn't like playing with him because, she said, he wasn't very good at keeping time. And my sister, who is still alive and is a violinist, knew Anton von Webern and Alban Berg extremely well – Berg even entrusted her with the first performance of one of his works. Even so, at this distance of time, she is a little sceptical about the dodecaphonic music which Schönberg tried to launch.

This is the background of a person who became an art historian rather than a musician. I did learn to play the cello very badly and never practised enough, but the visual arts played less part in my parental home. Of course, my father used to take us children to the Kunsthistorisches Museum, which was very close to where we lived. On a rainy Sunday we used to go there,

though when I was a small child I always wished he would take us to the natural history museum with the stuffed animals. But later I, too, enjoyed the paintings in the Kunsthistorisches Museum, and my parents' library was certainly one of the formative influences of my life. Not that they had a particularly large library, but they had volumes of the *Klassiker der Kunst*. And the series edited by Knackfuss – monographs on the leading masters of the Italian Renaissance and of the Dutch seventeenth century – were a matter of course in our house.[2] We looked at these and talked about them. So that while I was at school at the Gymnasium, I acquired an increasing interest first in pre-history – stone axes and things which interest small boys – and later also in ancient Egypt and classical art. As happens in middle-class families, I would get books on subjects that interested me for my birthday or for Christmas. When I was about fifteen or sixteen, I read books on Greek art and on medieval art. As soon as Max Dvořák's book came out, with the title – not by him – *Kunstgeschichte als Geistesgeschichte (Art History as the History of the Spirit)*, I was given it as a present and devoured it.[3] I found it one of the most impressive books I had ever read. On Greek art I read a book by Hans Schrader on Phidias.[4]

It was a convention in Austrian schools that for the final exam there should be what one might call an extended essay written over the last few months of the academic year. In the year 1927–8, when I was eighteen, I selected as a subject the changes in art appreciation from Winckelmann to the present age. I have sometimes thought that this is all I have ever done – pursued my interest in this particular subject – and I have often asked myself why I selected this subject.

I selected it partly because I had read a book by Wilhelm Waetzoldt, *Deutsche Kunsthistoriker*, on the development of art history – which I found very interesting.[5] But I also selected it because I was puzzled. I was puzzled – remember, these are the late 1920s – because in the generation of my parents and of our friends, the approach to art was very traditional indeed. It was a tradition going back to Goethe and the eighteenth century, in which the subject matter of art was very relevant and the classics were of great importance. People who had travelled to Italy came back talking about works of art they had seen and admired there. But I was already touched at that time by the new wave, which reached me through books. I am speaking of Expressionism, of the discovery of late medieval art, of late Gothic, of Grünewald, of the woodcuts of the late fifteenth century and such things. I was, therefore, confronted with a new approach to art which did not chime in with what I knew from the older generation. I think this was the reason why I selected this topic of how the appreciation of art had changed from the time of Winckelmann to the Romantics, and from the Romantics to the

Positivists, and from the Positivists to the later periods in which, of course, Max Dvorák figured largely, together with other writers of my own time.

With this idea in mind, that art was a marvellous key to the past – an idea which I had learned from Dvorák – I decided I wanted to read the history of art at Vienna University. There were two chairs of art history in Vienna because there had been a quarrel between Dvorák and a fellow professor. One holder of a chair was Josef Strzygowski. He was an interesting figure, a kind of rabble-rouser in his lectures, a man emphasizing the importance of global art, of the art of the steppes of the migrant populations.[6] It was, in a way, an early expressionist version of anti-art, because he hated what he called *Machtkunst*, 'the art of the powers', and he wanted a complete re-evaluation of art. Not stone architecture, but timber architecture was what mattered, and such crafts as tent-making. I went to his lectures, but I found him very egotistic, very conceited, and I was rather repelled by his approach.

The holder of the rival chair, Julius von Schlosser, was a quiet scholar. He was the author of that famous standard work, *Die Kunstliteratur*, which is still the most admirable survey of writings about art from antiquity to the eighteenth century.[7] He was steeped in these texts, but he was not a good lecturer. His lectures were more or less monologues. He reflected on problems in front of his audience, in so far as the audience managed to keep awake. But he was, at the same time, a towering scholar. He was at the Vienna Museum before he took the chair at the university after Dvorák's death. Everybody knew that his erudition was formidable, and therefore one respected him despite his aloofness and oddity. Thinking back to how he taught, I'm still filled with admiration at the way he conceived his task of introducing his students to the history of art.

Apart from his lectures which, as I have said, were not very successful, Schlosser gave three types of seminars. One that was natural for him was on Vasari's *Lives of the Painters*. His students took one of the lives and analysed it according to the sources and all related aspects. It was taken for granted that everybody knew Italian. It was inconceivable that you should go to Schlosser and not be able to read Vasari. But there were two other more interesting seminars. Every fortnight he had a meeting in the museum in the department of which he had been the keeper, the Department of Applied Arts. He selected for his students objects which he had found puzzling while he was still in charge – an ivory here, a little bronze there – and he asked the student, 'What can you make of it? What do you think it is?' One had ample time to prepare these reports, because they were given out at the beginning of the year and they usually dragged on much longer than he intended. One had time therefore to find one's way into the problem that had interested

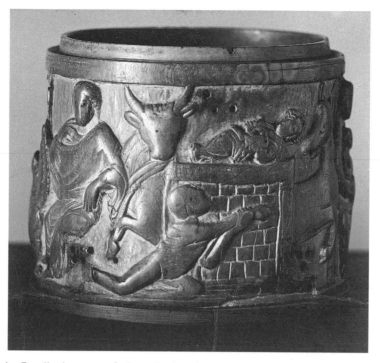

1. Pyxis. Carolingian copy of a Late Antique ivory. Vienna, Kunsthistorisches Museum

him. For example, I had to talk about an ivory book-cover of the Carolingian period, representing St Gregory writing, and try to fit it into the period.

The following year, Schlosser gave me another ivory, a pyxis (Fig. 1). It was a little puzzling both in iconography and in other respects. It was considered Late Antique but I came up with the suggestion that it wasn't Late Antique, that it was a Carolingian copy of a Late Antique ivory. Schlosser said, 'Don't you want to publish this in our yearbook?' In those days, there was no real distinction between undergraduate and graduate. One was treated as an adult. As soon as you entered the seminar you were a colleague, as it were, and you were taken seriously. I think that was a great education. I did, in fact, publish something about this ivory in 1933.[8] It was my first publication. At that time I had started being a medievalist, as they would call it nowadays. I tried my best to survey the whole field. I was struck by its arbitrariness and by the many blank patches on the map of seventh-, eighth- and ninth-century art history. I became a little sceptical about the possibility of finding exactly when and where this particular ivory carving was made. And this was one of the reasons why I gradually turned away from medieval studies.

The other type of seminar which Schlosser gave was on problems. Although he was very aloof and one never thought that he had read a

I I

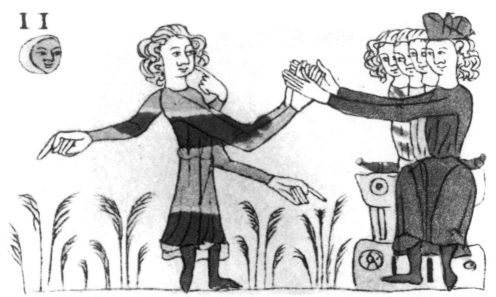

2. A vassal swearing the oath of allegiance to his lord. From *Der Sachsenspiegel*,
a fourteenth-century manuscript. Heidelberg University Library

contemporary book, all the time he had his finger on the pulse. He asked me one day – he asked the students and I volunteered – to talk about *Stilfragen*, the first great book by Alois Riegl (1858–1905), on the history of ornamental decoration.[9] Schlosser had known Riegl very well. He used to talk about him with admiration, but also with slight distance. He always mentioned that Riegl had been very hard of hearing and was a rather lonely, self-centred scholar. I was asked to tell Schlosser and his seminar what I thought about the book after the lapse of many years – and this I did. Much later, I returned to the subject several times. I have been accused of not being particularly respectful about Riegl, but in fact I admire him very much and my acquaintance with his work goes back to those early student days.

Another problem which Schlosser set, one which I also discussed in one of his seminars, was the *Sachsenspiegel*, a legal manuscript of the fourteenth century which dealt with various legal rituals and the gestures appropriate to them: when you swear the oath to your feudal lord and similar formalities. These were the hand gestures represented in this manuscript. A historian called Karl von Amira had written about the *Sachsenspiegel*, and Schlosser was interested in fitting this into a general subject.[10] Thus I became interested in the gestures and rituals of medieval legal practice (Fig. 2). And this is another subject which has continued to fascinate me: communication through gesture.[11]

The subjects that were set, therefore, were certainly adult subjects. Standards were high. The number of students in Schlosser's seminar was

not large; we were a very close-knit community. One talked about one's subjects all day, with one's colleagues. They gave one tips. One gave them tips. And we also learned a great deal about each other's subject. It was in this form that we studied art history. Lectures were not as important. Seminars much more so. And, of course, Schlosser wasn't the only one who gave seminars. We had some seminars in the museum. We also had seminars under Karl Maria Swoboda, under Hans R. Hahnloser and under Hans Tietze. At that time Tietze was writing about the Cathedral of St Stephen, so we had a seminar in front of the Cathedral on the various aspects of its history. The formation of a student was much less rigorous then. We were not expected to cover a particular ground. I am not sure that during all the years of my studies I heard the name of Rembrandt mentioned very often. But we were introduced into dealing with problems and methods and such matters.

In the Continental universities it was a matter of course that you didn't attend lectures only in your own subjects, but went to any lecture that interested you. If you wanted to hear about late Latin, you went to a lecture on late Latin. And if you wanted to hear about history, you went to the history lecture, or whatever it was. You went and sampled lectures and subjects, and I did so quite frequently, as did all my colleagues. It was, therefore, much less of a prescribed syllabus, except that you were expected at the end to select a subject for a thesis to submit to your teacher – in my case Schlosser. Because there was no division between undergraduate and graduate, the course ended when you had written your Ph.D. thesis. Usually you were expected to do this at the end of the fifth year of study. It was considered very important, yet it didn't take more than a little over a year to write.

Vienna is geographically close enough to Italy and I went there fairly often to look at museums and works of art. On one of these trips I saw the Palazzo del Tè in Mantua and found it a very puzzling building indeed, with its strange architecture and its even stranger fresco cycle by Giulio Romano (Figs. 3 and 4). Now this was a time when Mannerism was all the intellectual fashion. People talked a good deal about the significance of Mannerism, and particularly about the problem of whether there was Mannerism in architecture as there was in painting. Here was a building, the Palazzo del Tè, which was built by the same man who did the paintings, Giulio Romano, and I thought that was a very good object for discussing the question of whether Mannerism existed in architecture. I suggested to Schlosser that I would like to write my dissertation on Giulio Romano as an architect. He thought it was a very good idea, and so off I went and did it.

I went to Mantua and worked in the archives a little. I tried to find new

3. Detail of the doorway of the west façade of the courtyard
of the Palazzo del Tè, Mantua. *c.*1526
4. Polyphemus, with Acis and Galatea in the background. Fresco by Giulio Romano
and assistants in the Sala di Psiche, Palazzo del Tè, Mantua. *c.*1528

documents, but mainly I tried to interpret the strange shift in architecture
which had happened in the next generation after Raphael. After all, Giulio
Romano was Raphael's favourite pupil. I discussed these matters in my
dissertation. But throughout this time, I was becoming a little sceptical
about the current interpretation of Mannerism as an expression of a great
spiritual crisis of the Renaissance. If you sit down in an archive and read one
letter after another by the family of the Gonzaga, the children and the
hangers-on and so on, you become gradually much more aware that these
were human beings and not 'ages' or 'periods' or anything of that kind. I
wondered about these people undergoing such a tremendous spiritual crisis.
Federigo Gonzaga, the patron of Giulio Romano, was in fact a very sensuous
prince, particularly interested in his horses, his mistress, and his falcons. He
was certainly not a great spiritual leader. Yet, Mannerism was the style in
which he had built his castle outside the town, the Palazzo del Tè. Therefore,
I started asking myself whether this idea about art being the expression of
the age wasn't a cliché that was in need of revision, and whether there were
other forces operating within society. In this case it seemed pretty clear to me
that what was expected of court artists such as Giulio Romano was some-
thing bizarre, something to surprise, something to entertain, and all this I
found confirmed, in a way, while investigating this artist.

My development, therefore, intellectually moved away from the approach I had learned from Max Dvořák. This move was certainly encouraged by Schlosser, although he would never have said a word against a former colleague. Yet his scepticism and aloofness were very much felt in the way he spoke about these matters. He was really steeped in the past and disliked any stereotypes of this kind, without specifically condemning them.

I handed in my dissertation in 1933,[12] and thus completed my course in art history. At that time, the situation in Vienna was economically very serious. I had absolutely no chance of a job. My father had warned me of that long before, but he never protested against my studying art history. So, indeed, having graduated, I had no job. But I had friends and I went on working. One of the friends who had a great influence on me later on was Ernst Kris, who was keeper of what had been Schlosser's department before: the department of Applied Art in the Kunsthistorisches Museum.

Kris had meanwhile also become very interested in psychoanalysis. He belonged to the circle of Sigmund Freud. Having written some very important pieces of, as it were, orthodox art history on goldsmith work and engraved gems,[13] he hoped to see how much of this new approach could be applied to art history. Freud had written a book on wit, on the joke, and Kris had the idea that it would be very interesting to write on caricature as an application of wit to the visual arts. He invited me to be his assistant, to write on caricature with him. We jointly wrote a lengthy manuscript, which was never published, but we wrote small essays which were published.[14] I learned an enormous amount after my graduation, working practically every day with Kris on this project. He was a man of unbelievable industry. He was at that time both keeper of the department and a practising analyst, and in the evening I would come round after supper and he would explain to me things about psychology. I count him among my teachers, despite the fact that the project was aborted because of political events. I still have the vast unpublished manuscript at home.

The project was aborted because this was the time when National Socialism advanced in Germany and threatened the independence and the well-being of Austria. Kris was one of the few who were aware of what was happening in Europe: he always read the *Völkischer Beobachter*, the Nazi daily, and he knew what these people were about, what was awaiting us, and what was coming if the international front, which very feebly tried to maintain the independence of Austria, broke down. He urged me to look for a job not within Austria, where I wouldn't have found one in any case, but outside. He recommended me to Fritz Saxl, the director of the Warburg Institute. At that time, the Warburg Institute had emigrated from Hamburg in Nazi Germany to London. Saxl engaged me to come to England in 1936

because he had committed himself to publishing the literary remains of the founder of the Institute, Aby Warburg. Obviously the notes and drafts of Warburg could be handled only by somebody whose mother tongue was German. He needed an amanuensis, as it were, to help sort these notes and write about them, because his assistant, Gertrud Bing, was too busy with other things and could not really find the time. I accepted his offer.

In the first week of 1936, I moved from Austria to England – before the *Anschluss*. I was immensely lucky that I did not have to witness the *Anschluss*. I escaped before it actually happened, because Kris had so strongly urged me to do so and because he found a job for me. Not that it was a very lucrative job. I received a grant and on that grant my wife and I decided to marry. It was a very, very small sum we had when we settled in London and I became part of the staff of the Warburg Institute.

Aby Warburg, who founded the Institute as his private library in Hamburg, was in fact an art historian very interested in cultural history, and in the tradition of Jakob Burckhardt.[15] He called his institute, or library, the Kulturwissenschaftliche Bibliothek Warburg, the library for cultural history. What concerned him was what he described as 'cultural psychology'. The most important thing to remember about the Warburg Institute is not what it is but what it is not. It is not an art-historical institute and it never was. Art history as an academic subject was quite new in England at that time. The Warburg Institute in England was privately supported. A number of refugee scholars worked there in many different fields connected with what interested Warburg: the 'after-life', as he called it, of classical antiquity.

So I found myself in an entirely new milieu[16] among rather eminent scholars, including my former friend and fellow student Otto Kurz, who had also come to the Warburg Institute through Kris. These were the 'overshadowed' years, before the outbreak of the war, when everybody felt that things couldn't last very long because Hitler was rising in power and was claiming one country after another. One felt that one day it was going to end in war. When war finally came, the Institute was evacuated. Because of the danger of bombing, the library was removed to a country estate. But I did not stay among the staff of the Institute. I spent the six years of the war listening to broadcasts, mainly German broadcasts. From 1939 till 1945, I was what was called a radio monitor.[17] Not an easy job – hard work, long hours, much pressure. But I was, in one respect, very lucky. Imagine being forced for at least eight hours a day to translate from German into English. I learned the language reasonably well, of course. And I also learned other things. I became interested in perception, in the problem of hearing, and in other matters which were concerns at that time. So I wouldn't claim that these six years when we were not in London – London was under bombardment –

were wasted years for me. They were wasted only in the sense that it was not until after the war that I could go back to scholarship. My first paper was very much in the tradition of the interest of the Warburg Institute at that time: Neo-Platonic symbolism. I wrote about Botticelli's mythologies and on emblematics.[18] I also resumed my work on the papers of Warburg and taught at the Institute, but not the history of art.

The institute of the history of art in London was, and is, the Courtauld Institute of Art. The Warburg Institute had meanwhile been taken over by the University of London, though it was a rather odd body and nobody knew quite what we were doing and why we were doing it. There was a rumour circulating that we were an institute for iconography, an idea that is quite wrong and quite misleading, but still widely believed. One of our interests was indeed in iconography, but it was not by any means the only interest that we had. I taught not art historians, but historians who were studying Renaissance civilization. I became a university teacher, taught classes on the patronage of the Medici, the survival of Neo-Platonism, Vasari, astrology – all these cultural subjects which are not directly connected with the history of art as the history of styles. Thus, what is usually called mainstream art history – connoisseurship, attributions – is very much on the fringe of my formation. I was never much concerned with it, not entirely through a lack of interest, but because my work took me into very different directions.

Perhaps I should mention that while still in Vienna and being rather underemployed in 1934–5, I had the opportunity given to me by a publisher to write a world history for children. This book, which I wrote very quickly in a few weeks' time, was a commission which simply required the help of an encyclopedia, more or less. For example, I looked up when Charlemagne was born and I wrote it into the book, and then I quoted or paraphrased a contemporary source describing his personality and his habits. I tried to find at least one such source for every chapter to lend authentic local colour to the narrative. This book was an unexpected success. It was translated into a number of languages and it was even revived in Germany after fifty years.

Before the *Anschluss* put an end to everything, the Viennese publishers next asked me whether I would like to write a history of art for children – to which I replied, history of art isn't for children and I can't write it for children. So they offered a little more money. Their first offers were very meagre, but I was in need of money and I tried to think of what I could do. This, of course, is really the origin of *The Story of Art*, which I started writing at the suggestion of an English publisher – who in the end did not take it. It was then written for the Phaidon Press.[19] As soon as my slavery at the monitoring service had ended, I decided I must quickly write this book because I wanted to go back to research. I engaged a typist to whom I

dictated three times a week. In this way the book was soon finished. The publisher printed it and, once again, I had a piece of luck. It was a great success. Many editions were published. It has been translated by now, I think, into at least eighteen languages.

So at this point I had two lives, as it were. To the outside world, I was the author of *The Story of Art*. Within the Warburg Institute nobody was interested in that book, and I don't think anyone ever read it. In fact, Saxl, the director of the Institute, said that he did not want me to write such a popular book, but to return to research and do proper work. I nevertheless had promised to write the book – so I did. But I did it on the quiet, as it were, and yet for many outsiders this is what I am known for. I was able to write it, I think, because I used my own memory as a kind of filter. I wrote it almost without consulting reference books. I just put down what I remembered of the history of art after the distance of time and I told it as a story. This is how the book developed in its narrative form, and why it is called *The Story of Art*.

I used illustrations which I had at home. Thanks to my wife, we had the *Propyläen Kunstgeschichte* in our library. I picked out illustrations which seemed suitable to me, and in this way I improvised the various chapters. If the book has a certain freshness, it's because I never thought of it as a textbook or anything of that kind. I just had to write it, and so I wrote it. It interested me, of course, to see the conspectus of the whole development from a certain vantage point, but it wasn't intended as a teaching aid of any kind.

Even so, *The Story of Art* plays a certain part in my biography. I was back in London after the war when the book came out. A very favourable review appeared in the *Times Literary Supplement* which, I now know, was written by Tom Boase, the director of the Courtauld Institute. When it came to the election of a Slade Professor of Fine Arts for Oxford, which was a guest professorship for a period of three years, he proposed me and I became Slade Professor in Oxford. Not that this meant leaving the Warburg Institute; it was only a matter of twelve lectures or so in the academic year. However, the prestige of the position which Ruskin had once held was sufficient to give me a different kind of standing. For three years I was Slade Professor in Oxford and lectured on many topics. Later I was made Slade Professor in Cambridge and was also invited to Harvard. And so it went on and on. Thus, by this concatenation of circumstances, I became sufficiently known so that from the point of view of my career I did not have to worry what my job would be.

The position at the Warburg was not so simple because, as I told you, it is not an art-historical institute and I was not an art historian there, but a reader in Renaissance studies. Through the mediation of Kenneth Clark,

who had liked some of my writings, I was invited to give the Mellon Lectures in Washington, for which I chose the subject of art and illusion because of my interest in perception and in psychology.[20] This is the first book in which I staked my claim to be interested not only in the history of art as it is taught, but in something different.[21] That difference is an interest in *explanations*. Explanations are scientific matters: how do you *explain* an event? I thought that certain aspects of the development of representation in the history of art, which I had discussed in *The Story of Art* in the traditional terms of 'seeing and knowing', deserved to be investigated in terms of contemporary psychology. I spent a good deal of time in psychology libraries. I studied the subject for the sake of explanation – that is, explanation of the phenomenon of style – because the phenomenon of style as it had been seen traditionally did not satisfy me. Style became one of my worries, one of my problems, because the idea that style is simply the expression of an age seemed to me not only to say very little, but to be rather vacuous in every respect. I wanted to know what is actually going on when somebody draws a tree in a particular way, in a particular tradition and in a particular style. By looking into books on psychology, I learned the importance of formulae.

When another opportunity arose after the publication of *Art and Illusion*, and I was invited to give the Wrightsman Lectures in New York, I chose the other side, as it were. I thought, 'Well, I have tried to explain something about representation, now I should like to explain something about form or decoration.' So I gave a series of lectures which turned into the book *The Sense of Order*.[22] In other words, my ambition – and it was rather a lofty ambition – was to be a kind of commentator on the history of art. I wanted to write a commentary on what actually happened in the development of art. I sometimes see it as representation in the centre with symbolism on the one hand and decoration on the other. One can reflect about all these things and say something in more general terms. It was my ambition to do precisely this.

This, of course, meant that I never became a proper art historian. I never became a connoisseur. I wouldn't say, when people asked me, that I had no opinions about whether this painting is or is not by Raphael, but it isn't my main interest to practise connoisseurship. My main interest has always been in more general types of explanation, which meant a certain kinship with science. Science tries to explain. In history we record, but in science we try to explain single events by referring them to a general regularity. Here, I think I should mention another friend who had a great influence on me, the philosopher of science, Sir Karl Popper, who was always interested in the problem of research and of scientific explanation. I learned very much from him about these matters, both in perceptual psychology and in the more general problems of science.

So you see that I moved in a certain sense outside the charmed circle of art history. By the 'charmed circle' I mean the people who say, 'You know this picture will come up at Christie's in three weeks' time. Do you really think it is by Luca Giordano? And if it is, how much do you think it will fetch?' I have never been able to join in these conversations, and I'm still unable to do so. On the other hand, I don't want to give you the idea that I look down on people who are able to do so. Some of my best friends are connoisseurs. If they are real connoisseurs, then I respect them very much.

But this is a different matter, a different approach altogether from the one which tries to explain. I should add briefly that in dealing with explanations, I became very interested in the changing functions of the visual image. Also, one can ask, how do traditions change? What is their influence? You all know the slogan that 'form follows function' in architecture. An element of that is true for the image-maker. The poster has a different type of formal treatment from an altar painting. Here, the history of image-making, as I like to call it, sometimes impinges on social developments, on the role of an image in a particular society. All this must interest anybody who looks at the whole development and asks the uncomfortable question, 'But why? Why? What actually went on at that time?' I don't claim that one can ever give a full answer to this question of why, but one can always speculate – and this is not always fruitless.

My current work deals with another approach to a question which was important in *Art and Illusion*. My discussion of the development of representation has led to the interpretation that I am an advocate of naturalism and that I see the history of art as an unbroken progress towards naturalistic, photographic images, which is, of course, nonsense. I am now interested in the reaction against certain movements in representation due to the tides of taste. One of my projects, upon which I have been working too long, is on what I call the preference for the primitive among lovers of art: that is, the rejection of things which are considered decadent, corrupt, too sweet, too insinuating, the reaction against the ideal of beauty. All these reactions have interested me for a long time. There are parallels in classical antiquity, but the movement really started in the eighteenth century. This book, which I am still hoping to write, is called 'The Preference for the Primitive', in which psychological explanations inevitably figure, as do other things as well. So here, again, it is a rather large-scale topic I am trying to tackle. I have discussed it in lectures several times, which has its advantages and its disadvantages. Once a subject has gelled in one form, it's not so easy to boil it up again and to dissolve it to make it into a different kind of chapter. But I'm doing my best.[23]

The Embattled Humanities:
The Universities in Crisis

The views I am going to express are those of a partial outsider. I have not been educated in this country and the patchy knowledge I may have acquired of the English educational system during my academic life certainly does not extend beyond the university sector. However, in reading the debates about the future of higher education it has seemed to me that one point of view was rarely or never expressed with sufficient force, the view which happens to be mine. I did not think it up myself: I encountered it in its perfect formulation when I was first offered the position of a Readership in the University of London almost thirty years ago. I was happy to turn up the contract in my files for there I found what my university considered the duty of a Reader to be. The duty of the Reader, it says, was or is 'To do all in his power to promote, by research and otherwise, the advancement of his subject'. I suppose that legally my duty to do so ceased on my retirement from the university, but maybe the title of an academic is what is known in canon law as a *character indelebilis*; like a priest who has been ordained, he cannot wholly divest himself of his role. Thus I must still seek to do all in my power 'to promote, by research and otherwise, the advancement of my subject', the history of art and of ideas, in other words the humanities. The duty comprises, as you noticed, the use of other means, apart from research – such as, I take it, to promote the advancement of my subject at this educational conference.

What I shall argue as forcefully as possible is that the overriding loyalty of the academic will and must be the loyalty to his subject. Let me hurry to assure you that this need not imply what is called a cloistered attitude or a withdrawal into mythical ivory towers. We cannot claim to be doing all in our power to promote the advancement of our subject unless we teach it, for what would happen to the subject if we died or retired? Our loyalty demands indeed that it must be our profound concern to secure this advancement by passing on not only knowledge but attitudes of research to those who are willing to listen to us. It is they who will have to promote our subject in the future.

Nor would I say that this loyalty stops at the door of the classroom. The advancement of the subject depends to no small extent on the respect it

Address given to the North of England Education Conference at Chester in January 1985

gains among colleagues and ultimately also in the wider world. Writing books, giving lectures, reviewing, even joining in public discussions, should not be seen as self-promotion; they can serve the paramount duty I have outlined, they can enlist interest and make people see that the subject must neither be perverted nor sacrificed to other considerations. The last few years have convinced me not only of the importance but also of the difficulty of this task.

Some time ago I was privileged to be seated during a social function next to a cabinet minister. Naturally I did not want to spare him my worries, but I cut no ice. He did not see, was his curt response, why the universities should not make sacrifices when everybody else was asked to do so. I gave up. I knew I would not be able to make him see that he was talking nonsense. It is not the universities which are asked to make a sacrifice but those who would have benefited from attending them. We all know the name of the Moloch on whose altar they must be immolated; he is called 'Society'. During one of our periodic student troubles an attractive and eager girl came to interview me for a student paper; when I mentioned the danger – luckily averted – of a post in papyrology being frozen in my university she replied earnestly: 'But what if society does not want papyrology?' What indeed? Admittedly it is hard to imagine how society can make its will in such matters known. Through a referendum? Through rallies in Trafalgar Square or through party manifestos? But how can the voter be made to see that this arcane subject may at any moment transform the picture of our cultural heritage as it has transformed it in the past? A book on political science which fails to take cognizance of Aristotle's treatise on the Constitution of Athens found in a papyrus is as incomplete as is an account of European comedy that fails to discuss the recently deciphered fragments from Menander, the great playwright who stands at the fountainhead of this tradition.

It was not for nothing that we were asked to advance our subject. For good or ill the humanities can only advance or collapse. They are no more capable of standing still than bicycles are. It was shocking to read that the link between teaching and research might have to be abandoned. Whatever may be true of other subjects, a course in any of the humanities cannot be entrusted to crammers. Those who cannot advance the subject should never find employment in higher education. What the student should learn, as a friend of mine once put it succinctly, are facts and doubts.[1] For the facts he need only memorize textbooks. But the doubts can be conveyed and instilled only by those who work at the frontiers of knowledge and have re-examined the evidence, papyrological or other. Hence a subject that does not advance stagnates and atrophies. The historian knows what happens to societies where education is reduced to rote learning and new ideas are frowned upon.

To hope that we can keep our science and technology advancing while condemning the humanities to suffocation is worse than naïve. And just as science and technology need laboratories and instruments, so the humanities cannot meet their function without their most important tool, libraries, without which we cannot promote the advancement of our subject. Any cut in the budget of a library will of necessity slow down or impede that advance. The reduction of staff will probably curtail opening hours or lengthen the time it takes for a title to be catalogued, bound and made accessible to users. And any cut-back in purchasing funds will probably result in wholly irreparable damage. A library in which periodicals are found to have been discontinued and new publications neglected is like a concert grand with some of the keys or strings missing. It is useless; but while the piano can perhaps be repaired, the lacunae in the library are unlikely ever to be filled, even after the lean days are over. It can no longer meet the requirements of scholarship.

Admittedly not all printed stuff is healthy pabulum. I have myself occasionally poked fun at the academic industry and the flood of unnecessary publications; I am also aware of the pull of intellectual fashions spawning an ever-growing volume of modish inanities which threaten the humanities from within. But unless we want to appoint our librarians as censors, we must be enabled to be our own judges. To allow others to tell us what is good for us – or for the nation – to teach or to learn, would be to surrender our prime responsibility.

I am happy to acknowledge that the Secretary of State for Education has been a steady advocate of history and of its teaching at school.[2] But unless we teach the teachers not only facts but also healthy doubts, their lessons may soon be reduced to the level of '1066 and all that', or, worse still, pervert history into a tool of propaganda. After all, we know that an informed and critical attitude is the only viable antidote we have against the danger that has threatened and continues to threaten the rational outlook of whole generations who are intoxicated by bogus history. For the same reason I was less than happy to read that in his pronouncement he laid such a special stress on political history. Has political thought no history? Have not art and science or for that matter education? In every one of these fields the added time dimension will allow us to see the subject in the round, as it were, in stereo rather than in mono.

Let no one say that the benefits of such enhanced vision will be confined to the so-called élite. We must believe and do believe that what we teach or write will enter the bloodstream of our civilization and quicken its pulse. Communication through the media has vastly increased during the last thirty years, and though it has also led to the circulation of nonsense and worse, it

has brought millions in touch with recent advances. Think of Sir Mortimer Wheeler and his skill in rousing interest in his subject – archaeology – to mention but one among the master communicators.

I know that nobody wants to stop such good work, provided they do not have to find the money for it. But here, of course, is the rub. I have learned from my friend Sir Karl Popper that those who have the power of decisions must first of all watch for the unintended consequences of their policies, and these, you will agree, are worrying indeed. The basic facts are simple enough: the Government wish to contain or reduce the money spent on higher education and they have told the University Grants Committee in terms which have been frequently quoted that they are anxious to see 'a shift towards technological, scientific and engineering courses and towards other vocationally relevant forms of study'.[3] It is not hard to see that given the limits of funding such a shift can only be carried out at the expense of other subjects, notably the arts and the social sciences.

There have been excellent answers to this demand, from the British Academy[4] and from the Association of University Teachers.[5] The former has reminded the Government that we need not only an economically viable Britain but a civilized Britain; the latter has rightly deplored 'the continued devaluation of the contribution made to the nation by the arts and social sciences'. But I am not going to repeat these arguments here, for I cannot see how they alone can win the day.

I for one believe that it would be safer for all of us who are loyal to the humanities to face the dangers squarely. After all, as Dr Johnson said notoriously, 'When a man knows he is to be hanged in a fortnight, it concentrates his mind wonderfully.' From this point of view I am sure it would be advisable for us to believe in our coming execution, and should there be a last-minute reprieve from the noose, or rather the axe, the exercise will not have done us any harm.

You will not be surprised to hear me say on what it is we should concentrate our minds. Even in a financial crisis, we must, in the words I have quoted before, 'do all in our power to promote, by research and otherwise, the advancement of our subject'. Anything that does not contribute to this aim may have to be jettisoned, as long as we do not compromise our loyalties. Not that I am eager to see anything jettisoned. I have learned to appreciate the system of higher education in this country, and though I am not uncritical of some of its aspects I am not so sure that it would be easy to improve it. But we have been told, most recently perhaps by Lord Flower,[6] that the universities will have to be flexible and flexibility necessitates reflection on priorities. It is here, of course, that the question of necessary sacrifices must inevitably confront us. Over the

centuries our institutions of higher education have developed into finely tuned instruments in which all the conflicting demands made on them appear to be so carefully balanced that nothing can easily be omitted or even added without serious harm to the whole. Hence the outcry that inevitably goes up when any part of the system is threatened. We have seen those who are anxious to spare the taxpayer money eyeing that magnificent edifice from all sides with axe or shears in hand, bridling at the cost of the ground rates in a desirable part of the city, at the expense of a low student-to-staff ratio, at the needs of research, at the tenure system, and of course at the expenditure on students' grants, making our flesh creep about the *per capita* cost of every student who sits in a classroom.

It is not my brief to go over these calculations, nor would I be competent to justify my suspicion that they are frequently spurious. I am convinced that our paymasters mean business in the worst sense of the term, and that we are not likely to soften their resolve either by futile demonstrations or even by reasoned pleas. Hence every one of the faculties of the universities has to decide what item of their budget they consider reducible with least damage to the educational process. That cannot be done in the abstract. The consequences of such amputations can only be assessed by looking beyond the frontiers of England to the way things are ordered in other countries, not forgetting Scotland.

As everyone knows, there is one feature of higher education in this country as it has developed particularly in the old universities which is unique in the world. I mean of course the tutorial system. Unfortunately it is also one of the most expensive features of our institutions, and there have been plenty of moves to water it down. Speaking here as always for my own subject, I think we must regard the preservation of the individual tutorial as a high priority, at least as soon as the student is committed to share in our quest. But we must also be realistic and admit that this commitment is not necessarily the rule among those who apply for places.

I do not want to sound satirical in discussing so vital a subject, but I think it can be argued that one of the functions for which our universities exist in the public mind can be described in anthropological terms as that of a *rite de passage*. Just as many tribes all over the world segregate the adolescents in specially designed huts before they undergo the gruelling ordeal of initiation into adult society, so we have established what I like to describe as youth camps, where the young of certain sections of society are kept and housed, and submitted after a fixed period of time to the ordeal of so-called finals.

I have no reason to doubt that puberty rites fulfil a real function in the life of tribal societies, and I know the same to be true of our beautiful youth camps. Next to the tutorial system of a close relationship between the

teacher and the taught nothing is more important, after all, than contact with one's peers. We all have learned at least as much from our fellow students as we have learned from lectures, and the idea of a community of learners is not to be scoffed at. But from the point of view of my subject it is clear that this advantage is purchased at a very high price. Not only is it expensive to maintain these youth camps with their dormitories, refectories, halls and facilities for recreation, their very expense reacts back on the teaching process: it imposes strict limits on admissions, on the length of the course and on the assessment of performance.

I have called the finals 'ordeals' not because they are necessarily frightening, but because they share with the genuine ordeal their once-and-for-all quality. For in its original meaning, of course, the term denotes a method of deciding between guilt and innocence by subjecting the suspected person to some physical test fraught with danger, such as plunging the hand in boiling water, walking on red-hot ploughshares or being thrown into a pond bound hand and foot. God would see to it that the innocent came to no grief and the guilty showed the scars. I hurry to confess that I have myself participated in the grading of finals and that I have never found them cruel or unfair. Even so, I have found them irrational, for the simple reason to which I have alluded – they test the candidate's knowledge at a given moment of time, and they must do so, because normally he could not be allowed to stay on beyond the period for which he has received his grant. Rationally, of course, there is no reason why somebody who writes a poor answer about Rembrandt should not know a lot about him in a few weeks' time. Those of us who seek to advance the subject would surely prefer tests to finals, for a test, whether it is a driving test or a language test, simply indicates the candidate's fitness, and I need not tell you to what extent various forms of tests are used in many educational systems here and in the United States. I do not know how many of those which are required for a degree are repeatable.

Officially, as it were, the awarding of degrees, or qualifications, has always been the dominant function of universities. The need for such qualifications is obvious in certain fields such as medicine and law and possibly also theology. In the humanities proper their function seems to me marginal. It is true that both the students themselves and their prospective employers value them as an indicator of merit; they save a lot of time for selectors and often serve as a passport to further success for the lucky ones who have obtained a 'first'. There is much talk nowadays about these added opportunities which a university education confers on graduates. I am not sure that this applies to the present as it undoubtedly did in the past, but if there are such advantages they can derive only from the confidence which the awarding university still widely enjoys. There are plenty of institutions which confer quite worthless

degrees; if others are far from worthless on the market place their value must be due to the academic excellence that only the teachers themselves can judge and preserve.

Those who want to shift the balance from arts subjects to more vocationally relevant courses are obviously critical of this general confidence in the humanities. Maybe they are right in thinking that appointment boards regard good grades in any subject too much as an indicator of what are called the qualities of the mind. But they are wrong if they ignore the fact that reading an arts subject under an inspiring teacher can and should be an enriching experience even for those who do not wish to advance the subject. Life, after all, is often sad, and it is barbarous cruelty to want to cut off our young people from this source of strength, from the inspiration they can derive throughout their lives from this vitalizing contact with the masterpieces of art, literature, philosophy and music, whatever their future employment or unemployment will demand of them. I suppose this is precisely what the organizers of this North of England Education Conference meant by *Education for Humanity*.

Even so, let us not forget that the examination and degree structure we have inherited is neither God-given nor universal. It cannot even boast of a venerable age. It only spread through the system after the middle of the last century, and I read that as late as 1888 several hundred professors, teachers and others in England signed a protest stating that education was being sacrificed to examinations.[7] I think I would have been among the signatories. One of my reasons would have been the conviction that the examination system reacts back on the syllabus and parcels out the subject into neatly examinable gobbets of special periods and set texts. However well we may train the student in one of these topics, we too easily forget in the process how limited the subjects are which we can so prescribe. I suspect that you can obtain a 'first' in the History of Art without ever having looked at Chinese painting or even a Greek temple. Having sat on various Boards of Studies I have experienced how difficult it sometimes is for a new subject to be admitted; naturally so, for once a course is on offer it must be manned, as it were, and this creates serious administrative and staffing difficulties. Indeed it seems to me that the flexibility Lord Flower has recommended on general grounds also demands a reconsideration of the examination system in the humanities. I know that these limitations do not apply in theory to postgraduate studies, but then, the better we teach our undergraduates the more we are likely to mould and fix their interests so that they will, and should, want to go on with what they have been learning.

The reassuring certainty that my words are most unlikely to influence events has emboldened me to speculate on the way I would proceed to

promote the advancement of the humanities without necessarily increasing expenditure. I would remove the barrier between first and second degrees, between undergraduates and postgraduates, a barrier that is very marked in the States but unknown to a good many other systems of higher education. Instead I would propose a distinction between the learning of skills and the using of skills. The initial year or years would be devoted to the acquisition of skills which the student will have to use later if he is to advance his subject. Needless to say, the first and foremost of the skills necessary for the humanities are languages, including a mastery of the mother tongue and, if possible, of the classical languages. Latin in particular has been the medium of communication in the Republic of Letters for so long that ignorance of that language makes it hard indeed to interpret and understand the creations of other ages and other cultures, and that, as I see it, must always be one of the aims of the humanities.

I am not merely advocating language skills because of the access they give to students to a greater range of literature: languages are the most important depositories of any culture. In acquiring their vocabulary we are also forced to reflect on their modes of thought, their dominant ideas and their distance from our own mental habits. They make us see our own language in stereo. I am not sure that a year abroad or a language laboratory can serve as a substitute here for a truly propaedeutic course. Thus I would not make any of these skills an entrance requirement, but I am afraid I would make their mastery a condition for proceeding further. The first period would thus be a period of very intensive work and the students would be expected to devote all their time to it. Contrary to the facile and irresponsible talk that fills the air nowadays, they should not expend their energies on washing dishes or driving minicabs; if they have any spare time they should use it for reading books or sitting in on more advanced lectures to help them decide what subjects they want to make their own if they make the grade.

I say 'if', because I would set the standards of tests very high at the border between skill learners and skill users. I hope it does not sound cynical if I express the hope that the height of this hurdle would also result in the added advantage of reducing the numbers admitted to courses in the humanities. (Those who are excluded should have the chance of turning to other studies in which a knowledge of languages would surely do them no harm.) The result of this highly selective admission should enable the maintenance of a favourable staff-to-student ratio and the practice of individual tutorials, all the more as the absence of a syllabus and the large range of choices would spread out the students over the whole of the arts faculty. Those admitted would soon be expected to write papers for seminars based on their own reading and research, and these would cumulatively entitle them to some

form of qualification to be agreed with the authorities. It could, but need not, be graded.

In proceeding towards this goal, the crossing of boundaries between the so-called disciplines would be encouraged, but not enforced. Students would be as welcome to use their knowledge of Latin for a study of Erasmus or of Newton, provided they found a teacher ready to guide and advise them, and if there were none in one university they should be enabled to move to another.

You will perceive that far from being wildly Utopian this scheme reflects aspects of higher education in various parts of Europe and the United States, except, to repeat, the insistence on an initial acquisition of language skills. This, as far as I know, is now being planned for a course in Japanese culture, where the need for such a prior training is of course more evident, but not more essential, than it is for the study of our own culture.

I have described myself at the beginning as a partial outsider, and you will now appreciate why I had to do so. The University of Vienna, where I studied between 1928 and 1933, shared very few of the features I came to know and appreciate when I first taught a course in London in 1937. The principle that used to govern higher education on the Continent of Europe, at least in German-speaking countries, was summed up in the slogan *Lehr- und Lernfreiheit*, 'freedom to teach and to learn'. I know how tragically and criminally this principle was broken shortly after my graduation, and I also know what burden of responsibility it put on the student. Everyone who had passed the leaving exam of the Gymnasium, the *Matura*, was entitled to attend university, and masses did so, since the fees for enrolment were minimal. Moreover, many more students than here lived at home and were maintained by their parents. Only if they decided to change universities, as they were always free to do, might they have to look for digs and perhaps for other means of support. But this spirit of liberality was purchased at a very high price. Nobody felt responsible for the intellectual or spiritual welfare of the students, least of all the academic staff, because this milling mass of youngsters who were free to attend any lectures in any faculty or subject had rarely any contact with the high and mighty professors.

As I mentioned in the Introduction to this volume, there were two chairs of art history at Vienna in my time. One of the professors, Joseph Strzygowski, attracted the crowds with his brilliant polemical lectures on the arts of practically the whole world; the other was a quiet scholar, Julius von Schlosser, whose memory is still green in our field, but who lectured with obvious reluctance to a few devoted followers on the problems and uncertainties of our studies. It was this wise teacher of doubts whom I chose as my guide and who ultimately administered to me, after five years of

study, the oral examination misleadingly called the *Rigorosum*. I was alone with him in his room and after he had asked me to discuss a few photographs he had brought along he looked vaguely at his watch and said, 'I really should examine you for an hour, but after all, I know you.' He was right, not because I was such a good student, but because he had heard at least five of my seminar papers on a variety of topics and had read and accepted my lengthy doctoral thesis. Believe it or not, this *Rigorosum* was the only formal examination in my subject I ever had.

When many years later I wrote my book *Art and Illusion* I decided to dedicate it to three of my teachers. I am often compelled to think of this dedication when I hear the shrill talk on higher education that surrounds us. The great student of Greek art, Emanuel Loewy, whose lectures and seminars I was so fortunate to attend, was 71 when I entered the University, having returned to his native Vienna from Rome, where he had held a highly respected position. Schlosser was 67 when I graduated, and given his lack of enthusiasm for lecturing he would, of course, long have been asked to take early retirement. Ernst Kris, my third dedicatee, was not a university teacher at all, but a museum man. I therefore very much doubt whether in the conditions prevailing now and in those which threaten the humanities in the future I could have learned anything. I can't imagine that I would ultimately have been offered that contract and accepted those obligations which I mentioned at the outset.

I would not have indulged in these personal reflections if my own limited experience did not suggest that, in the humanities, teaching and learning are very personal matters which cannot be governed by bureaucratic standardization. Whatever may be true of those 'vocationally relevant forms of study' such as technological, scientific and engineering courses, our commitments as humanists cannot be circumscribed and costed by governmental agencies.

In fact, although I have talked about our institutional framework and even suggested radical changes, I am convinced that all systems can turn out humanists capable and eager to advance their subjects. Those of us who meet colleagues from all parts of the world will testify to this universality of our quest. It is true that many of them have a similar tale to tell of short-sighted parsimony and government interference. Unhappily this is not surprising. Broadly speaking, government must try to hold the balance between two legitimate interests: those of the citizen as taxpayer and those of the citizen as parent. The spokesman of the taxpayer insists that expenditure on education be kept at a minimum and that the cost should at least be recouped by the returns the economy can expect from the training of students in 'vocationally relevant subjects'. The citizens as parents – as we have recently experienced again[8] – instruct their representatives in Parliament

to make sure that at least their offspring will obtain the social privileges that they connect with education. To mediate between these conflicting pulls the principle is adopted, at least on paper, that those who can benefit should indeed be admitted.

I would not want to criticize this formula or its variants, though I find them all depressingly vague. In any case you will remember that I have pleaded for another interest to be taken into account, that of the subjects we are appointed to teach in the humanities and elsewhere. If we believe in education for humanity, we must get our priorities right and provide for those among the young who cannot only benefit themselves, but also advance the arts and sciences, which will outlive us all if our civilization is allowed to continue. It would be folly to take this for granted. Civilizations have been known to die.

Those who hold the purse strings are fond of repeating that 'He who pays the piper calls the tune.' Let them never forget that in a society wholly devoted to practical skills there can be no pipers and that those who call the tune will be met by uncomprehending silence. And once the pipers are gone, they may never be heard again.

Relativism in the Humanities:
The Debate about Human Nature

This Congress being devoted to old and new controversies, I have taken my theme from a quatrain by Goethe dating from the 1820s, which is surely of relevance both to Germanic studies and to the other humanities:

'What was it that kept you from us so apart?'
I always read Plutarch again and again.
'And what was the lesson he did impart?'
'They were all human beings – so much is plain.'[1]

In the very years when Goethe expressed his belief in the universality of human nature, Hegel was giving his lectures on the philosophy of history. Right at the beginning he formulated the opposite view, which I should like briefly to characterize as 'cultural relativism'.

Every age has such peculiar circumstances, such individual conditions that it must be interpreted, and can only be interpreted, by reference to itself Nothing is shallower in this respect than the frequent appeal to Greek and Roman examples which so often occurred among the French at the time of their Revolution. Nothing could be more different than the nature of these peoples and the nature of our own times.[2]

What is at issue here is not, of course, Hegel's assertion that ages and peoples differ from each other. We all know that, and Goethe, the attentive reader and traveller, also knew, for instance, how far the revels of the Roman carnival differed from the Feast of Saint Roch at Bingen on the Rhine, both of which he had described so lovingly. What makes the cultural historian into a cultural relativist is the conclusion which we saw Hegel draw, that cultures and style of life are not only different but wholly incommensurable, in other words that it is absurd to compare the peoples of a region or an age with human beings of other zones or periods because there is no common denominator that would offer us a yardstick.

Friedrich Meinecke, who investigated the roots and the rise of this conviction in his fundamental work, *The Origins of Historism*,[3] realized that Goethe was somewhat in two minds about this trend, though Meinecke mentions neither the epigram about Plutarch nor the semi-humorous verse which follows it in the *Zahme Xenien*:

Address given to the Seventh International Congress of Germanic Studies in Göttingen in August 1985

> To censure others Cato was prone
> Himself he preferred not to sleep alone.[4]

The context makes it quite clear that the old sage of Weimar thought he understood Cato only too well, for after all, he had learned from Plutarch that the ancients were all human beings, men and women of flesh and bone like any of us. It is, of course, this conviction which cultural relativists are proud to have left behind, because they refuse to acknowledge any constants that would enable us to recognize a permanent human nature behind all changing appearances.[5] Hegel would probably have pointed out that Cato belonged to an earlier phase of the self-realization of the Absolute than Goethe. Marx would have argued that the economic circumstances of a slave-holding society must have resulted in a different ideological super-structure from that of early capitalist Weimar; the arch-relativist Oswald Spengler would have emphatically denied that a product of the 'Faustian' civilization could have any way of understanding a man of the ancient world; and a racialist, of course, would have pointed out that the psyche of the Mediterranean race differed wholly from that of Nordic man, even if – as must be feared – Cato may not have had a dash of inferior, that is Etruscan, blood, which would certainly help to explain his sensual leanings.

I hope you will forgive me if I do not dwell at length on these theories and pseudo-theories. He who wants to force an open door is likely to fall flat on his face, and if he tries to force a bolted door the result may be even more unpleasant. What concerns me is only the situation which arises for the humanities from the extirpation of the notion of human nature from our vocabulary on the ground that, in contrast to the concepts that occur in the natural sciences, this notion does not describe anything tangible or clearly defined.[6]

Nobody has wrestled more with this problem than Wilhelm Dilthey, who contributed so much to the development of the humanities, especially in Germany. However much Dilthey referred to psychology for its value to the study of human culture, he still questioned the justification of basing this research on the nature of man. 'The individual' – he wrote for instance – 'is merely a nodal point of cultural systems, of organizations which are inextricably intertwined with its existence; how could it then offer a basis for understanding?'[7] In contrast to the natural scientist the humanist must therefore forgo causal explanations, the discovery of valid laws. He is not concerned with explanation but with understanding, with hermeneutics, a branch of knowledge still to be established which should enable us, who are subject to constant change, nevertheless to interpret the changing realities of other forms of human life.[8]

We must certainly be grateful to Dilthey and other historicists for having

argued that the humanist will always have to be interested in individual and non-repeatable facts. Even so, I do not think that we humanists should allow anyone to forbid us occasionally to look up from our detailed research, indeed from turning round and asking in what wider context the problem we have in hand might be seen? How much and how often we do that may be a matter of temperament, but if we are honest with ourselves, we will also realize that even the original choice of our subject for research presupposes an explicit or implicit scientific theory.

I need hardly dwell on the fact that these are questions which have become very topical today in many of the fields of our enquiry. On the one hand ideologies have gained an increasing hold over them, on the other the wish to dispense with any theoretical framework has landed the humanities in a cul-de-sac. What I have in mind, above all, is the demand that has been raised during the last few decades that not only the search for explanations but even the striving for understanding should be thrown on to the scrap heap. For now the idea of man is to be altogether removed from our field of vision; we confront only the text, and whatever sense we may make of it is and remains our own sense and not the one intended by the author.[9] What Goethe found in the text of Plutarch, and what we in our turn find in the lines I have quoted, remains in the last analysis our own business. Cultural relativism has led to the jettisoning of the most precious heritage of all scholarly work, the claim of being engaged in a quest for the truth. Since the testimonies of the past must no longer be regarded as testimonies, our concern with them cannot be much more than a clever game that does not serve knowledge but simply the display of intellectual acrobatics.

I do not want to enumerate all the tendencies which aim today to co-operate in this enterprise of deconstruction. The catalogue of Greek ships in the *Iliad* is not its most entertaining section and a roll-call of the academic warlords who are aiming at dismantling the citadel of our studies would hardly be more amusing. Thus I will limit myself to introducing you to one of the myrmidons, because his battle cry suits my books so very well. I am thinking of the valiant warrior Norbert Bolz, whose paper 'Odds and Ends: From Man to Myth' culminates, after dutiful obeisance to the tribal heroes Heidegger, Lacan, Lévi-Strauss, Adorno, and Richard Wagner, in the sentence 'for Man does not exist'.[10] Might not the author have confused *homo sapiens* with the snark of Lewis Carroll?

Joking apart, I know very well that it may also be due to my age that I can make so little sense of the canonical texts of that movement, but since I am not a relativist I still do not believe that every generation has its own truths. I prefer to rely on my contemporary, that great student of literature, M. H. Abrams, who has concerned himself intensely with this school of thought

and has come to the conclusion that it must be considered an ephemeral intellectual fad.[11] It probably appeals to the young because it permits its followers to look down on the poor uninitiated who not only believe in Father Christmas and in the stork but even in Man and in Reason. It adds a lot to one's self-respect if one has learned to see that all this is humbug, a fairy-tale for children which we have long outgrown. It is an opinion – I believe – which sounds doubly convincing because it is undeniable that in our reading of texts we inevitably run the danger of misunderstandings. Whoever is afraid of doing so can now comfortably withdraw into scepticism and dismiss any striving for understanding as naïve and obsolete.

Well, the insight 'to err is human' is not new, nor do I think that it should make us despair of progress in knowledge. Such despair arises only when we expect too much. The demand of 'all or nothing' which may appeal to the young must be countered on the part of the mature humanist by the reminder that we must practise a little humility. You may perhaps discern in this advice the voice of Karl Popper and you would be right.[12] He has convinced me that neither in the sciences nor in the humanities must we aim at total solutions, but that we still have the right to go on asking and searching, because we can learn from our mistakes. I believe that this also applies to our efforts at understanding other peoples, other civilizations and other ages. No doubt it is fallacious to conclude from the fact that they were all human beings that they must also have thought and felt as we do. Ethnology has long confirmed that some institutions and ideas of remote tribes are harder to understand than others. Here the influence of cultural relativism must certainly be welcomed, that is, where it restrains us in applying our own cultural standards to other societies. And yet even here exaggerations must be avoided, for the negation of all standards can only lead *ad absurdum*. I am thinking of the much-discussed argument which denies us the right of disbelieving that magic can control reality, since our notion of reality is rooted in our language and our culture and is therefore not applicable beyond these narrow confines.[13] One is tempted to ask whether these arguments are more than examples of modish gamesmanship. In any case in ethnology there are certain correctives which prevent relativism from dominating the entire field. After all, travellers to remote regions have seen their foreign fellow-humans laugh and weep, play and quarrel; anyone who has been lucky enough to see films and photographs of the life and behaviour of totally isolated tribes, such as those Irenäus Eibl-Eibesfeldt has brought home and used to illustrate his recent book *The Biology of Human Behaviour,* can no longer doubt that certain human reactions are indeed universal.[14]

The historian frequently lacks these controls. He must essentially rely on the testimonies of the past which tradition and coincidence have preserved

for us, documents of legal practice, of literature, art and religious cults. Small wonder that the encounter with these testimonies of a vanished style of life have focused attention particularly on the variability of man. Nature abhors a vacuum and the same applies to the human mind. Where testimonies are absent, the imagination takes over to fill the void and thus we come to fashion the image of people in past ages on the impression which we derive from their art. Hearing or reading of man in classical antiquity or of 'Gothic man' (particularly in German writings) we automatically visualize a typical figure we remember from the art of these ages.

Great humanists such as Johan Huizinga and Ernst Robert Curtius have warned us against this type of mental short-cut which I have described as 'the physiognomic fallacy'.[15] I must admit that my own field of study, the history of art, has been responsible for many such misunderstandings whenever it claimed that the style of every period can and must be interpreted as a symptom or – as the saying goes – as the expression of the spirit of the particular age or nation. Thus the champion of expressionism in art history, Wilhelm Worringer, declared quite consistently three generations ago in his book *Der Geist der Gotik* (The Gothic Spirit): 'For art history Man as such can exist as little as can Art as such. These are ideological prejudices which condemn the psychology of mankind to sterility.' And thus the decoration and drapery style of medieval works of art suggested to him the surprising conclusion: 'Nordic Man is a stranger to rest and tranquillity; his whole creative power is concentrated on the idea of unbridled and unchecked movement.'[16] He obviously never asked himself whether the notion of a whole population of 'Fidgety Phils' can be confirmed from other types of evidence, indeed whether his diagnosis is not refuted by the art of the Van Eycks, Vermeer or Caspar David Friedrich who, after all, were presumably also 'Nordic Men'.

What has been called the hermeneutic circle, the search for the confirmation of the initial intuition, degenerates simply into a circular argument if only allegedly supporting evidence is admitted. Thus the rendering of space in a certain style is explained by reference to the way the world was 'seen' in that period which, in its turn, is supposed to account for the peculiarities of representation – and nobody asked whether people who did not know our kind of perspective were also incapable (as a psychologist once asked wittily) of hiding behind a column if they did not want to be seen,[17] or whether the Chinese, whose painting ignores the contrast between light and shade, are really not in the position of seeking refuge under a shady tree on a hot summer's day.

I believe that the fallacies which tempted art history to adopt cultural relativism also occur in other fields of the humanities; I mean the inference *ex*

silentio, the idea that the life and thought of the past can only have exhibited those features which are also known to us from artistic manifestation. A classical philologist once notoriously suggested that the ancient Greeks must have been colour-blind since they had so few words for colours. One would then have to conclude that we also are colour-blind, since our languages have infinitely fewer names than there are hues we can perceive. The conclusion, of course, is based on a misunderstanding of the nature of language, because language must be selective if it is to serve the function of communication. To be sure, this varied selectivity of language poses enormous difficulties to the translator, and yet I must again agree with Popper, who has warned us in this connection not to confuse a difficulty with an impossibility. However hard it may often be to render the meaning of a sentence in another language, and however much we may have to resort to glosses and roundabout explanations, the sense can be made accessible even though it may entail a loss in neatness and elegance.[18]

I need hardly add that works of great literature from other periods and civilizations confront us with similar difficulties. The concepts, the human relationships, the institutions of which they speak, stand constantly in need of laborious explanations. But the effort that we expend on these tasks should not tempt us to equate the world which we encounter in the poetry and prose of foreign civilizations with the everyday reality from which they sprang. What applies to language, after all, applies even more to the means of these art forms: the topoi, the types we encounter in these texts, never reflect the infinite variety of experience but rather the autonomous traditions of literary genres.

A book such as Auerbach's *Mimesis* has shown us to what extent new means of expression become receptive to new experiences, but even where they do not enter into literature we have no right to assume that these experiences never occurred in everyday life.[19] Admittedly we cannot know this for certain. It is clear that the text of Plutarch is also dependent on the traditions and conventions of the ancient world and leaves many questions unanswered which might perhaps have interested a modern psychoanalyst. Goethe's remark, 'They were all human beings', does not formulate an ultimate truth so much as a hypothesis. We might describe it as a working hypothesis or perhaps as a heuristic principle,[20] because I believe it is always worthwhile to make the initial assumption that even in foreign countries and in distant ages we have to do with people who are not all that different from ourselves – even though this assumption may occasionally fail to stand a further test.

Perhaps I may here insert a little anecdote which should illustrate my conviction more clearly than lengthy methodological reflections. I am thinking

of a discussion about the intellectual history of the Renaissance in which I was provoked to the remark that one should not treat 'Renaissance Man' as a separate species, and was tempted to say that I was sure that these people too liked to stay in bed in the morning. It was a risky assertion but I was undeservedly lucky, for I was able to tell my opponent at the next occasion that Leonardo da Vinci describes symbolic carvings on Tuscan bedsteads which are intended to warn lazy sleepers not to waste too much time there, 'particularly in the morning when one is rested and sober and should be ready for fresh exertions'.[21]

What I am driving at is the simple insight that in speaking of Man one must not lose sight of the old Adam, that old Adam who insists on the satisfaction of those drives which all people have in common. True, the way in which various cultures try to cope with the insistent clamour of our natural instincts is subject to countless variations,[22] but whatever particular solution may have been adopted, no style of life is conceivable in which the tension between the urge for satisfaction and the pressures of cultural demands fails to find expression. Literature, above all, has frequently concerned itself with these tensions. Think of the contrasting figures of Don Quixote and Sancho Panza, the one whose head has been turned by the ideals of his culture, the other who has remained enough of a peasant to know what he wants, exactly like Tamino and Papageno in Mozart's *Magic Flute*. Ancient Indian drama also knows of a similar contrast between the noble hero who speaks Sanskrit and a comic figure by name of Vidushaka who, despite belonging to the Brahmin caste, speaks the popular language of Prakrit and is always out to indulge his stomach.

When speaking of the difficulties that exist in understanding foreign cultures and their values we must not omit therefore to take account of important differences in this respect. As children of nature we are all much more alike than in the spheres of the highest refinement. It is not for nothing that Mephistopheles says to Faust: 'The worst company will make you feel that you are a man among men,' and since it is the devil who speaks we may understand him to say: 'Precisely the worst company.' Indeed we then hear him remark in Auerbach's tavern, 'Just watch and see how splendidly bestiality will reveal itself.' Beneath the all–too–human there is the layer of animality:

> We feel as barbarously well
> As fifty thousand swine.[23]

We must not forget, however, that the opportunity for this kind of regression is also specific to a given civilization. Some civilizations forbid the consumption of alcohol and know of no open carousals of this kind. For

Goethe and his contemporaries, on the other hand, there were also more noble ways to achieve freedom from the normal constraints of culture:

> And big and small shout with delight
> To be a man here is my right.[24]

'Here' means, in the context, in the freedom of nature outside the city, and this feeling of liberation is again specific to a given culture. Maybe it did not exist before Rousseau, though the tradition of the idyll reminds us that the life of the shepherd, close to nature, had long before been idealized by the town-dweller, who longed for a form of existence remote from the pressures and cares of civilization. We others, if we may believe Schiller, can throw off this burden only in privileged moments. I am of course thinking of his 'Ode to Joy':

> With your spell you can restore
> What strict fashion now divides
> Men are brothers as before
> Where your gentle wing abides.[25]

Where Schiller here speaks of 'fashion' (*Mode*) he refers to convention, in other words what the Greeks called *thesis* in contradistinction to *physis*, nature. Free from the constraints of convention, the poet says, all human beings are alike.

Maybe the Age of Reason has rightly been accused of oversimplifying this contrast, but it is to this sublime simplification that we owe the concepts of the Rights of Man and *Humanität*. On the other hand, this simplification also explains in its turn the reaction of 'historism', which did not have to wait for Hegel.

Today, after two hundred years, it should be obvious that the polarity of convention versus nature is certainly insufficient to do justice to the infinite variety of cultural life. Our biological inheritance consists less of overt traits than of dispositions which can be developed or atrophied in the life of the community. Neither among animals nor among humans are all these developments reversible. Some behaviour patterns really become second nature and create human types with their own mentalities and their own possibilities and limitations. The humanist who is interested in these complex processes will have to turn to psychology, for however many schools and problem areas there may exist in that science, they are all governed by Alexander Pope's dictum: 'The proper study of mankind is Man.' True, since psychology aims at being a science it must not submit to any dogma, not even to the dogma of the unity of mankind, yet I for one side with those of my contemporaries who oppose relativism.[26] I believe with them that we must start from

the hypothesis that there are indeed constants in the psyche of man with which the humanist can reckon. Naturally we must not expect too much. It may sound trivial to say that the enjoyment of rhythmical movement is common to all normal human beings, but without this basic disposition we would not have the various types of dance, or those refined forms of rhythm which have so marvellously blossomed forth in Western and in Indian music, and have also led to ever-fresh miracles in the poetry of all nations.[27]

I am convinced that the visual arts also rest in a similar way on biological foundations. Like the disposition for rhythmical orders which here manifests itself in the decorative art of all peoples, so the pleasure in light and splendour is common to us all. Man is a phototropic creature; if he were photophobic, like the termites, he would always have shunned the light. Thus radiant splendour, sparkle and glitter have always been seen as the prerogative of secular and religious power out to impress and to overawe. Admittedly it would be wholly misleading to try to explain the origins of art exclusively with reference to these inborn positive reactions. Only the interaction between fulfilment and denial, between the delay of satisfaction and the surpassing of expectation, leads to what we call art, and for this to happen it needs a developed tradition and a universal admiration of masters who can control such psychological effects.[28] But however varied these structures and these sequences may be which result from such an interplay of elements, they all operate within fields of tensions which derive their energy from the original polarity of universal human reactions.

In any social community every colour, every sound, and naturally also every word, has a feeling tone which determines its exact position within this system. It goes without saying that these various systems will not be accessible to the outsider without an effort of empathy, and yet there is much evidence to suggest that they all share a sufficient number of features to justify us in making the attempt. Quite generally it can be said that every one of the so-called sense modalities tends to evoke resonances in other senses and that this type of correspondence facilitates understanding. The universal capacity of language to resort to synaesthetic metaphors must be due to this inborn disposition.[29] In German we say 'helle Freude', the English speak of 'a bright hope', and Eibl-Eibesfeldt reports that among the Eipos of New Guinea one expression for joy is 'the sun shines on my breast.' If the termites had a language they would have to speak of 'dark joy', of a 'gloomy hope', and of 'night descending on their antennae', for they shun the light. The inhabitants of tropical climates naturally prefer coolness to warmth, and so Indians would rather be coolly than warmly received, but even so the Gita likens the Divine to the light of a thousand suns.

Far be it from me to want to send the practitioners of Germanic studies on

a hunting expedition after psychological literature on the metaphor, a litera-ture which may still have to be written.[30] For as I discovered to my surprise and admiration, these insights have long since been laid down in the canoni-cal text of their studies to which I can refer them – I mean the German Dictionary initiated by Jacob and Wilhelm Grimm. It was a fortunate acci-dent that prompted me to search this book for examples of synaesthetic metaphors, which I wanted to use to illustrate my belief in the universal validity of certain psychological reactions. I had not expected the wealth of treasures which lies hidden there for the psychologist of expression.

I must recommend to you to read up the term *süss* (sweet) in that diction-ary, though you may have to take a day off for the purpose. The entry with its derivations runs to at least seventy-eight columns. But right at the beginning we are presented with an important insight. We learn that the word *süss* did not originally signify a taste which was subsequently applied to other sensory modalities, as in a sweet smile, sweet harmonies, or sweet rest; on the con-trary, the word appears originally to have been synonymous with soft to the touch, mild or pleasurable, that is, it refers to that positive pole of our sensa-tions of which I spoke, and it is for this reason that it also signifies the taste which is biologically pleasing. However, this narrower meaning only became fixed in contrast to other tastes, that is, to bitter and sour, which in their turn point to further ranges of feeling. But the dictionary also throws much light on the reaction of surfeit, which is of such psychological and aesthetic importance.[31] Here it is the derivative *süsslich* (roughly corresponding to the English 'syrupy') which receives a pejorative connotation, most of all since the eighteenth century, when the term begins to express revulsion. It thus anticipates the meaning of *kitschig* (roughly 'chocolate-boxy' or 'cloying') which, in its turn, has reacted back on the overtones of the word 'sweet'. We no longer much like to use it as a term of aesthetic approval. After all, we live in an age in which the dread of being *kitschig* has assumed endemic propor-tions, while it especially welcomes artistic creations which go, as it were, against the grain.

Ideally the study of comparative literature should be extended to embrace a comparative study of expression, in which the meaning of metaphors might offer a bridge into the wide and fascinating field of synaesthetics for which psychology is competent. But that is music of the future. Rather than losing myself even further, I propose to resort to an example which might help me to sum up what was and is my essential point.

The first two stanzas of a poem by Simon Dach dating from the year 1638 will, I hope, not be unwelcome in this context since they will bring us back to Germanic studies. Its title runs 'The Bridegroom to His Dearly Beloved Bride on Her Visit to His House':

Welcome, welcome, you my treasure
 You, the solace of my heart.
Oh what sunshine and what pleasure
 Does your presence here impart.
Splendours blaze across this house
Which your golden rays arouse.

Everything will bid you greeting;
 There is not a brick or tile
Which delighted at this meeting
 Will not hail you with a smile,
Where the walls which you behold
You will soon turn into gold.[32]

No doubt the trained student of German literature will be able to explain how this poem relates to the tradition of the epithalamia and which position it occupies within the work of Dach. He will also be able to tell us that the poet put these words into the mouth of a wealthy contemporary who had commissioned him to write them. We can therefore agree with those of our colleagues who insist that it is always the text that matters and not the alleged sentiment of the author, to which we really have no access. But this does not mean that the text is fair game and that we must grant to deconstructionists that the line 'Splendours blaze across this house' might also be interpreted as alluding to a conflagration, which might possibly be read by a fanatical Freudian as a symptom of anxiety that the bride might destroy the bachelor's cosy mode of life – nor that we should allow an orthodox Marxist to discern an indication that she might want to sell the house since we read that she 'will soon turn [the walls] into gold.'

Speaking seriously, we need not permit anyone to deprive us of our conviction that we can enjoy and understand these fine lines as they were intended to be understood, quite irrespective of the fact that the middle-class culture of the so-called Baroque Age differed widely from our own style of life. For what use would be our imagination if it could not close such a gap?[33]

The cultural relativist is still welcome to remind us that the situation from which this poem springs would be even harder to understand in a society where the abduction or the purchase of brides is the norm and where nobody lives in houses. If these barriers were really quite insurmountable in principle we would have to take leave forever of Goethe's dream of a 'world literature'. He could never have coined this beautiful term if his reading of Homer and of Shakespeare, of Hāfiz and Kalidasa, and finally of Plutarch, had not convinced him 'They were all human beings – so much is plain.'

Relativism in the History of Ideas

When I was honoured by the invitation to contribute to this seminar on the history of ideas I felt bound to warn my kind hosts that they vastly overrated my competence in this field. This is not simply a *captatio benevolentiae*. I have discovered long ago that at my age one is confronted with the hard choice of either reading or writing. If one is writing one cannot also keep up with the literature in many areas, and so one falls behindhand. Practically the only contacts I have had with the field which interests this seminar were through oral tradition, as it were, through conversation with friends and colleagues. I have indeed been privileged to have known one of the pioneers of the history of ideas, the late George Boas, who collaborated for many years with Arthur O. Lovejoy.[1] It was in fact George Boas who expostulated with me in one of his letters that I should not criticize relativism as I had done, since the word meant no more than that ideas are related to each other, which I cannot possibly deny and shall not deny today.

But the idea for this contribution came to me through another personal contact, one made many years ago at the Warburg Institute with that great historian of ideas, the late D. P. Walker. It was Walker who remarked to me one day, as we were sitting together in the Common Room, that the history of the witch-craze would have to be written in different terms if it turned out that witches could indeed perform the ghastly deeds for which they were punished. This is the problem of relativism I have in mind. If we still believe in the existence of witches (and I know that some people do), the *Malleus maleficarum* would figure in the history of ideas as a contribution to knowledge and be placed beside Gilbert's *De Magnete* or Harvey's discovery of the circulation of the blood. In regarding the belief in witches as erroneous we write the history of these beliefs differently.

I don't want to be misunderstood. I have learned enough from another friend, Sir Karl Popper, not to dismiss human error as something culpable or even useless. I have been told that students of science often refuse to be interested in the history of their subject since they regard it simply as the history of errors which no longer concern us. You surely cannot write the history of ideas if you adopt such a negative attitude, but you cannot do so either, I want to contend, if you eliminate the notion of error altogether and adopt a wholly relativistic stance.

Contribution to a conference on the history of ideas given in Rome in October 1987

I suspect it was Thomas Kuhn's book, *The Structure of Scientific Revolution* (1963), which appealed to the tender conscience of historians by warning them not to feel superior over past centuries and past ideas, though I have heard Kuhn say explicitly that he too believes in the progress of knowledge.[2] Maybe it was a misunderstanding of Kuhn which made people think that he said what they wished to hear, namely that the claims of science to add to our knowledge are untenable. I would not be surprised if that had happened, for similar misunderstandings happened to me when *Art and Illusion* was read (or possibly not read) as a plea for complete relativism in the representation of nature.[3]

Let me briefly say how I see the problem in relation to the various forms of human thought which must interest the historian of ideas: I hope I am not causing offence if I suggest that the historian of religious ideas cannot but be a relativist. He must remain neutral in his account of the conflict about the *filioque*, that is, whether the Holy Ghost proceeds from the Father alone, or from the Father and the Son, a conflict which cost so many lives and contributed to the schism between Eastern and Western Christianity.

At the other end of the spectrum we have the history of technology. Here, I suppose, there are no out-and-out relativists. The invention of the wheel and the invention of nuclear power are facts which cannot easily be disputed away.

If I propose to place the history of science next to technology in my schema or spectrum, it is not because I wish to advocate a pragmatist conception of science, but rather because it may be argued that every technological invention also implies a scientific discovery. In the case of nuclear power this is obvious; the case of the wheel, however, may warn us not to expect that every scientific discovery implied in technological inventions must also have been formulated as such by the inventors. I dare say that the Australian aborigines who invented and perfected that astonishing weapon, the boomerang, could not have explained its flight path in terms of the science of aerodynamics, but we all believe that this must be possible in principle unless the boomerang is based on magic.

I say 'we all believe', because our ideas about both technology and science are rarely independent of the system of beliefs which are called *Weltanschauung* in German and ideologies in English, though the word has perhaps too much of a political flavour to suit my purpose exactly. In my schema, I would suggest, ideologies must be placed between science and religion. It is precisely the history of ideas which tells us how often scientific discoveries were either favoured or impeded by ideology, pervasive beliefs, such as the belief in progress or the rejection of magic.[4]

The history of ideas is obviously confronted, very frequently, with such interactions between ideologies and the developments of science, and it is

again my contention that this interaction cannot be studied if we give up the belief in the objectivity of certain scientific discoveries.

I have never been fond of purely abstract discussions of such questions of method, and in what follows I shall give instead a series of half a dozen concrete examples, briefly illustrating various aspects of the problem.

Let me take my first example from my own field, which has concerned me a good deal – the place of perspective in the history of art. There have been attempts by such eminent historians of art as Erwin Panofsky and Pierre Francastel to interpret the introduction of perspective in the early quattrocento in terms of a change in ideology.[5] In my view this aspect has been much exaggerated, for nobody has claimed so far, to my knowledge, that the invention of eyeglasses a century earlier was a symptom of a new world view, though a new world view it certainly produced for old people with bad eyes.[6]

In my view the application of the science of optics to the practice of painting, which resulted in the invention of perspective, has a similar objective validity which also explained the rapid spread of the device. I have written too much on this controversy to want to dwell on it further. Let me rather turn to another example, which is also close to my own area of interest, the deciphering of the Egyptian hieroglyphs. It is an example of which I am fond because I doubt that even the most committed relativist would maintain that ancient Egyptian texts cannot now be read with a fair degree of certainty and that objective progress was made by the science of archaeology as soon as this became possible. It was not possible as long as the false belief persisted, which goes back to the Neo-Platonists and to that curious treatise, the *Hieroglyphica* by Horapollon, the belief that these signs and images were invented by the ancient Egyptian priests to embody profound insights of their mystical philosophy.[7] This belief, in its turn, was of course deeply rooted in the ideology of certain Renaissance scholars who had faith in the *prisca theologia*, the existence of a tradition of ancient esoteric wisdom, a current which has been so fruitfully explored both by Walker and by Frances Yates.

The historian of ideas who believes that this conception of ancient Egypt was wrong and that we now know what the texts tell us will have to trace the gradual decline of the faith in the *prisca theologia*. He will study Vico's somewhat ambivalent attitude and other writers who preceded Champollion's first success in deciphering the Rosetta Stone published in 1824. All this is obvious, but it is only obvious for those of us who are not relativists in the sense I have described.

Let me turn to a very different example, though one which concerns the same period which witnessed the correct decipherment of the hieroglyphs. I refer to the discovery of meteors, to which another friend at the Warburg, Otto Kurz, once drew my attention. I take the facts of the story, which is very

far removed from my own field of work, from a recent book by John G. Burke entitled *Cosmic Debris, Meteorites in History*.[8] The crucial fact is that meteorites had been falling on the earth from the sky from time immemorial but that the learned world refused to believe it, dismissing any new report as simply the result of ignorant superstition. The author rightly claims in his introduction that the episode furnishes a remarkable illustration of how a theory can dominate the minds of even the best scientists. He continues:

> This observation is, of course, not a new one. Historical accounts of the revolution in astronomy and physics that led to the rejection of the Aristotelian–Ptolemaic cosmos and to its replacement by that of Copernicus, Galileo, and Newton have clearly demonstrated how tenaciously scientists can cling to a familiar theory. With respect to the fall of meteorites, however, there were no religious beliefs that were possible influencing factors. The prevailing theory was that, apart from the celestial bodies, interplanetary or cosmic space did not contain any matter except the subtle and invisible aether. Therefore, neither stones nor irons could originate there. A subsidiary eighteenth-century theory affirmed what was true – namely, that stones or minerals could not be generated in the Earth's atmosphere. Taken together, then, theory held that stones could not and did not fall from the heavens.

The first chapter of the book is entitled 'Disbelief', the second 'From Disbelief to Acceptance'. I gather from these exciting pages that the first scientist who voiced the belief that a meteor that had fallen in Poland really came from the sky was Franz Güssman, a Jesuit who became professor of Natural History at Vienna, where he published a treatise, *Lithophylacium Mitisianum* (1785), but his opinion was wholly ignored. It was only nine years later that Chladni proposed the hypothesis of the cosmic origin of meteorites, but acceptance continued to be slow. In 1812, Burke notes, Pierre Bigot de Morogues complained that

> the Academy of Sciences had in vain appointed a committee to ascertain the reality of the fall of stones. Many parts of France, Germany, Italy and England were almost simultaneously the theatre of these events. Sworn testimony and a multitude of witnesses confirmed their truth in all of Europe without having shaken the opinion of the majority of learned people. Almost all looked with disdain at the pieces of evidence offered to them, and only listened with boredom to the recital of the factual circumstances, without even deigning to compare them in order to deduce their probability.

The story is surely not untypical of many episodes in the history of

scientific discoveries, and I cannot imagine how it could be coherently told without using the terms truth and error.

I agree that even in such a case the historian of ideas should not yield to the temptation of explaining the failure of the 'orthodox', of allowing himself to be convinced by the evidence simply in terms of human stupidity. To be sure, stupid people have always been around both inside and outside intellectual circles, but this fact would not be sufficiently interesting to warrant a study. So, in trying to explain the episode, the historian should consult what Popper has called the Logic of Situations;[9] he should reconstruct the choices in front of these men and make us see why they found it so much easier to accept the Aristotelian explanations with which they had been brought up than to jettison them for a step into an unknown and as yet unstructured view of the Universe. The mental habit of accepting authority in such matters also forms part of an ideology which, as we know, yielded only slowly to the opposite habit of always believing the latest idea that arrives on the market.

In both cases the historian of ideas will not be able to avoid resorting to psychological explanations: some of them, like the tendency to conformism, are almost too trivial to spell out, others may take him into fields of social and individual psychology which are beset with risks. But, to repeat, whatever explanation he seeks in his work, he cannot begin to do so without having made up his mind where the truth of the matter was to be found. The tasks confronting the historian of ideas are rarely as clear-cut as in the previous example.

Perhaps I may briefly allude here to a problem which confronted me when I was engaged on the intellectual biography of Aby Warburg.[10] It is an intellectual, not a psychological biography; I was concerned with his ideas and his interpretations rather than with his psychological problems, but I found that the two could not be kept apart. Warburg himself knew that very well; he recognized early on that his interpretation of the mentality of the Florentine bankers in Lorenzo de' Medici's circle was influenced by his own experience of the bankers of Hamburg and, of course, by his ambivalent attitude towards his own milieu. Near the end of his life he wrote that astonishing note suggesting that it sometimes seemed to him that his interpretation of the classical tradition and of its polarities rested on what he called an 'autobiographical reflex', due to his own manic-depressive constitution; the manic element being represented by figures in rapid motion, such as the type he called the 'nympha', the depressive element by the recumbent rivergod.[11] As a biographer I could have simply noted this remark, but you will agree that as a historian of ideas I was obliged to ask myself whether, and to what extent, these psychological factors distorted Warburg's vision of the Renaissance.

To assess and describe such a distortion one would have to have an opinion of where Warburg departed from reality in favour of his obsessions. This may not always be easy, for how can I tell that my own view of Renaissance realities is not also coloured by my own preoccupations? If I understand it correctly, it is this question that has led the theory of hermeneutics to its particular type of relativism.[12] But once more, I think one can go too far. There is an example at hand: Warburg's wish to establish continuities in the tradition of symbols from the ancient world via the Arabs to the Renaissance led him to postulate that the first so-called 'Decan' of the ram in the astrological fresco cycle of the Palazzo Schifanoia in Ferrara, which illustrates a list of these figures deriving from Arabic sources, is really the classical figure of Perseus disguised almost beyond recognition.[13] In that theory the wish was father to the thought; but Saxl told me that he found it impossible to convince Warburg of his error. I am not mentioning this here, of course, to make the obvious point that Warburg was not infallible, but to suggest that the intensity of his wish in establishing continuities had such strong psychological roots that he could not free himself from his preoccupation, and for this psychological diagnosis we must know that the hypothesis he presented was not only mistaken but really unfounded. It cannot be done in relativistic terms.

Let me discuss yet another example, a problem that began to interest me in connection with a book I am trying to write on the history of taste which I propose to call 'The Preference for the Primitive'. As far as the historical background goes I can indeed rely on the studies of primitivism by Lovejoy and Boas, who have shown the link between this idea and the cyclical conception of history, the widespread belief in the rise and fall of cultures and in the analogy between the life-cycle of organisms and that of the arts. Wherever there is a belief in decline or decadence there must be the corresponding longing for an age and an art still uncorrupted and still innocent.[14] But in continuing the history of these ideas into the nineteenth century it became clear to me that a new element here entered, the biological notion of degeneracy. Once more I had to appeal to a university colleague for help in a field very far from my own. My spies told me that in the Unit of the History of Medicine, which forms part of the Department of Anatomy and Embryology of University College, London, a course had been given on 'The theme of degeneration in European history, cultural theory and social science, 1860–1914'.

Dr Michael Neve, who gave this course, very generously passed on his material to me, and I learned from his bibliography how many books there were on this important topic which I had not read and shall never read. I also learned of the crucial role played in this story by an important medical trea-

tise of 1857, B. A. Moral's *Traité des dégénérescences physiques, intellectuelles et morales de l'espèce humaine*. This was in its time a serious medical investigation, which also much influenced Lombroso. It seems to me a fascinating story to watch how this medical concept merged with the older idea of decadence, a notion about which there exists a stimulating though somewhat unsystematic book by Richard Gilman, *Decadence: the Strange Life of an Epithet*.[15] The term *décadent* became a vogue word in the later part of the nineteenth century, when it was no longer invariably used in a negative sense. The romantic idea that genius and artistic creativity were somehow allied to illness and madness made this cult of decadence possible. In 1885 there even appeared a short-lived journal called *Le Décadent*, and authors from J. K. Huysmans to Oscar Wilde and Thomas Mann vied with each other in celebrating these interesting and morbid states of mind. Nietzsche, of course, got hold of the notion and branded everybody he disapproved of, from Socrates to Richard Wagner, with that epithet.

In 1892 the successful journalist Max Nordau published a book, *Entartung* (Degeneracy), which he dedicated to Lombroso and which was very widely discussed and also believed. Among the degenerates, he pilloried Whistler and Cézanne. There is a strange link between this book by an aggressive Zionist and the Nazi condemnation of 'degenerate art'.[16] Alas, this notion is of course not the only idea which National Socialism derived from the biological ideas of the nineteenth century. The ideology of racialism as launched by Gobineau and Chamberlain derived their justification from the alleged contrast between the healthy and pure Nordic races and the hybrid degenerate populations which threatened to swamp and destroy civilization.

Even more than forty years ago, before the more recent triumphs of the science of genetics, these views were rightly dismissed as rubbish by biologists. I quote from a popular book by H. Kalmus of 1945:

> One of the worst superstitions, and one which has probably been doing much damage, is the idea of degeneracy, a sort of all-round decay of mythical racial qualities, which is held responsible for the biological downfall of families and nations. There is no reason to believe that such catastrophes ever happen.[17]

I suppose the author could be so confident in his rejection of that once-popular belief because he had been brought up in the knowledge of Mendel's theory of heredity, according to which every fresh pairing leads to a fresh random mixture of the respective genes. It is well known that Mendel published his observations in 1865 but in so remote a place that they did not become common knowledge until much later. Before that happened, biological

inheritance was seen as a linear development and interpreted in a wholly deterministic way as a step-by-step increase or decrease of certain characteristics. I do not know how much difference it would have made if these facts had been understood by writers such as Zola or such early racialist politicians as Schönerer, but I would submit that the story gains added interest if it is written in terms of truth and error.

Let me return to Walker's remarks about the witch-craze with which I started. He said, as you remember, that the story would have to be told differently by the historian of ideas if he thought that it was not a craze but a well-founded conviction. It is impossible for a complete relativist to write it sensibly. But do we know that there really are no witches or never were? The Latin proverb says that *negativa non sunt probanda*. How can any one of us claim to be sure that no one at some time or some place ever performed magic?

This reflection must make the historian pause before he attributes the so-called witch-crazes entirely to psychological causes. There is no reason to think that all those who believed in the existence of witchcraft were insane; after all, the belief had the sanction of the Bible and of classical literature, and it is more likely than not that a good many of the victims of these delusions were themselves convinced that they could inflict harm on enemies or damage the crops. One might say that the belief itself was not wholly irrational, though the waves of panic and persecution that swept across unhappy Europe also call for an explanation in terms of mass psychology. But even when all this is granted, the historian of ideas will acknowledge the wisdom of Leonardo, who found a very compelling argument against the claims of the magicians.

> Surely, if this necromancy did exist, as is believed by small wits, there is nothing on the earth that would be of so much importance alike for the detriment and the service of man. If it were true that there were in such an art the power to disturb the calm serenity of the air. . . what kind of naval warfare is there to hurt the enemy so much?[18]

Leonardo was right in asking this simple question, just as the *Malleus maleficarum* was surely wrong in recommending that witches could be discovered by torture. Another contact at the Warburg Institute, Carlo Ginzburg, once told me that it was the Holy Office which more or less put an end to the persecution of witches when it issued a directive that no one should be condemned for *maleficium* unless it could be proved beyond doubt that the harmful effect on a person or on the crops could not possibly have been due to natural causes. It was this change in ideology which put an end to this horror.

In speaking of a horror I have again abandoned relativism, this time moral relativism. I have expressed the belief elsewhere that the humanities, to which the history of ideas surely belongs, would atrophy and die if they attempted to become 'value free'.[19] Ideas originate with human beings and affect human beings and to discuss them with cold objectivity seems to me inhuman in the true sense of the word.

Relativism in the Appreciation of Art

There is a charming little dialogue among the sayings and parables of the Daoist sage Chuang-tzu, who lived around 300 BC. It is entitled 'The Joy of the Fish'.[1]

> One day Chuang-tzu was promenading with his friend Hui-tzu on the bridge across the Hao river. Chuang-tzu said: 'How cheerfully the nimble fish are jumping and flitting about. This is the joy of the fish.'
> Hui-tzu said: 'You are not a fish, how, then, can you know of the joy of the fish?'
> Chuang-tzu replied: 'You are not I, how can you know that I do not know of the joy of the fish?'
> Hui-tzu answered: 'I am not you, and so I really cannot know you fully. But it is still certain that you are not a fish, and so it is perfectly clear that you cannot know of the joy of the fish.'
> Chuang-tzu said: 'Let us please return to our point of departure. You said, "How can you know of the joy of the fish?" But you knew already, and still asked. I know of the joy of the fish by my own joy in watching them from the bridge.'

The exchange must have been proverbial in China, for some thousand years later the great poet Po Chü-i (772–846) wrote two brief stanzas of a sceptical comment entitled 'Reflections by the Pool'.[2]

> In vain did Chuang and Hui dispute together on the Hao bridge:
> Human minds don't necessarily know the minds of other creatures.
> An otter comes catching fish, the fish leap out:
> This is not fish-delight, it is fish-alarm!
> The water is shallow, the fish are scarce, the white egret is hungry:
> Mind hard at work, eyes wide open, he waits for the fish.
> From the outside he looks at ease, but within he is distressed:
> Things are not what they seem – but who would know?

What the poet says is that if he had been on the bridge, he would have warned the sage not to rely too much on his intuition. The strength of

Introduction to a volume of essays on paintings in the Mauritshuis, The Hague, 1989

subjective convictions is no safeguard against errors. We never really know if we are right, but we sometimes know that we were wrong.

Is it too far-fetched to imagine an analogous conversation taking place among the paintings of the Mauritshuis, let us say in front of one of Abraham van Beyeren's still lifes? 'How Van Beyeren enjoyed the sparkle of light on these precious vessels', says the art lover. 'You are not Van Beyeren', his down-to-earth companion reminds him. 'How do you know he enjoyed it?' 'You are not I', is the reply. 'How do you know that I do not know? In any case I know, because of my own enjoyment.'

But then an art historian who overhears the exchange hands the art lover a catalogue.[3] He draws attention to the watch on the table and to the upturned wineglass and informs him that what he sees is an allegory of *vanitas* (Fig. 5). He is meant to reflect on the transience of earthly pleasures, for the sparkle will not last. Simply to enjoy the feast of the eye is to miss the message of the painting.

Paul Valéry, in the passage that provides the motto for this collection, takes up a position somewhat in between that of the art lover and the art historian.

A work lasts to the extent that it is capable of appearing quite different from what its author made it. It lasts in order to be transformed, and to the extent that it contained the potential for countless transformations

5. Abraham van Beyeren: *Still Life*. Mid-1600s. The Hague, Mauritshuis

6. Rembrandt: *The Militia Company of Captain Frans Banning Cocq*
(known as *The Night Watch*). 1642. Amsterdam, Rijksmuseum

and interpretations; or else it must comprise a quality independent of its author, not provided by him but by his period or nation, and which acquires value from the change of period or nation.[4]

No doubt Valéry would have encouraged the art lover to surrender himself to his own subjective response, since the work of art can only endure in the minds of men, but he would have done so precisely because we would never know what it meant to its creator.

Maybe the art historian demurs. Granted that these vessels are part of a *vanitas*; was he wrong to claim in the catalogue that Van Beyeren painted them with pleasure, and indeed with love? Now it is the art historian's turn to be questioned how he can tell. Might not the artist have groaned while painting them? We shall never know, but Valéry is surely right in claiming that the work of art is independent of its creator and endures in and through a variety of interpretations. And yet, the Chinese poet was also right in insisting on the fallibility of our spontaneous reactions. We must be ready at any time to give up our fancies if they turn out to conflict with the facts.

Rembrandt's *Night Watch* (Fig. 6) is *not* a night watch, and all comments that took their cue from this apocryphal title are not only obsolete but simply wrong. If proof were needed of the ease with which our response to works of art can be influenced, it could be found in the hold which such erroneous titles have had on the minds of suggestible critics.

One example may here stand for many. There is a pair of connected statues in the Ludovisi Collection in Rome (Fig. 7) which was wrongly believed in the seventeenth century to illustrate a humorous anecdote related by the Latin grammarian Aulus Gellius. The story tells of the wiles used by one Papirius, a young Roman, to evade the indiscreet questions of his mother, who wanted to know what he had heard in the Senate.[5] Inspired by the title, the well-known critic Abbé du Bos wrote in 1719 that 'no feeling has ever been better expressed than the curiosity of the young mother ... the very soul of this woman can be seen in her eyes, which pierce and caress her son at the same time.' Here, as so often in that period, the author can be seen to have read all the requisite emotions into fairly expressionless features. Had he but paid attention to the woman's cropped hair, which is a sign of mourning, he would have controlled his flight of fancy or at least have turned it in a different direction. It is now thought that the group represents a last farewell, such as is frequently shown in Greek funerary art.

Clearly one interpretation is not as good or as bad as another. The archaeologist or the historian cannot be expected to forgo his birthright of guarding the evidence. He may not wish to ask for the credentials of any personal

7. Roman portrait group (known as *Papirius and his Mother*).
Rome, Museo Nazionale Romano (Ludovisi Collection)

association that comes into the mind of the critic, but he can only allow the stream of consciousness to flow between the banks of facts.

There is a close analogy here between the visual arts and the arts of poetry and music. The interpretations of a given poem may vary greatly, but they find their limit in the words on paper, some of which will never allow themselves to be 'de-constructed'. It is the same with the composer's score. There may be many readings of the same symphony, all of which respect the notes, but any performer who ignores the markings has lost the right to claim that he is presenting the work in question.

If this analogy is accepted, it follows that it may be misleading to apply such terms as 'subjectivity' and 'objectivity' as mutually exclusive in our dealings with the arts. The search for an objectively correct performance can lead to a deadly mechanical rendering wholly devoid of meaning, just as the indulgence in subjectivity can efface the creation it pretends to serve. Without an initial engagement, a readiness to respond, or (to use the chilling psychological term) a willingness to project, the poem, the composition, the painting or sculpture will remain inert. Clearly this expenditure of energy will not come to pass unless we are primed by our culture to expect a rewarding experience. If we do not know the language of the poem, the idiom of the music or the style of the image, we are unlikely to make the required effort. But has it not turned out that even our feeling for nature is largely conditioned by our education? If Chuang-tzu had not absorbed from Daoism the sense of unity with nature, he would not have responded as he did to the movement of the fish in the water.

But just because there is this affinity between a feeling for nature and a feeling for art we must not disregard the difference. We cannot and need not try to understand a rock or a tree, but we can seek to understand the creations of another human being, however far removed in place or time. There may be limits to this possibility, but this does not absolve us from the need of a different kind of controlled attention, without which we are left with the solipsistic pleasure of enjoying our own enjoyment. Without the presence of these three elements, that of initial readiness, of involvement, and of detachment, the work of art can never be brought to life.

Whoever studies the history of art criticism has many opportunities of seeing these contrasting tendencies at work. As we have seen from the example of Papirius, the critics of earlier centuries were always ready to respond to the dramatic, story-telling functions of art. It was to display their skill in verbalizing their reactions in front of images of every kind that ancient orators developed the genre of *ekphrasis*, which was cultivated wherever the classical tradition held sway. A certain licence to re-create rather than to describe the work in question was taken for granted even by such masters as Goethe. But

it was only in the nineteenth century that a great critic made such subjectivity his watchword. 'To see the object as in itself it really is,' writes Walter Pater in the Preface to *The Renaissance* (1873), 'has been justly said to be the aim of all true criticism whatever; and in aesthetic criticism the first step towards seeing one's object as it really is, is to know one's own impression as it really is ... What is this song or picture ... to me? What effect does it really produce on me?' [6]

Those who have read the captivating essays that follow this programmatic declaration will recall how far Pater went in following this prescription. Witness his famous musings on Leonardo's *Mona Lisa*: 'She is older than the rocks among which she sits.' Few modern readers would not here want to shake the writer and shout: 'Wake up, wake up, she is not!'

No wonder that the aspiration of art history to become a science has led to an ever-increasing reaction against such blatant subjectivity. But where do we draw the line between the required attention to the objective property of a work and those qualities which every beholder must contribute from his own store of experience?

The story goes that the eminent medievalist Adolph Goldschmidt once took over Heinrich Wölfflin's seminar and opened the meeting by throwing a slide of a Dutch landscape painting on to the screen with the question: 'What do you see?' 'I see a horizontal, crossed by two verticals,' responded one of the students. 'Actually', said Goldschmidt gently, 'I see a little more.'

Approaches to the History of Art:
Three Points for Discussion

I THE PROBLEM OF EXPLANATION

In science we seek to explain an individual event by referring it to a general law of nature. If I let go of this pencil and it falls, we explain this fact by Newton's law of gravity. Strictly speaking this is not quite so. For if this pencil were made of light material and filled with gas it might not fall but rise to the ceiling like a balloon, being lighter than the air it displaces, which may cause us to remember the law for floating bodies discovered by Archimedes, who was so excited about it that he ran naked through the streets of Syracuse shouting 'Eureka!' (I've got it!).

Unlike scientists, who have had many reasons since the time of Archimedes for shouting Eureka!, we humanists have been less fortunate and that for the obvious reason that the events we try to explain tend to be immensely complex and can never be reduced to one easily formulated law, which we may describe as the cause of the event.

Even so, I agree with Sir Karl Popper that there is no difference in principle between explanations in history and in science; the difference is in the direction of our interest.[1] We humanists are less interested in such general questions as why bodies fall, sink or float, than in individual cases, particular events such as the outcome of a battle or the spread of a style.

The need for the explanation of singular events is not really peculiar to history. It also arises quite frequently in our daily lives and it is useful to remember these examples first. Think of one of the many accidents or disasters of which you read in the newspapers: an explosion, an air crash, Chernobyl, or the Zeebrugge ferry disaster. In each of these cases, committees of experts have been appointed to pinpoint the causes, not only for apportioning blame and legal costs, but also for the sake of preventing a repetition of the accident. These experts, it is useful to remember, work within the framework of science. They know that a ferry cannot float on the surface when the open bow doors allow the water to stream in, and that a plane will crash when the engines stop. They do not mention these general laws in their final report because they are taken for granted. What they want to find out in every case is the combination of causes that ultimately led to the tragic outcome, and they know perfectly well that they would be faced by what is

Introductory remarks given at the Erasmus Symposium in Holland in 1988

called an 'infinite regress' if they pursued every individual cause to its ante-
cedents. They may find, for example, that the member of the ferry crew
whose job it was to close the doors went to sleep instead, but they do not then
go into the question of why he was sleepy or neglectful. These facts may
perhaps interest his counsel for the defence in an ultimate trial, but they are
not what the commission was asked to find out.

What it is always asked to do is to *eliminate wrong explanations*, let us say the
charge of sabotage or maybe of black magic. If somebody tried to explain a
disaster by pointing to the fact that it happened on a Friday the 13th, or
because the planet Saturn was in the House of Aquarius, we would be en-
titled to reject the explanations as nonsense. I believe that for the historian
this rejection of false or naïve explanations is as important as the search for
better and more correct causal theories. We must clear the ground of rubbish
before we can build.

If I am asked how I came to be interested in many so-called disciplines
outside my own field, I need only quote the writings of the first art historian,
Giorgio Vasari, to be precise the preface to the second part of his *Lives of the
Painters* published in 1550:

> When I first undertook to describe these lives, it was not my intention
> merely to give notice of these artists and, so to say, present an inventory
> of their work; nor would I have considered it a worthy aim of my long
> and hard labours to trace their numbers, their place of origin or the
> place where they worked or where their works are at present to be
> found, because all that I could have done by means of a simple tabula-
> tion without anywhere giving my own opinion.[2]

Taking a leaf out of the ancient historians, Vasari, the contemporary of
Macchiavelli and of Guicciardini, then proceeds to explain what he considers
the true tasks of a historian to be, and confesses that it is these he adopted as
his model, endeavouring not only to express his judgement but also to
explain 'the causes and the roots of style' (*le cause e le radici delle maniere*).
With our expectation thus raised we may feel a sense of anticlimax when
Vasari comes up with his explanation. He attributes what he calls the rebirth
of the arts principally to the special air of Tuscany, while he also expresses his
conviction that the arts resemble the human body in having their birth, their
growth, their maturity and their decline. Such analogical thinking, as you
know, is still very widespread in historical writings, which abound in bio-
logical terms such as 'decadence'.

Anybody who takes these matters seriously must be struck by the inad-
equacy of the explanations which art historians have used in the context of
their narratives. I need hardly mention what I have called the mythological

tendencies of romantic historiography.[3] Mythology, of course, may be described as a primitive form of explanation. To use one of Popper's examples: the ancients might explain a storm or an earthquake by the theory that Neptune was angry, or a plague by the omission of a sacrifice demanded by the Gods. Romantic historiography, as I see it, is full of such mythological entities as the *Zeitgeist*, the *Volksgeist*, the process of production and the mechanism of biological evolution which are supposed to explain the historical destiny of cultures.

It is quite an interesting, if somewhat dispiriting, task to go through the writings of some of our best art historians to probe the explanations they incidentally or systematically offer their readers. Take Bernard Berenson, no doubt a great art historian, whose tabulations, as Vasari would have called his lists, certainly represent a landmark in our discipline. But when it comes to 'the cause and roots of style', to use Vasari's expression once more, Berenson has this to say in his brilliant essay on the Venetian painters, first published in the 1890s:[4]

> The growing delight in life with the consequent love of health, beauty and joy were felt more powerfully in Venice than anywhere else in Italy. The explanation of this may be found in the character of the Venetian government which was such that it gave little room for the satisfaction of the passion for personal glory, and kept its citizens so busy in duties of state that they had small leisure for learning. Some of the chief passions of the Renaissance thus finding no outlet in Venice, the other passions insisted all the more on being satisfied.

It was against this kind of easy chatter that what became the Vienna School of Art History reacted, insisting that their discipline should aspire to the status and precision of the sciences. One finds this overriding ambition particularly in the writings of the great Alois Riegl, who died in 1905 and left a body of work that is still regarded as presenting a challenge to his successors. It was Riegl who attempted to ground the history of art in the science of psychology as he knew it. According to the tradition of that time, which reaches back over many centuries, we must analyse perception into its main constituents, seeing and touching. The eye, so it was believed, can be considered an optical instrument much like a photographic camera, allowing an image of the outside world to be formed on the retina. This image was necessarily flat and we derived our experience of space, of the third dimension, exclusively from touch. Using this simple framework, Riegl developed an all-embracing theory according to which the representation of nature in art underwent cycles of changes, moving from touch to vision or, as he put it, from the haptic to the optic. The ancient Egyptians built up their images

from knowledge acquired by touch, the Impressionists from the image on the retina. This secular process Riegl proposed to explain by the theory that man's will to form (*Kunstwollen*) moved with a kind of clockwork regularity from the 'haptic' to the 'optic' pole.[5]

The skill, ingenuity and learning with which Riegl fitted his observations of figurative art, of ornament and of architecture into this scheme, which he even extended to embrace the development of philosophy, must certainly demand admiration, but having read Riegl with much care in my student days I felt the need to examine the evidence afresh.

Needless to say, this desire does not imply a lack of respect for the author of these theories – in a way we should always probe theories before adopting them in our work. In this particular case it is surely evident that the psychology of perception current today differs vastly from the simplistic ideas about vision and touch with which Riegl operated. To mention only one factor, we are very much more aware than he was of the role of movement in our perception of space. To put it a little more technically, it is the flow of information reaching us from the visual world which matters decisively in our perception. One of the problems faced by the painter who wants to represent an aspect of the visual world is of course that pictures do not move. He must stop the flow of information on which he is used to rely and this is no trivial feat. To cut a long story short, this fact accounts for the observation that the imitation of nature in art is a skill encoded in tradition that must be learned – a point to which I shall return. It was also the topic of my book *Art and Illusion*,[6] in which I attempted to account for the slow evolution of naturalistic styles from what one might call pictographic methods to more or less photographic ones.

But let me emphasize very strongly that the psychology of perception which interested me in that book can never offer more than a very partial explanation of an individual event in our field. It may contribute one of the strands in the complex tissue of interacting causes and events, but there will always be a myriad of others: the psychological disposition to enjoy splendour and sparkle and the counteracting effects of sophistication resisting these primitive delights;[7] the social aspects of competition, the desire to outdo one's rival in any one particular effect, a desire which also presupposes that we must have information about what the rival has achieved. I have written of the auction effect, what I called the logic of Vanity Fair.[8]

Looking at the world of fashions and of styles the historian will notice that some particular feature will suddenly attract attention and become the object of rivalry. It may be the length or shortness of skirts, the size of orchestras in which the princelings of Germany competed, or the daring in breaking social taboos on the stage with more and more nudity, such as we have witnessed

in our day. I have suggested that it is part of that logic that to attract attention you must be different from the others, and therefore you must think of something new as soon as the others have caught up with you. It is important to realize that these matters are not really the province of psychology. They are not rooted in what is called human nature, because after all there are many societies in which there are no similar competitions. What must be taken into account in such events is also what Popper has called the logic of situations. He refers to such simplified models as are now familiar from the science of economics which investigate the possible effects of a particular move.[9] To use his example: if somebody wants to buy a house in a particular area he wants to pay as little as possible, but the very fact that he has entered the market is likely to drive the price up. On a more drastic scale we have experienced the effect of the introduction of computers as at least one cause of the recent crash of the Stock Exchange. If you programme your computers to sell shares when their price drops below a certain point, more and more shares will be thrown on the market in a feedback effect which will increasingly lower the prices.

Even here you must be aware of hitting upon an explanation which really explains too much and would never allow the situation to be remedied. Quite generally, it stands to reason that the historian must apply what is called common sense. There are so many competing overriding theories offered to him – Marxism, racialism, psychoanalysis, structuralism and any other global theory claiming to explain the whole of human behaviour and of history. These claims often sound attractive: they operate with selected examples and promise the practitioner a safe method of dealing with his material, but a moment of reflection should convince him that their promise is bound to be spurious. It is bound to be spurious because the explanations we seek will always depend on our interest and on the question we wish to ask.

When I gave a seminar on these questions of method attended by a number of excellent young historians we developed a kind of shorthand language for this problem. We called it 'Cupology'. The word arose because one of us took a teacup which stood on the table and attempted to list the questions you might ask about it. You might begin by wanting to know what it was made of: if it was made of china the train of thought would get you immediately to the fascinating history of its manufacture, if it was made of plastic even more so. If you asked why it had a handle you needed some elementary physics to explain the conduction of heat to your fingers. You needed medicine to explain the popularity of tea as a refreshment, and geography to describe how tea came to the West from China. You needed botany for your account of tea plantations, not to mention the tragic effect of the importation of Tamils into Ceylon by the British to work these

plantations. Surely it would not be hard to introduce aesthetics or sociology. Properly handled, each of these questions might result in an interesting paper, or even in a book. The decision as to which question to ask will always remain with us. We will be guided partly by the tradition of research in these matters, partly also by the chance we perceive of finding out something new. What the historian needs in such matters is some tact and some flair, what is called 'an eye for a problem'.

We are often exhorted to engage in interdisciplinary research, but I am far from sure that this is a valid issue. What we call disciplines are, at best, matters of organizational convenience in academic life. It is surely convenient to have a department of Sanskrit in which you find the dictionaries and the texts relevant to this study, and also the specialists whom you can consult. But each of these specialists is likely to ask very different questions, questions of comparative philology, of the history of religion or of the development of Sanskrit logic. Each of them must be able to look out of the window, for if we draw the blinds and close the shutters we shall see precisely nothing.

II TECHNOLOGY AND TRADITION

As I indicated above I believe that the history of art can be conceived in terms of a technological progress, a series of technical inventions which led to the increasing perfection of the imitation of nature, which of course is not the same as aesthetic perfection. Not only can the history of art be so conceived, it was written in this form by the first historians of art in Antiquity and in the Renaissance. If you open the thirty-fifth and thirty-sixth books of Pliny's *Natural History*,[10] written at the beginning of our era, you will find that he regularly mentions the technical improvements introduced by individual artists. A certain Cimon of Cleone was said to have invented the painting of profiles and also of heads looking back, upwards or downwards. He distinguished between the joints of the limbs and made the veins visible. The famous Polygnotus started to paint people with their mouth open, showing the teeth, thus overcoming the rigidity of their features. Parrhasius was the first to bring symmetry into paintings, to impart expression to the head, and to paint hair beautifully. And so it goes on. Pliny compiled these rather primitive characterizations from Greek sources which are lost to us. Primitive or not, there is little doubt that the history of art owes its existence to the realization that the methods of artists had changed and were changing at the time when these writers lived, and that works of art produced a few generations or centuries earlier looked to them crude and unskilled.

As we know, Vasari looked upon the development of painting and sculpture up to his own time in a similar way, though with greater understanding

and sophistication. His work became the standard account of the development of Italian art from the thirteenth to the fifteenth century, but ever since the Romantic period his technological bias presented something of an embarrassment to historians of art. They rightly hesitated to speak of progress between such great masters as Giotto and Fra Angelico, Botticelli and Michelangelo. The devaluation of technological skill in twentieth-century art and art teaching further contributed to this embarrassment. The history of art should not be taught as a history of technological progress but as the history of various styles, each perfect in its own right as a valid expression of the age.

I take a different line. Not that I want to deny the glories of Archaic or Romanesque art, which are no longer in need of defenders. But I have become convinced in my work that the technological approach has been sadly neglected in the history of art and that it is time to restore it.

When I referred in the first part of this essay to 'Cupology', I stressed that you can go in any direction from any object and find interesting problems for your research. But precisely because this is so, I think we should not be tempted too easily to neglect the object itself. We must learn to focus on it rather than yield to what may be called the centrifugal tendencies of certain intellectual fashions. No doubt it is interesting when studying the arts of Florence to learn about the class structure of that city, about its commerce or its religious movements. But being art historians we should not go off on a tangent but rather learn as much as we can about the painter's craft. We should ask ourselves how these masters achieved certain effects and how these effects or tricks were introduced and modified – precisely the type of question Vasari asked.

I have found in my work that so little has been done in this respect that I have sometimes been tempted to say that we do not yet have a history of art worthy of its name. More or less the only aspect of this history that has been thoroughly discussed is what is called the rendering of space, including the history of perspective. There is little work of equal detail on the history of light in painting or on the rendering of texture.[11] I was astonished to find for instance how little art historians had attended to the ways of painting eyes or to the question of when and how the highlight in the eyes was first discovered and then rediscovered. Another time I was equally surprised to find, when studying Leonardo's *Trattato* and his precepts for painting trees and foliage in various types of illumination,[12] how little attention had been paid to the history of this development, though I was able to pay tribute to John Ruskin's *Modern Painters*, a work that certainly does not neglect the craft aspect of painting – but then it was written almost a century and a half ago.

I trust I need hardly explain how I see the connection between the study of technology, the tricks of the trade in the crafts, and the study of tradition. We

all know that the craftsman learned while serving as apprentice to a master and that these systems and standards were carefully regulated by the guilds. But even before and after this system had crystallized, the need of any craft demanded the continuity of its exercise. Hence what is characteristic of almost any craft tradition is the formation of centres of excellence.

Go back in history as far as you like, to the days when Solomon built his temple in Jerusalem. We read that he sent for Hiram of Tyre, the son of a Phoenician and a man filled with wisdom and understanding and cunning, to carry out all work in brass.[13] Who can doubt that the account reflects the situation, so often repeated in history, that in the absence of a local tradition a master was called from a centre of acknowledged excellence? In later centuries the city of Damascus gave its name to high-quality blades, while in the Middle Ages the Moselle region produced that wonderful Mosan type of metalwork of which the church treasures of Europe contain such lovely examples. We all know of Persian carpets, Brussels lace, Delft tiles, Dresden china, Cremona violins, to list a few more examples almost at random, and in more recent time, Swiss watches, Japanese cameras and perhaps Scotch whisky.

I frankly do not know if any social historian has set himself the task of investigating this phenomenon as such; maybe he would find that there are too many variables involved to make a profitable field of study. Many craft traditions are no doubt dependent on the availability of materials, like china clay or lacquer, and with them on tools and equipment which are literally handed on from master to apprentice. But what matters most is obviously a kind of skill which cannot be learned overnight, what we call 'know-how', which is more than theoretical knowledge and rather a feel for the material and for the problems of the craft which must become second nature.

I know perfectly well that craftsmanship alone is not the same as artistic genius. Dou, the marvellous craftsman, never became a Rembrandt. But could Rembrandt himself have become Rembrandt if he had never mastered the craft? Once more I think that much contemporary aesthetics tends to neglect what I have called the technological aspect of the great achievements in the history of art. As far as we can tell, these transcending achievements have always grown out of the soil prepared and fertilized by a great craft tradition. I believe that in this and other respects we tend to use the word creativity too lightly. Creativity does not come out of the void. It is the impulse to search out the possibilities and the varieties of solutions offered by the craft tradition which will produce novelty and originality, because what the craftsman learns is not only to copy but also to vary, to exploit his resources to the full and push his skill to the very limits of what a task will allow and suggest. This is what almost any master will do, but the outstanding individual will

transcend this high level and produce a work that we then see as the culmi-
nation of the tradition: a Stradivarius violin in Cremona, a Taj Mahal in
India, or the stained-glass window of the *Belle Vierge* at Chartres Cathedral.
The question I should like to raise briefly is whether there can possibly be an
explanation of these high points in the history of art.

We art historians are so used to acknowledging the importance of these
centres of excellence that we do not hesitate to call a painting or an
illuminated manuscript 'provincial' if we find that it does not come up to
the standards of the tradition. But why should a work produced in a
provincial workshop far from the hub of events fall short of excellence? Why
should not a man of talent and originality have lived and worked anywhere
and produced works to equal or surpass the most renowned creators of the
age? It is a question which also engaged the mind of Vasari, and his answer
has a strong sociological slant. He attributes the decline in standards to the
lack of competition. Thus he tells us of the reason why the great Donatello
decided to return to Florence after completing his wonderful works at Padua.
He found, according to Vasari, that he encountered too much praise and
applause. He preferred to go back to his native city where he was constantly
criticized, because these strictures would make him work harder and thus
achieve greater glory.[14]

I have quoted elsewhere Vasari's marvellous analysis of the Florentine
situation in his *Life of Perugino*, which again centres on the bracing artistic
climate of Florence, where you had to be very good indeed to survive at all.[15]
We know that Vasari does not speak for himself only. When Dürer came from
Nuremberg to Venice he noted with some surprise that a Venetian engraver
he had admired in Germany, Jacopo Barbari, was not highly esteemed in his
native town. 'People say', wrote Dürer, 'that if he were better he would stay
here.' In other words he would brave the competition of his rivals.[16]

I would not have referred to these testimonies if I did not think that there
is something in this sociological explanation of artistic excellence. What it
brings out implicitly, above all, is the importance of a critical audience, a
public of discriminating connoisseurs whose high standards do not allow the
artist to get away with anything but the best. Indeed, if we speak of traditions
here, we must never forget the role of the consumer, patron or client who
forms an important element in the equation.

In my essay on 'Art History and the Social Sciences'[17] I stressed that this
rise of an informed public is by no means confined to the arts and that there
is no kind of display or skill in any culture which lacks its connoisseurs or its
fans. There will always be a circle of followers who can discuss and appreciate
the so-called finer points and whose response will help to make or break
reputations. There are traditions in appreciation as well as in creativity. It will

be the point of the last section of this essay that we neglect this tradition at
our peril.

III 'VALUE-FREE' HUMANITIES?

My answer to the question posed by the title will surprise no one. I have
always been convinced that the humanities must depend on a system of
values and that this is precisely what distinguishes them from the natural
sciences. Even so, it may still be worthwhile rehearsing my reasons for this
opinion, because there is a strong intellectual trend nowadays advocating the
opposite point of view. What is sometimes called 'The New Art History',
which is sometimes but not necessarily allied to a Marxist interpretation,
aspires precisely to an elimination of bourgeois prejudices and academic
conservatism. Why just study Raphael or Rembrandt? Should the historian
not be as neutral as the scientist? The astronomer will not pick on stars for
his spectral analysis because they sparkle so prettily, and the botanist will
not stick to just roses or tulips.

Of course there is something to this argument. There is no reason why an
art historian should not study the minor masters or the humble products of
popular crafts. Just as the linguist will be concerned with any text in the lan-
guage he studies, a magic spell, a prayer, a contract or an offer of sale, so the
student of images should be ready to concern himself with any product of the
kind. The reason why I am sceptical about this claim that has been made for
a new art history is not that I find this approach wrong or distasteful, but
rather because I cannot see what should be new in it. We have had this kind
of discipline for several centuries; it is called archaeology, a type of study that
has particularly flourished in England, where the Society of Antiquaries was
founded back in the eighteenth century. If you turn the pages of their Journal
and their Yearbook you will not see many paintings by Raphael among the
illustrations, but figurines, potsherds, carved beams or tombstones, in short
any artefact that interests the archaeologist as evidence for his investigations
– be it of early settlements, of trade routes, of patterns of cultivation or any
other aspect of our history. Archaeology may indeed claim to be a science
making increasing use of scientific tools and methods such as carbon dating,
pollen analysis or thermoluminescence. Needless to say, these methods have
also spilled over into art history because we cannot afford to neglect any kind
of evidence or source of knowledge. But neither can we afford to lack a
principle of selection, a point of view. Once more I may remind you here of
what we called 'Cupology' (see p. 66). 'Cupology', if I understand it rightly,
belongs to archaeology. Any cup or beaker may serve to get us talking and
investigating one of the innumerable chains of cause and effect that

ultimately resulted in the object in front of us. But as art historians we have a different ambition. We are concerned with the history of art and art is an embodiment of values. Admittedly I am begging the question here. As I have stressed elsewhere,[18] there are two meanings of the term 'art' in English, a neutral one which describes any image, as when we speak of child art or the art of the insane, and a valuative one, as when we say 'this may be the work of a madman but what he has produced is a work of art'. We cannot say this without an implicit standard of values and this standard we cannot find in the objects; we can only find it in our own mind. The history of art, like the history of literature or the history of cookery, is concerned with achievements. In the second part of this essay I outlined some of the conditions of such achievements – the competition of craftsmen and the encouragement of a discriminating public. This discrimination can admittedly also go wrong or be imperilled by intellectual fashions or snobbish concerns. It may have happened in Holland in the late seventeenth century, when Frenchified fashions all but destroyed the native tradition; it may have happened again in our own days, when the cult of progress threatened the continuities of art.[19] But whether you agree with this verdict or not, we could not even discuss it without our own standards of values.

I can well imagine that those who have read my essay on 'Art History and the Social Sciences' were disappointed about my discussion of values in the arts. Having insisted at such length that I believed in the reality of these values, that I was sure Michelangelo was indeed a greater artist than the English seventeenth-century painter John Streater, you found me confessing that these things cannot be proved by arguments. I mentioned the many teachers today who feel the need to convince their students of the reality of these achievements, but I expressed the view that these values are too deeply embedded in the totality of our civilization to be discussed in isolation. 'Civilization', I wrote, 'can be transmitted, it cannot be taught in courses leading to an examination.' Maybe you found this a disappointing conclusion to an important debate.

I am all the more happy to find that I can reinforce this conclusion by quoting the authority of that great Dutch historian Johan Huizinga. I suppose I had read this important utterance long before I wrote my paper, but I had forgotten how much I owed to it. I am referring to his brief article on 'The Definition of the Notion of History'.[20] The article takes issue with a number of definitions Huizinga found in authoritative German handbooks for students of history which concentrate on history as a science. Without wishing in any way to deny the scientific aspirations of the modern historian, Huizinga found this approach much too narrow. After all, history existed as a pursuit long before academic history was established.

In reflecting about the history of historiography Huizinga rightly stressed what I have also stressed, that all historiography must be selective. Imagine the modern historian visiting an archive to pursue his research. He will find room after room and shelf after shelf filled with mountains of files. They are the written records of a tiny selection of events now lying in the past, maybe the records of land sales, police records, or registers of births and deaths. What we call historical research is of course really nothing but a search among these records, a search for an answer to the question which happens to interest us for the moment. As Huizinga said, 'The past as such without a further qualification means nothing but chaos.'

Every civilization has conceived of history as a search for its own origins. Earlier cultures received their history in the form of myths and in the shape of epics such as Homer's. I need hardly stress what role the cult of ancestors and the legal claims based on ancestry played in the formation of historiography. Thus Huizinga comes to the conclusion that history is best defined as 'the intellectual form in which a civilization renders account to itself of its past'.

Note that this definition does not exclude that value-free investigation of the history of settlements or of trade routes, which I relegated to archaeology. Our civilization is a rational one and it demands rational answers based on evidence which can be tested by the methods of science. But our civilization, like all civilizations, is also held together by values – social, moral or aesthetic. It is these values which I found embodied in what I call the canons of art, the standards of mastery without which there could be no history of art. I mentioned earlier that the first historians of art selected their material by the criteria of the technological progress in the representation of nature. They did so because these were the standards of their own civilizations. We all know that these standards have fluctuated and changed. Practically every new movement in art has looked for its own ancestors and has influenced the writing of art history. German Expressionism all but discovered Grünewald; the Surrealists not only admired Bosch but even erected a special pedestal for Arcimboldo, who has not yet entered my canon. In any case it is a proof of the liveliness of our civilization that the canon is often revised and new values are emphasized. These values need not be mutually exclusive; you may be able to appreciate both Raphael and Rembrandt, both Dante and Tolstoy. What you are not able to do, in my view, if you want to go on practising the humanities, is to throw away all standards of value. Dehumanizing the humanities can only lead to their extinction.

The Conservation of our Cities:
Ruskin's Message for Today

Be it heard or not, I must not leave the truth unstated, that it is again no question of expediency or feeling whether we shall preserve the buildings of past times or not. We have no right whatever to touch them. They are not ours. They belong partly to those who built them, and partly to all the generations of mankind who are to follow us.[1]

I know of no clearer or more uncompromising answer to the question 'Why preserve historic buildings?' than these defiant words, which John Ruskin wrote in 1849. They are taken from *The Seven Lamps of Architecture*, to be exact, from the sixth chapter, which bears the title 'The Lamp of Memory' (Fig. 8). As a historian I feel bound to commemorate Ruskin at this hour, because it may well be that without the rousing words of this prophet this Congress[2] would never have taken place.

I intend to come back to Ruskin several times in the course of this address to provide evidence for that assertion, but first the historian must also ask, how did Ruskin himself arrive at this position, unparalleled in this extreme form? We have seen that he bases his categorical ban against the least kind of interference with old buildings on a twofold argument: they belong not to us but, in the first place, to our ancestors who built them, and, in the second place, to our heirs. So, placed between past and future, we are not their owners but merely their trustees. What is so novel about Ruskin's contention is, above all, the extension of the idea of a monument to the whole of our architectural heritage, and I shall have more to say about that, too.

A monument, in the original sense of the term, is destined for future generations which, for their part, should respond to its message and take it to heart. Very often this message to posterity is contained in an inscription, which sometimes outlives the monument itself. Think of the famous lines from the grave at Thermopylae:

> Go, tell the Spartans, thou who passest by,
> That here obedient to their laws we lie.

The gravestone itself has long since disappeared, the burial place cannot be found, and there are no Lacedaemonians left in the world, but the

Address given at the First International Congress on Architectural Conservation in Basle in March 1983

8. Balcony in the Campo San Benedetto, Venice,
from *The Seven Lamps of Architecture* by John Ruskin, 1849

message has come down to us over centuries and with it the fame of the three hundred Spartans who sacrificed their lives. It is posthumous fame which is the purpose of a monument and, to ensure its continuance, rulers and conquerors have seen to it that its construction is as massive and permanent as possible. Admittedly, this has occasionally provoked posterity to cast down the statues of detested figures and efface the inscriptions. Roman law even knew the sentence of *damnatio memoriae*, the eradicating of memory, and, properly considered, it also shows that Ruskin was not so wrong when he denied us the right to deprive the future of the monuments of the past. Our emotions tell us that there is still something like a right to an afterlife, which expresses itself in the conservation of monuments. What our ancestors achieved and suffered should not be surrendered to oblivion.

This right is, perhaps, independent of whether the past addresses us direct, as is the case with an actual monument, or whether we have a reason for commemorating it in connection with some historic event. In the latter case we say that memory sanctifies a place, and here the Swiss will think of Rütli, the clearing in the woods where their Confederation was founded, the English of the little island of Runnymede, where the Magna Carta was signed, and

9. West face of the Naiku *shoden*,
Ise Jingu, Japan

Americans of Gettysburg. This sense of sanctification corresponds to what we call piety. The Latin word *pietas*, from which the English word originates, means not merely devoutness; it includes loyalty to parents, to family and to the homeland. But, above all, piety manifests itself in the attitude towards religious traditions. Sacred shrines, the graves of martyrs, and indeed relics and ancient customs, are the object of piety. And yet I know of only one religion which imposes on its believers the pious duty of maintaining architectural monuments; I am thinking of Shintoism in Japan, and in particular of its greatest sanctuary at Ise (Fig. 9), with its devotional shrines constructed of timber.[3] As early as AD 690, a decree ordained that these buildings had to be wholly rebuilt every twenty years, without alteration. Except for very brief interruptions during periods of internal strife, boards and beams have been transported there in solemn procession every twentieth year, before the old ones rotted. And it is almost certain that at least some of these dwellings of the Gods confront us today precisely in the form in which they were erected more than one thousand five hundred years ago.

However, since Western civilizations hoped to secure the durability of monuments through stone and mortar, that solution was not available to

them. Age renders buildings venerable in the West, but it does not preserve them from the pious zeal of restorers. As Professor Alfred Schmid has demonstrated in his contribution to this Congress, it was not the sacred but the pagan edifices, whose might and size seemed to defy the centuries, which were first regarded as monuments. Because Rome, the metropolis, fell into ruin in the Middle Ages, the derelict fragments of antiquity became silent witnesses to a vanished splendour: *Roma quanta fuit ipsa ruina docet* ('How great Rome once was, is still shown even by the ruins'). In the Renaissance, when cattle grazed on the Forum, the contrast between the miserable present and the glorious past became a commonplace of humanist rhetoric, and the Popes of Rome strove not to allow the evidence of the past to disappear. After several abortive beginnings Raphael was commissioned by Pope Leo X to arrest the destruction of antique remains, meaning mainly inscriptions and sculptures; but at least the claims of *sacrosancta antiquitas* to the care of posterity were thus recognized in principle.[4]

It is significant that the enthusiasm for the might and splendour of ancient Rome devalued Christian buildings. If it had not been for the ambition of Pope Julius II to build a new Rome, it would never have been possible to come to the decision to demolish the most venerable church in the Papal capital, the Basilica of St Peter (Fig. 10), which dated from the time of Constantine the Great, and to have a new church built by Bramante (Fig. 11), which would rival the Hagia Sophia in Constantinople. What concerns us in this episode is the fact that this bold disregard of piety led to a protest, which for the first time, perhaps, attempted to uphold the rights of the past. In 1517, the year of Luther's public protest against the sale of indulgences to finance the rebuilding of the basilica, a little satirical pamphlet appeared in Rome under the title *Simia* ('Ape').[5] It was directed against Bramante, who had died three years previously, and describes a dialogue with Saint Peter, who, as we know, guards the Gates of Heaven. When the architect arrives, the saint asks him: 'Aren't you the man who destroyed my church?', whereupon a third person not only confirms this but also adds: 'He would have destroyed all of Rome, if only he could.' After all, Bramante had been given the sobriquet *Il Rovinante*, ('The Destroyer'). Saint Peter then asks the architect direct: 'Why did you destroy my church in Rome, which by its age alone reminded even the worst unbelievers of God?' Note the form in which the question is put. The highly venerable monument itself, not just its dedication to the saint, bids us to be reverent. Its destruction is an impiety in every sense.

But Bramante does not allow himself to be intimidated. On the contrary, he refuses to enter Heaven unless he is permitted to take charge of its architecture. To begin with, the steep path from Earth to Heaven must disappear. He wants to build a new convenient road, so that the souls of the

10. The atrium of old St Peter's, Rome, with the new church rising in the background, mid-sixteenth century. Drawing by Giovanni Antonio Dosio

11. St Peter's, Rome

weak and old can ride up on horseback. Then he wants to build a new Paradise, with beautiful, cheerful dwellings for the blessed. As Saint Peter will not hear of this, Bramante declares he will go to the Mansion of Pluto and there build a new Hell in place of the old dilapidated one, which has almost been destroyed by the flames.

Here, possibly for the first time, a theme is touched upon which continues to echo through the centuries, the lament about the pride of architects, their irreverence and arrogance. Who knows, perhaps in those days we would have joined in this condemnation. And yet, I do not need to stress that there are two sides to the matter. However much we deplore the ruthless demolition of the old basilica of St Peter's, we would not gladly forgo Michelangelo's dome, which Friedrich Schiller, for his part, was able to celebrate as the symbol of Rome's greatness:

> Any beggar in the eternal city
> Can regard us Northerners with pity
> As he looks upon the monuments of Rome
> Naught but beauty meets his dazzled eyes
> When he sees a second heaven rise
> In St Peter's awe-inspiring dome.[6]

Yet Schiller wrote that poem 'To My Friends' not as a *laudator temporis acti*. On the contrary, his message is:

> We, we live, these times belong to us
> For the right is ever with the living.[7]

How and when, you may ask, did the loss of this proud self-confidence come about, which alone can explain Ruskin's injunction for a standstill in building?

One might adduce social and psychological reasons, but I think that as far as architecture is concerned, the self-confidence was well founded. After all, many generations benefited from dominant architectural idioms, recognized styles, which, in a way, reduced the risk of putting up new buildings. Except for such men as Julius II and Bramante, no one troubled himself about innovation. On the contrary, an architect who received a commission to build a new house or renovate an old one was able to consult prevailing customs. Indeed, most beautiful old towns, whether Solothurn or Amsterdam, Rothenburg or Bath, owe their unity and harmony precisely to the absence of any striving for originality.[8] This adherence to tradition did not of course exclude the possibility of improvements. Where a type of house or façade was established, it was easier to introduce practical or aesthetic variations, which themselves became traditional (Fig. 12). This steady development gives the

12. Houses in the Herengracht, Amsterdam, 1943–6. Drawing by De Poorters

buildings of these epochs the character which we like to describe as 'organic'. When we speak so confidently of things which are organically rooted in the locality, we are certainly resorting to metaphors, to figurative expressions; but there must be reasons why this comparison with natural growth continually forces itself upon us. Probably it is because, as the old saying goes, Nature, too, does not act by fits and starts: new forms of life have arisen gradually from the variations which have particularly proved themselves in the struggle for existence. It is this adaptation to the environment which distinguishes the development of building – think, for example, of those farmhouses which accord so naturally with their surroundings that they seem like part of the landscape (Fig. 13). Something of this unplanned balance is expressed in the traditional townscapes, and about this, too, Ruskin has written what is, to my knowledge, the most beautiful and convincing statement of its kind, in which he indicates the reasons which make these buildings so precious. For us today, admittedly, Ruskin's excited prose is a shade too rhetorical; nevertheless, listen to him once more:

A fair building is necessarily worth the ground it stands upon, and will be so until Central Africa and America shall have become as populous as Middlesex: nor is any cause whatever valid as a ground for its destruction. If ever valid, certainly not now, when the place both of the past and future is too much usurped in our minds by the restless and discontented present. The very quietness of nature is gradually withdrawn from us; thousands who once in their necessarily prolonged travel were subjected to an influence, from the silent sky and slumbering fields, more effectual than known or confessed, now bear with them even there the ceaseless fever of their life; and along the iron veins that traverse the frame of our country, beat and flow the fiery pulses of its exertion, hotter and faster every hour. All vitality is concentrated through those throbbing arteries into the central cities; the country is passed over like a green sea by narrow bridges, and we are thrown back in continually

closer crowds upon the city gates. The only influence which can in any wise there take the place of that of the woods and fields, is the power of ancient Architecture. Do not part with it for the sake of the formal square, or of the fenced and planted walk, nor of the goodly street nor opened quay. The pride of a city is not in these. Leave them to the crowd; but remember that there will surely be some within the circuit of the disquieted walls who would ask for some other spots than these herein to walk; for some other forms to meet their sight familiarly.

It seems to me that here Ruskin has put a finger on a decisive point, which is certainly essential to answer the question 'Why preserve historic buildings?' Technical progress and the rapid change in our environment make the past all the more precious to us. It almost seems as if there was a kind of law, which I would like to call the Law of Compensation. The faster the transformation, the greater the desire for permanence. Without the impressions, which 'meet [our] sight familiarly', a feeling of alienation takes hold of us, indeed of fear, which threatens our mental balance: and not only in modern times; no one has spoken more forcefully about this feeling than the great lyric poet of the Middle Ages, Walther von der Vogelweide (*c.*1170–1230), in his 'Lament for Lost Youth':

13. Cottage in Selworthy, Somerset

> The people and the land where I have spent my youth
> Have become strange to me, as if it weren't the truth.
> Those who my playmates were, are sluggish, old and sore:
> The fields are lying waste, the forest is no more.
> But for the rippling waters which still flow, as of late,
> Indeed I feel my misery would have become too great.[9]

The stream, the sole childhood memory which he can greet as familiar, preserves the poet from extreme spiritual distress. Today it would probably also have fallen victim to drainage.

I am not one of those people who nowadays prefer to write the word progress between quotation marks. Even the landscape of Walther's youth had long been a cultivated landscape. For generations it had been cleared, ploughed and planted and had so to continue if field and wood were to offer the population shelter and food. We are ever more painfully conscious that there is no progress without a price. If meadow and field are to go on flourishing, we must protect them from the exploitation which can so easily transform whole regions into deserts. Even the greatest boons, such as the advances in medicine, present us with the grave problems of overpopulation and an ageing population. And yet, who would really like to be transplanted to one of the European towns as they were two hundred years ago, without street-lighting, refuse disposal, or hygenic water supplies?

Listen to the musicologist Charles Burney, reporting thoughtfully in 1773 on his visit to Potsdam:

> In visiting the principal streets and squares of this beautiful city, which is well-built, well-paved, magnificent, and new, I could not help observing, that foot passengers were here, as well as in every other city of Europe, except London, exposed to accidents from being mixed with horses and carriages, as well as from the insolence and brutality of their riders and drivers, for want of a foot-path . . . perhaps, England is the only country, at present, where the common people are sufficiently respected, for their lives and limbs to be thought worth preserving.[10]

No wonder the desire for improvements was at the fore then. This mood between resignation and hope is tellingly reflected in the words of the Hungarian count Fekete de Galantha, published anonymously in Vienna in 1787:

> An infallible means of making Vienna rank with Paris and London, indeed, of raising her above these two magnificent rivals, would be to execute the following plan, the realisation of which, perhaps, the year

2400 will see, if the ever-active and extraordinary intellect of the Emperor [Joseph II] leaves it to others to carry out. . . .

One would have to knock down the fortifications and join the suburbs to the actual city, by which means a significantly greater number of inhabitants could be accommodated. Then, in order to widen the side streets, numerous buildings could be pulled down, so that the crowds which now flood the public places could distribute themselves in the city more easily.

The progress of taste, for which the sovereign has given more than one example . . . would impart a less old-fashioned aspect to the buildings. Then one would no longer lay eyes on the shapeless colossi, in whose piled up storeys the owner takes much more satisfaction than the eye of the indignant beholder.[11]

In those days, as we perceive, the accusation of greed applied not to the land speculators who pulled down the old buildings, but to the landlords who wanted to keep their tenement blocks.

Well, Vienna did not have to wait until the year 2400 before the walls and the glacis had to yield to the Ringstrasse, and even the most zealous architectural preservationist will not wish this step quite undone (Fig. 14). Yet there can be no doubt that what I call the Law of Compensation makes an appearance at the same time as the desire for progress, that is to say, the growing

14. View of Vienna about 1680. Engraving by Folpert van Ouden-Allen.
Vienna, Nationalbibliothek

demand not only for preservation of historic buildings but also for their statutory protection. The radicalism of the Enlightenment, which reached a climax in the French Revolution, led, as we know, to the destruction of the royal tombs in St-Denis and the profanation of Notre-Dame Cathedral, which was transformed into a Temple of Liberty. No wonder that a sense of offended piety, in which, naturally, national sensitivity, political interest and intellectual currents were interwoven, made itself felt ever more urgently. On both sides of the Rhine there were efforts to turn that feeling into action: in 1810 the French minister responsible for venerable monuments ordered a census of such buildings, and nine years later he approved a budget 'pour la conservation des anciens monuments', which was soon followed by legislation and a Commission for Historic Monuments. In Germany in 1815, the architect Carl Friedrich Schinkel composed a memorandum to the Prussian Ministry of the Interior 'on the preservation of ancient monuments and antiquities in our country'; at the same time the Boisserée brothers campaigned for the recording and completion of Cologne Cathedral; and in 1818 the Grand Duke of Hesse promulgated a law according to which the old monuments of his territory had to be inventoried.[12]

Admittedly it seems to us now, in retrospect, that the romantic longing for the vanished past often had devastating consequences for our architectural inheritance. Wherever there were the means, medieval cathedrals, castles and secular buildings were sacrificed to an academic ideal of supposed stylistic purity, through which the traces of the past were erased cosmetically and the genuine monuments transformed into false theatre architecture. Soon, however, clear-sighted connoisseurs began to oppose this activity. As early as 1839 Montalembert said that antiquities had two enemies, vandals and restorers, but in his own country the almost superhuman energy and conviction of Viollet-le-Duc triumphed over the doubters and his hand still weighs heavily on the medieval monuments of France.

In pursuit of an answer to this problem the historian is again led back to Ruskin; it was he who lent his considerable authority to putting a stop to this activity. But it would be better to let him speak for himself:

Neither by the public, nor by those who have the care of public monuments, is the true meaning of the word restoration understood. It means the most total destruction which a building can suffer: a destruction out of which no remnants can be gathered: a destruction accompanied with false description of the thing destroyed. Do not let us deceive ourselves in this important matter; it is impossible, as impossible as to raise the dead, to restore anything that has ever been great or beautiful in architecture.

Ruskin, who attached so much importance to manual work, stressed repeatedly that the spirit of the dead craftsman cannot be conjured up again, and that even the most careful copy must be a counterfeit. 'There was yet in the old some life', he says,

> some more mysterious suggestion of what it had been, and of what it had lost, some sweetness in the gentle lines which rain and sun had wrought. There can be none in the brute hardness of the new carving....

> Watch an old building with an anxious care; guard it as best as you may, and at any cost, from every influence of dilapidation. Count its stones as you would jewels of a crown; set watches about it as if at the gates of a besieged city; bind it together with iron where it loosens; stay it with timbers where it declines; do not care about the unsightliness of the aid: better a crutch than a lost limb; and do this tenderly, and reverently, and continually, and many a generation will still be born and pass away beneath its shadow.

When *The Seven Lamps* was reprinted thirty-one years later, Ruskin wrote a bitter and angry preface. He called it the most useless work he had ever written; the buildings which he had described with so much delight had in the meantime been torn down 'or scraped and patched up into smugness and smoothness more tragic than uttermost ruin'. Ruskin was too pessimistic. Admittedly it took a long time for his conviction – that the ideal of 'purist restoration' had and has fatal results – to gain widespread support. But we read with relief in the Charter of Venice of 1966 that according to its Article 11 the valuable contributions of all epochs must be respected, for purism is not the aim of restoration. Satisfactory though it is that the fight against the purist restorers has finally been won, it was a relatively easy victory. One had only to persuade the well-meaning Romantics that this costly practice did more harm than good. The fight against the destruction of old buildings was another matter. It had to reckon with quite different forces and powers and, properly speaking, it could never be completely won, for the standstill which Ruskin desired was neither possible nor really desirable. As so often in life, there is a real moral conflict here, which cannot be talked away. To quote Friedrich Schiller once more:

> Ideas can dwell together easily
> But solid things will clash in real space.[13]

I can hardly imagine a space where 'solid things' clash more against each other than our towns. If that were not so, there would be no discussion or debate such as engages us today.

15. The Blacksmiths' Guildhouse, or Schmiedzunfthaus, in Basle.
Watercolour by J. J. Neustück, 1861

Here I must make a confession. When I was honoured with the invitation to give this lecture I had no idea how much had been written on the subject and how much there would be to read: not only the continuously changing laws and ordinances in all European countries on the care of monuments, which certainly fill many volumes; not only the countless books, periodicals and articles which have dealt with this question over more than one hundred years; but above all the meetings, conferences and international symposiums whose collected papers, as I realized with trepidation, frequently comprised a thousand closely printed pages. I had to content myself with considering the full bookshelves which I found under the classification 'conservation' in the library of the Royal Institute of British Architects as an expression of that psychological law which I have called the Law of Compensation. Precisely because the last hundred years have brought such decisive changes, because new modes of transport, new materials, new social attitudes and, above all, a new density of population have confronted the guardians of the architectural heritage with ever graver problems, our heritage – which year by year is increasingly threatened – year by year becomes more precious. I am not talking merely of academics or of high-minded aesthetes; I was delighted in the course of my unsystematic reading when I came across a local example: some twelve years ago there was a disagreement in Basle about the preservation of the Schmiedzunfthaus (Fig. 15), which was finally saved from demolition by

a referendum with a majority of 1400 votes. These votes were assuredly not all cast by art historians.

We often ask ourselves how much the individual can do to remedy a growing evil. Here, too, Ruskin is a shining example. In spite of his depression, he did not give up and in an essay which he wrote four years after the publication of *The Seven Lamps*, on the occasion of the opening of the Crystal Palace, he put forward a concrete plan:

> Something might yet be done, if it were but possible thoroughly to awaken and alarm the men. . . . If every man, who has the interest of Art and of History at heart, would at once devote himself earnestly – not to enrich his own collection – not even to enlighten his own neighbours or investigate his own parish-territory – but to far-sighted and fore-sighted endeavour in the great field of Europe, there is yet time to do much. An association might be formed, thoroughly organized so as to maintain active watchers and agents in every town of importance, who, in the first place, should furnish the society with a perfect account of every monument of interest in its neighbourhood, and then with a yearly or half-yearly report of the state of such monuments, and of the changes proposed to be made upon them; the society then furnishing funds, either to buy, freehold, such buildings or other works of untransferable art as at any time might be offered for sale, or to assist their proprietors, whether private individuals or public bodies, in the maintenance of such guardianship as was really necessary for their safety; and exerting itself, with all the influence which such an association would rapidly command, to prevent unwise restoration and unnecessary destruction.

Ruskin closes with the observation that a task of this kind contained its own reward; it would also require sacrifices and yet, as he says, 'is it absurd to believe that men are capable of doing this?'

It was not absurd. Success did not come overnight, but this conference is only one of many proofs that it did come. Twenty-three years after Ruskin's apparently utopian suggestion, his admirer William Morris founded the Society for the Protection of Old Buildings, later popularly known as 'the anti-scrape society'. I do not wish to give the impression that the conservation and protection of monuments had been waiting for this initiative alone. I have already directed attention to the origins of the relevant legislation which reach much further back. But it is just the history of this legislation which proves how much the pressure of public opinion during the last hundred years has contributed to the widening of the concept of a monument to embrace the whole architectonic heritage, including our familiar streets and

squares, even if they can claim no kind of historic significance. Let me illustrate this process by the British example.

In 1882 the Ancient Monuments Protection Act was concerned with sixty-eight monuments; these were almost all prehistoric. In 1900 more medieval buildings were included, and in 1907 even medieval half-timbered houses; in 1931 the statute also covered protection of the surroundings of ancient monuments, and by the next year the directive speaks of the protection of buildings, or groups of buildings, which are not ancient monuments in the original sense of the term. In 1937 the efforts to save the beauty of Bath made it easier for the Georgian Group to inventory all other buildings from before 1830, when different degrees of need for protection were introduced. Here I feel I must mention the contribution of Lord Duncan-Sandys who, as founder of the Civic Trust in 1957, bore the main responsibility for extending conservation from individual buildings to areas – the so-called conservation areas; whereupon, in the following year, the Victorian Society upheld the right of Victorian architecture to respect and consideration. Lord Duncan-Sandys piloted the Civic Amenities Act to victory in Parliament in 1967. In 1972 there were 170,000 buildings and 2,000 conservation areas under some kind of protection, though of course this protection was not and could not necessarily be made effective.

'Could not', because in these questions there are and must be at least two sides. Let me mention a little example drawn from London: on the road between Hampstead and Highgate stands an old and popular public house, the Spaniards Inn, and opposite that is a little toll-house (Fig. 16), before which conveyances once had to halt in order to obtain passage. The toll has long been done away with and the narrowing of the road between the public house and the toll-house has been a thorn in the flesh for many car drivers. The demolition of this modest monument of a vanished era had been decided upon, when one of the protesting citizens wrote to *The Times* saying that he appreciated that with the road widening the trip between the two suburbs might be reduced by five minutes – but what would people do with these five minutes? It seems that his argument struck home, for the toll-house was reprieved and I, too, am happy about this. But although these minutes may not matter in 9.999 cases, you could easily imagine a situation when a life depended on them. If that is so, then we bear the responsibility; but at the same time we can console ourselves with the thought that the slowing down of traffic would also avert accidents.

However that may be, one thing is certain: among the public at large, planners are increasingly regarded as meddlers, and whether they want to be Bramantes or only Rovinantes they have now been forced on to the defensive. This reversal originates to some extent from the widespread disillusion-

16. Toll-house by the Spaniards Inn in Highgate, North London

ment which has made itself felt in recent years – from the disappointed rejection of the modern movement in architecture, the growing suspicion of all planning, and genuine fear of what the future may bring. Books such as *The Death and Life of American Cities* by Jane Jacobs in 1961, which has the subtitle 'The Failure of Town Planning', and Rachel Carson's *Silent Spring* – an attack on the indiscriminate use of pesticides and weed-killers – from the following year, have translated Ruskin's message into the language of the twentieth century and initiated a whole political movement, the 'Greens', whose members are not always mindful how much easier ideas live together than objects.

We may sometimes feel that this movement has succumbed to the same immoderation as Ruskin. On 17 January 1983 I read in *The Times* of the astonishing fate of a nineteenth-century barn in a Lincolnshire village: the limestone-and-slate structure had recently been made a protected building, but the local authority declared it to be dilapidated and had it pulled down. They had the express permission of the planning department for this, but it was apparently based on a misunderstanding, which came to light when the local population promptly protested that the village had been deprived of an old landmark, whereupon the barn was re-erected.

I do not know the village or the barn and I do not in the least wish to pillory the villagers, but their action shows how far the idea of a monument has been extended. The newspaper article says expressly that the barn was a landmark, a word which probably derives from marine navigation and indicates an aid to orientation, enabling the captain to find his way near a coast. Such a

landmark sometimes turns into an emblem or symbol which remains, and is intended to remain, connected with a person, a family or a town.

I do not think I shall go wrong if I connect the increasing significance which the landmark has assumed in our minds with the ever-growing flood of tourism. Year in, year out, millions of our fellow citizens leave the comfort of their homes and crowd abroad for the sake of just such landmarks, which are considered 'sights'. If we can draw conclusions about the demand from the supply, then the monument becomes a 'souvenir' which we can take home on a postcard, or on an ashtray or, best of all, in our own photographs. It hardly matters whether the landmark reminds us of the past, like the pyramids, or of the present, like the Sydney Opera House. What does matter is its uniqueness; the Leaning Tower of Pisa, the Eiffel Tower, but also the Matterhorn, fulfil this function. To me the behaviour of the tourist taking photographs in front of these sights is enormously instructive: whether he wants to snap a spectacle of nature or a monument, the visitor searches assiduously for a viewpoint from which the intrusive evidence of the commonplace is as little visible as possible. He avoids the telephone wires, the cars and the posters. He is after the uniqueness, after what gives the area its character. 'That could be anywhere', the photographer says, meaning the standardized mass products of our civilization, such as petrol stations and garages, factories and tenement blocks. But here, too, new categories arise, which become new landmarks and monuments of a vanished age, like that barn and the disused railway stations in America, of which a certain cult is being made.

What stirs the traveller's imagination is an ideal. He is a refugee from the levelling tendency of our civilization. He is looking for what is called local colour. He would be happier if all the 'natives' still wore traditional costumes, always danced folk dances and, of course, served only their local dishes and drinks. As an Austrian by birth, I could tell you a thing or two about these bogus attractions. The native population no longer want to be extras in a performance which they cannot take seriously. What we can take seriously is our landscape and our architectural heritage, and we want to keep these landmarks for our sake and for the sake of posterity.

For the last time I want to let Ruskin speak. In his article on the Crystal Palace he addresses us direct on the subject of travel:

What do men travel for, in this Europe of ours? Is it only to gamble with French dies – to drink coffee out of French porcelain – to dance to the beat of German drums, and sleep in the soft air of Italy? Are the ballroom, the billiard-room, and the Boulevard, the only attractions that win us into wandering, or tempt us to repose? And when the time is come, as come it will, and that shortly, when the parsimony – or lassi-

17. Warsaw in 1944

tude – which, for the most part, are the only protectors of the remnants of elder time, shall be scattered by the advance of civilization – when all the monuments, preserved only because it was too costly to destroy them, shall have been crushed by the energies of the new world, will the proud nations of the twentieth century, looking round on the plains of Europe, disencumbered of their memorial marbles – will those nations indeed stand up with no other feeling than one of triumph, freed from the paralysis of precedent and the entanglement of memory?

The nations of the twentieth century have answered Ruskin's call; I am thinking not only of this Congress and the organizations which called it into existence, but of the sacrifices those countries have made which have seen their monuments and cities totally destroyed, such as the ravished cities in Eastern Europe, above all Warsaw,[14] which suffered so grievously in the Second World War (Fig. 17), as if they had been subjected to *damnatio memoriae*. In their worst time of suffering and deprivation the people rebuilt their houses and streets from the rubble, as if to prove that Ruskin's answer to the question 'Why preserve historic buildings?' was basically the right one.

Watching Artists at Work: Commitment and Improvisation in the History of Drawing

THE CHANGING PROCEDURES OF SKETCHING

Any artist who is intrepid enough to set up his easel in a public place soon comes to realize how many people crowd round him to enjoy the intriguing spectacle of seeing his images emerge and his work grow. One of the great masters of our time was actually persuaded to cater for this demand and allow the film camera to look over his shoulder. I am referring to the fascinating films showing Picasso drawing and painting. I shall always remember the moment when he got stuck and muttered, 'ça va mal, très mal'. I must hope that the title I rashly chose will not have aroused the hope that I shall be able to show how Leonardo hesitated over the smile of the Mona Lisa or how Rembrandt struggled with the *Night Watch*. The first thing a historian learns is to resign himself. There is so very much that we would like to know and will never know. But even without having been present, we are sometimes able to infer from the evidence of sketches how the images we know emerged under the artist's hands.

18. Hubert Robert: *The Artist sketching a Young Girl, c.*1773.
New York, The Metropolitan Museum of Art, Bequest of Walter C. Baker, 1971

The Gerda Henkel Lecture given in Düsseldorf in March 1988

19. Louis Léopold Boilly: *Houdon's Studio*, 1804. Cherbourg, Musée Thomas Henry

We would all like to have watched the scene when the eighteenth-century French painter Hubert Robert drew his little daughter under the eyes of his wife (Fig. 18). No doubt we would also have liked to visit the studio of his contemporary, the great sculptor Houdon, whom Boilly shows completing a small statuette after a model, which one of his younger students is also drawing (Fig. 19). What we do know is that both Hubert Robert and Houdon were accomplished masters of their period who were used to copying a motif from nature – something that does not apply to all times and civilizations. Their hand had learned to obey their eye, for without this collaboration of eye and hand no such image can ever emerge.

But even before this vital interaction they had to make a decision which every artist has to make before he begins his work. I refer to the choice of a starting point for their proposed creation. In my book *Art and Illusion* I have frequently mentioned the need for such a starting point.[1] I emphasized that even the most faithful imitation of nature must be based on a schema, a kind of scaffolding, which the artist can and will subsequently modify to match it with his motif. Yet I may have neglected to explain exactly why the way towards an imitation of nature must always proceed from such a schema. To put it briefly, the artist stands in need of a starting point because he must always create his motif afresh. To explain this, we need only compare the handmade image with any mechanical replica. Thus a sculptor can certainly

20. Drawing a silhouette, from the English edition of J. C. Lavater's
Physiognomische Fragmente, London, 1797
21. Drawing after the Model, from William A. Berry, *Drawing the Human Form*, New York, 1977

make a cast of a face or limb, and maybe there are such among the pieces we see in Houdon's studio. Painters also could resort to such a mechanical means even before the invention of photography. Hubert Robert was certainly familiar with a method which was much in vogue in the late eighteenth century, the silhouette, where the relative distance of candle and screen determines the scale of the portrait (Fig. 20). Here an attentive eye and a sure hand sufficed to trace the contours of a profile.

Where he lacked such an artificial support, the artist had first to create the scaffolding determining the scale in which he intended to work. A glance into the Life Class of any art school can explain this process. I take this illustration (Fig. 21) from the excellent book by William A. Berry, *Drawing the Human Form*.[2] It is obvious here that the student must first commit himself to a format before he can begin to copy the model. There is nothing mechanical in this commitment; he must build up the model from scratch, as it were, before he can start comparing the motif with his representation.

COMMITMENT AND IMPROVISATION

It is the purpose of this essay to explain why the kind and degree of this commitment vary so radically in different styles and different techniques.

A small unfinished sculpture from ancient Egypt (Fig. 22), intended to represent the God Osiris, shows us a stop on the straight road from intention to execution. The auxiliary lines on the block determine the proportion which the knife or chisel will then reveal, a process where there is really no going back, for once the block is spoilt it has become useless.

What applies to carving does not necessarily apply to modelling in clay, exemplified here by a typical eighteenth-century *modello* by the Bavarian

sculptor Johannes Wolfgang von der Auwera (Fig. 23). The forming hand can respond at any moment to a sudden inspiration: indeed a fortuitous movement can suggest to the artist's eye that he may depart from his original intention or abandon it altogether. Up to a point the road to the image has become unpredictable, but not of course less interesting.

If we ask a psychologist he will probably tell us that all intentional actions which we perform enjoy a certain latitude. Our intention applies as a rule only to the *what* and not so much to the *how*. Whether I want to lift the receiver of the telephone or put the key into the lock, I always gratefully rely on my eyes, which guide the hand to its target and save me the effort of groping, because any false movement is immediately corrected by visual control. In the language of the engineers this kind of interaction is known as feedback. On the whole we may say that the intention determines the *what* and the feedback the *how*. It is the character of this interaction which also decisively determines the production of images.

22. Unfinished statuette of Osiris.
Late Egyptian period.
Paris, Musée du Louvre

23. Johannes Wolfgang von der Auwera,
John the Baptist, 1755–6.
Munich, Bayerisches Nationalmuseum

4. Kreiskritzeln. 1;6,15. Ca. ¹/₄.

24. Scribbles by an 18-month-old child. From H. Eng, *Kinderzeichnen*, Leipzig, 1927

35. Bär, Affe und Mensch. 4;4,28. Etwa ³/₅ Gr.

48. Mann. 4;9,7.
¹/₂ Gr.

25. Bear, monkey and man. Drawing by the same child, at the age of 4 years and 5 months.
From H. Eng, *Kinderzeichnen*, Leipzig, 1927
26. Man. Drawing by the same child, at the age of 4 years and 9 months.
From H. Eng, *Kinderzeichnen*, Leipzig, 1927

DRAWING AND WRITING: THE WILL AND THE SKILL

The field in which psychologists first studied these interactions was the development of children's drawings.[3] It is well known that small infants enjoy scribbling wildly to give vent to their pleasure in movement, and in this case visual control is at a minimum (Fig. 24). Only gradually do we find an intention to emulate the classmates or the picture book and to represent something. Take these early attempts to draw a man, a bear and a monkey (Fig. 25); for all his good intentions the child has not yet learned to show us which is which by marking the decisive distinguishing features. These are what the child gradually becomes concerned with, and however clumsy his hand may be, he will soon acquire enough control of movement somehow to

indicate the head and the limbs (Fig. 26). Even when this basic intention has been realized, the *how* is largely left to chance, a chance which frequently gives pleasure to the child and to us. Indeed we are sorry when the child loses its innocence, and an awakening discontent with the *how* spoils his pleasure in drawing. This happens to most of us as soon as we realize that drawing is a difficult art that has to be learned through exercises.

Admittedly there is a form of manual skill which a child still has to learn at school, even though the demands seem to have been considerably relaxed. I refer to the art of writing. In contrast to the art of reading, the pupil must not only recognize the distinctive features of all characters, he must also learn to shape them until this ability has become nearly automatic. An English publication of 1750 contains the optimistic promise that anyone following its advice will find both writing and drawing easy (Fig. 27). Be that as it may, I still had to practise up and down strokes in my primary school, carefully distinguishing between the thin upward lines and the broad downward ones. I daresay this drill has now been abolished and we need not weep for it. Whatever the technical requirements of a skill may be, the learner will do well to analyse it into elements which psychologists call chunks. The singer must practise scales, the violinist bowings, and the calligrapher loops, as our textbook shows.

Naturally the study of handwriting has also become a science and it is to be expected that the study of art will still draw profit from these insights.[4] I am thinking not so much of graphology, as of the analysis of the basic demands to which handwriting has to adapt – let me call them the comfort of the writing hand, and the comfort of the reading eye. The writing hand

27. Page from *Writing and Drawing* by W. Chinnery, London, 1750

28. Letter from Beethoven to Anton Schindler, 1823. Berlin, Deutsche Staatsbibliothek

29. Autograph of one of Beethoven's violin sonatas, showing corrections,
1802. London, British Library

will aim at forms that easily respond to the sequence of motor impulses,
though this ease may come at the expense of legibility. An extreme example
is Beethoven's notorious scrawl, which looks so exciting. This note to
Schindler (Fig. 28) deals with nothing more dramatic than a request to have
the cobbler measure new shoes for his nephew. Needless to say, where
Beethoven aimed at precision, as in his scores (Fig. 29), he could restrain his
motor impulse at least far enough to allow the practised eye of the copyist to
read the notes – and woe to him, if he did not!

As I said, these are extreme examples, but there must be in any case some
kind of correlation between the time it takes to write (w) and the time it takes

to read (r) the writing. The faster the one the slower the other and vice versa, which might be expressed in a mathematical formula, such as $w \times r = 1$, a formula no more to be trusted than other such quantifications in human psychology.

So much is clear, however, that the impatient writer will pin his hopes on the patient reader, who in his turn will have to rely on context to reconstruct the message. All sign systems have to rely on what engineers call redundancy. The term does not have the sinister meaning it has acquired in our lifetime, but simply describes the safeguards that help us to fill in missing bits if a message is partly obliterated by noise. The paradigm of redundancy is the repetition of a message as in SOS, SOS, or testing, testing. Our language is rich in redundancies and this carries over into our writing, where we allow the distinctive features of letters to be submerged in the rapid movement of the writing hand. To show you a typical example of mildly art-historical interest, I reproduce a note by the Duke of Wellington to Sir Thomas Lawrence (Fig. 30): 'My dear Sir Thomas, I shall be most obliged to you if you will let me know if I shall sit to you on Sunday, & at what hour? Ever yours most sincerely, Wellington.' Mark how the dot over the i of 'Sir' has slipped forward with the moving hand, the t of 'most' has not been crossed and the 'most' has nearly regressed into a wavy line, as has the ou in the two 'yous'. He pulls himself together in the decisive word 'sit', and tangles his letters hopelessly in the superfluous 'most sincerely'.

It is understandable that administrators do not want to take the risk of having to spend so long a time in deciphering our efforts; accordingly, they ask us to fill in forms such as a passport application in block capitals, or what

30. Letter from the Duke of Wellington to Sir Thomas Lawrence, 1820

they now call printing. Significantly, however, they do not want us also to print our signatures, for here the movement of the hand acquires a special function as a mark of personal identity, so much so that the difficulty of imitating the flourish underlies our whole banking system. The more practised and the more rapid the signature, the less easily can it be copied.

IMAGE AND SCRIPT

Clearly these observations and distinctions can be applied without strain to the study of image-making. Indeed in earlier ages the kinship between script and image was obvious. Both rested on a conventional repertory of forms that the craftsman had to master. This affinity is neatly confirmed by the extant exercises from ancient Egypt, which show us how apprentices were trained in their skills. One example from Thebes (Fig. 31) shows an attempt to draw a human profile and a hieroglyph, the profile being first very unsuccessful and possibly subsequently demonstrated by the master. I leap across several millennia to demonstrate that even an unfinished illuminated manuscript such as that of the German epic *Willehalm* from the fourteenth century shows the same basic kinship between script and image; witness the firmly delineated outlines of the stereotype figures which still await the brush (Fig. 32). Even so, one can observe a new element here which would have been unthinkable in ancient Egypt. Mark the calligraphic flourishes which play around the initials and serve to prove the control and mastery of the scribe's practised hand.

Perhaps we are now in a position to speak of a spectrum that extends between two extremes: on the one side we find the methods of image-making

31. Egyptian drawings from the Temple of Hatshepsut, Deir el-Bahri, near Thebes, *c.*1490–1470 BC. Limestone. New York, The Brooklyn Museum, Charles Edwin Wilbour Fund

32. Part of a page from the Willehalm Manuscript, fourteenth century.
Kassel, Bibliothek der Stadt Kassel

which rest on drill, on the other free improvisation. In the case of the acquired drill, the *what* and the *how* still coincide. The scribe knows what he intends because he has so often done it before. But in the case of the flourish things are a little different. Here he may intend to give his hand free play. What we call penplay rests on a successful harmony between intention and improvisation. It turns out that wherever an artist deviates from the conventional schema, he must also rely a little on a happy chance. The *what* can be planned, the *how* never fully foreseen.

THE LIMITS OF PLANNING

The emancipation from the fetters of conventions that we can observe in certain crucial periods of the history of art also requires a radical shift in working methods. For when the artist intends to realize a novel idea which he has in his mind he can transcribe it as little as he can transcribe the motif he sees in front of him. This view may well run counter to prevailing belief, but I think it could be experimentally confirmed. I once asked a group of artists whether they felt able to visualize a single stroke of the pen or the brush so exactly that they could put it on paper or canvas without any deviation. There was not one among them who felt sure that that was possible. What is

possible and what the artist will always rely on is the process of feedback which I have mentioned, the subsequent correction or modification which brings him closer to his original intention – unless he prefers to follow the suggestion he owes to chance and to look for unintended effects.

It was the first historian of Italian Renaissance art, Giorgio Vasari, who formulated this insight for the first time.[5] He wished to remind the Venetian painters who, he thought, underrated the role of drawing, that our power of imagination simply did not suffice to realize in the finished work of art what we have seen with the eyes of our mind. In submitting our idea to the bodily eye, we cannot do without the method of sketching. Naturally this preparatory sketch is for the artist only one stage in the creative process. He tries out an idea on paper in order to correct himself. The road from the idea to execution leads through the important phase of self-criticism.

CONTINUOUS CREATION: LEONARDO DA VINCI

Thus I have arrived at long last at the art of the period which represents the vital transition from drill to improvisation: the Italian Renaissance. It was only at the end of the Middle Ages that the three factors of hand, eye and context came more or less independently into their own. No artist ever thought more intensely about the conditions of his own working pro-

33. Leonardo da Vinci: *Sketches*, c.1480. Windsor Castle, Royal Library
34. Manuscript of Keats's *Ode to Autumn*. Cambridge, Massachusetts, Harvard College Library

35. *Geometry*. Sinopia and fresco, *c*.1420.
Foligno, Palazzo Trinci

cedures than Leonardo da Vinci. His tendency to self-criticism manifests itself already in the earliest studies we have from his hand (Fig. 33), and soon became proverbial among his contemporaries.

In a passage on which I have commented elsewhere[6] without fully exhausting its significance, he turns on the painters who, as he puts it, 'want even the slightest trace of charcoal to remain valid', and asks them: 'Have you never thought about how poets compose their verse? They never trouble to trace beautiful letters nor do they mind crossing out several lines to improve them.' Keats's first draft of his *Ode to Autumn* is a perfect illustration of this (Fig. 34). It may be hard for us to appreciate the revolutionary nature of Leonardo's advice, for, to recall the terms I have used, he wanted to warn artists against a method which would tie their creative process down to the original commitment. Leonardo must have known that in one respect this advice struck at the heart of established workshop practice.

It was above all the medium of fresco painting which demanded such commitment and rapid execution. The need for planning compelled the fresco painters of the fourteenth and fifteenth centuries first to rough out their compositions in sinopia, red earth, on the wall before covering these preliminary drawings with another layer of mortar in the very process of painting in fresco, as we see in this example of a mural from Foligno of about 1420 (Fig. 35). I know that when these traces were uncovered they were

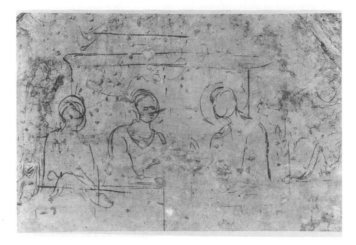

36. Florentine master: Sinopia, *c*.1400. Empoli, S. Agostino

found to appeal to twentieth-century taste for the bold and the simplified, but I doubt whether this interpretation can be quite sustained. Without wishing to ignore exceptions, it seems to me that even where the painter is seen hesitating or groping, as in this example from Empoli of around 1400 (Fig. 36), he still remains within what may be called the carving tradition, blocking out the main distinctive features first, with a sure and ready hand.

How much this capacity was valued in the Middle Ages is best illustrated by the anecdote about Giotto's O. We hear that the Pope had asked for a trial piece from the artist before commissioning him, whereupon Giotto took a brush and rapidly drew a circle so perfect that it looked as if it had been drawn with the aid of a compass, a performance for which he was much admired. But it was precisely this conception of his art which Leonardo felt wholly unable to accept. He wanted to leave the possibility for corrections open to the very last moment. He never renounced feedback, and that is one of the reasons for the ruined state of the *Last Supper* in Milan.

Those who know Leonardo's drawings also know how recklessly he sometimes improvised, because he knew that he could always start again. We can say with confidence that no trained apprentice of earlier years would have committed to paper a scrawl of the kind Leonardo scribbled on his study for a group of the Virgin, the Christ Child and a cat (Fig. 37), where the awkward profile of the Virgin is barely linked with the body by an overlong neck, and perfunctory hands fail to grip or to touch. One wonders whether any connoisseur would have dared to attribute this botched figure to Leonardo if the signs were not so unmistakable that it is drawn with the same pen as the enchanting figures of the Christ Child in various positions.

Maybe the master would have rejected any criticism with the remark that after all he made the drawing for himself and that the critic need not look at

it. In another part of the passage quoted above Leonardo advises the painter that he should not only be ready to change course at any moment, like the poet, but that he should also rely on redundancy: 'Membrificare non sia troppo' – 'Do not articulate too much', he says. The letters or characters of the artist who has mastered the rendering of the human figure are the members or limbs of the body; and there are indeed sketches by Leonardo, particularly those for the *Battle of Anghiari*, in which the rapid strokes neglect the limbs of the figures in the background while there is still some freedom for the play of the pen, for instance in the suggestion of the flowing cloak of the rider and the tail of the captivating figure of the galloping horse (Fig. 38).

In other sketches for the same composition the artist compelled himself, as it were, to do without the articulation of limbs by choosing to work on a tiny scale; but even here the flourish of the pen retains its function, as in the suggestion of the standard for which the horsemen are fighting (Fig. 39). Naturally, for Leonardo, this omission of details had its positive purpose. The unfinished, indeed the illegible, would continue to exercise his imagination; and he advised the artist to exercise his imagination by staring at patches on crumbling walls or into the smouldering embers of a fire:[7] 'Le cose confuse destano la mente' – 'Confused things stimulate the mind'. We

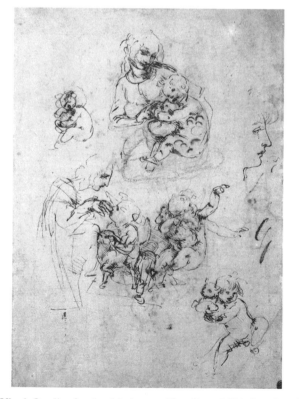

37. Leonardo da Vinci: Studies for the *Madonna with a Cat*, *c*.1481. London, British Museum

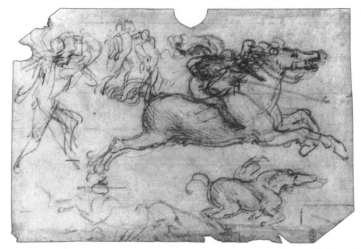

38. Leonardo da Vinci: Studies for the *Battle of Anghiari*, *c*.1504. Detail.
Windsor Castle, Royal Library

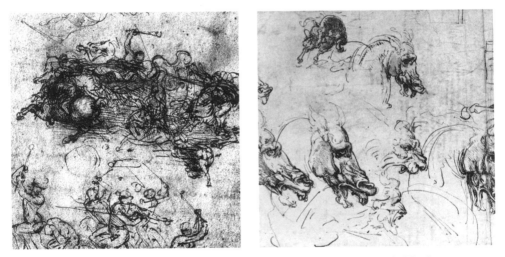

39. Leonardo da Vinci:
Studies for the *Battle of Anghiari*, *c*.1504.
Detail. Venice, Accademia

40. Leonardo da Vinci:
Studies for the *Battle of Anghiari*, *c*.1504.
Detail. Windsor Castle, Royal Library

know from Leonardo's further studies for the same battle piece how he pursued these suggestions in all directions, comparing the expression of fury in the head of the horse and that of the warrior with the physiognomy of a wild animal (Fig. 40). Only then would he proceed to elaborate the heads in detail (Fig. 41).

No doubt his contemporaries were wrong when they asserted that Leonardo was unable to finish *anything*, but deciding which road to take at any given moment was never easy for him. In one of his many studies for the group of the Virgin and Saint Anne (Fig. 42) the many revisions made by his circling hand confuse the drawing to such an extent that he proceeded to

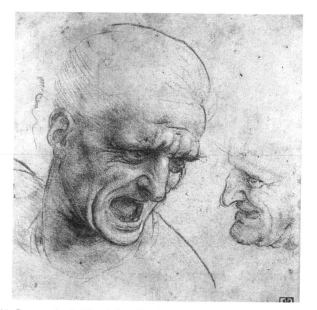

41. Leonardo da Vinci: Studies for the *Battle of Anghiari*, *c*.1504.
Budapest, Museum of Fine Arts

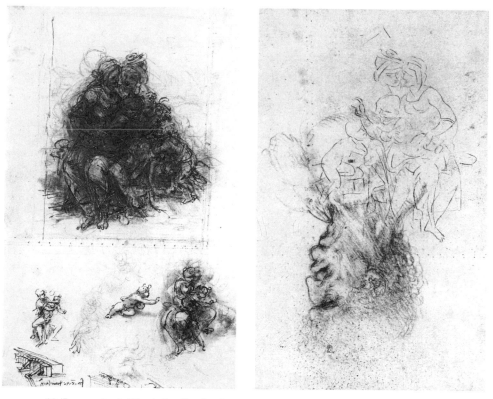

42. Leonardo da Vinci: Studies for Saint Anne, *c*.1505. London, British Museum
43. Leonardo da Vinci: Studies for Saint Anne, *c*.1505. Tracing on the reverse of Fig. 42.
London, British Museum

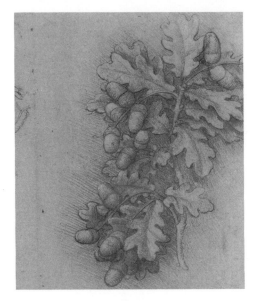

44. Leonardo da Vinci: Plant studies, *c.*1505. Detail
Windsor Castle, Royal Library

select the best outline out of the tangle of lines by tracing it with a stylus in order to be able to read it on the reverse of the sheet (Fig. 43). But when at last he reached the stage of execution, none of Leonardo's contemporaries surpassed him in his care and concentration.

How essential he considered this final stage of the clean copy is shown by another remark from the *Treatise on Painting*, which is likely to surprise art teachers of today. It reads: 'There are many young people who have a love and desire for drawing but no gifts, and that you can notice at an early stage if they lack industry and never complete the shading of their copies.'[8] That the apprentice had to make copies in order to train his hand, Leonardo took for granted, but what he demands in addition is the patience in shading and hatching, which of course concerns the motor movement of the hand. Some of the master's own wonderful studies after nature demonstrate how much patience and attention he devoted to this almost mechanical activity (Fig. 44).

THE COMMANDING INTELLECT: MICHELANGELO

If there is a typology of artistic procedures there can be hardly a more instructive contrast than the one between Leonardo and his younger contemporary Michelangelo. Leonardo's approach might be compared to that of modelling in soft clay, which at any moment permits fresh inspiration, whereas Michelangelo's preferred medium was marble. His unfinished statue of Saint Matthew in Florence (Fig. 45) and the working drawing for the projected river gods intended for the Medici tomb (Fig. 47) give some insight into his methods.

45. Michelangelo: Unfinished statue of
St Matthew, c.1503. Florence,
Accademia delle Belle Arti

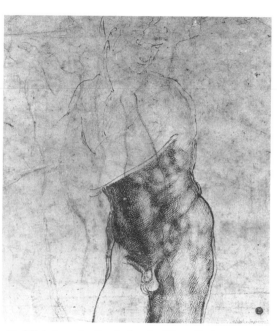

46. Michelangelo: Study for the Risen Christ, c.1514.
Collection of Sir Brinsley Ford, CBE, FSA

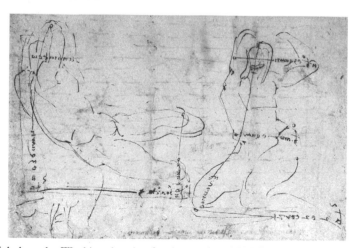

47. Michelangelo: Working drawing for river gods, c.1525. London, British Museum

Surely the best-known lines among Michelangelo's sonnets are his words:

> The greatest artist can think of no image
> That any marble block could not enclose
> Within its surface; but to reach it there
> It needs a hand ruled by the intellect.[9]

The idea expressed in this poem has often been connected with Michelangelo's Neo-Platonism but, as we have seen, the ideal of the firmly controlled hand which carries out the artist's intention has always been dear to the tradition of craftsmen. Michelangelo loved the adventure of working on the block, which could be spoiled and made unusable by a single false stroke. His drawings also testify to the sureness of his hand: he first lays down the outlines, after which the surface is brought to life by hatching (Fig. 46), in much the same way as he would use the chisel in sculpture. He used to say that the artist had to have the compass in his eye,[10] and even his first sketches show him in complete command of human proportions.

The rapid indication of a seated figure on one of the first projects for the Sistine ceiling is utterly simplified (Fig. 48), but it is obvious that the structure of the human body was always in Michelangelo's mind. We are reminded of the so-called lay-figures (articulated models) which were often used in the workshops of artists for the purpose of teaching and as an aid – Figure 49 shows two of the few which have come down to us from North of the Alps. Michelangelo was certainly never in need of such an aid. He knew the alpha-

48. Michelangelo: Study for the Sistine Chapel Ceiling, c.1508. London, British Museum

49. Lay-figures, c.1525. Innsbruck, Tiroler Landesmuseum Ferdinandeum

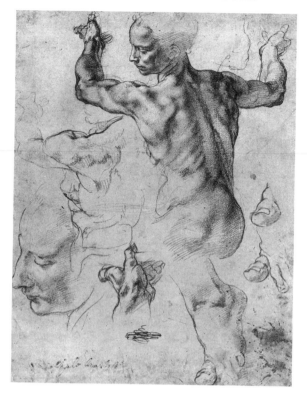

50. Michelangelo: Study for the Libyan Sibyl, *c*.1511. New York,
The Metropolitan Museum of Art. Purchase, 1924, Joseph Pulitzer Bequest

bet of the human body inside out, and his hands, in obedience to the intellect, could spell the anatomy of the model, as for instance in the drawing for one of the Sibyls (Fig. 50); it is obviously drawn from a male model which he analysed into the constituent elements. Thus it might be rash to connect Michelangelo's procedures in his working drawings for the Medici tomb exclusively with his predilection for the rigid discipline of sculpture.

It turns out that the master with whom Michelangelo was apprenticed had developed a somewhat similar technique of drawing. I am referring to Ghirlandaio, by whom we have a number of compositional sketches for his fresco cycle in Santa Maria Novella in Florence, which differ in character very much from the practice of his contemporary Leonardo. His sketches for the *Betrothal of the Virgin* (Fig. 51) and for the *Visitation* (Fig. 52) contain a number of figures reminiscent of lay-figures, for instance the figures left of the *Visitation* group with their rapidly jotted angular limbs, and the draped figures with their schematic heads and unfinished bodies. Observe also the way the drapery is brought out by hatching.

Michelangelo was unhappy in Ghirlandaio's workshop and later complained that he had learned nothing there, but such utterances need not be

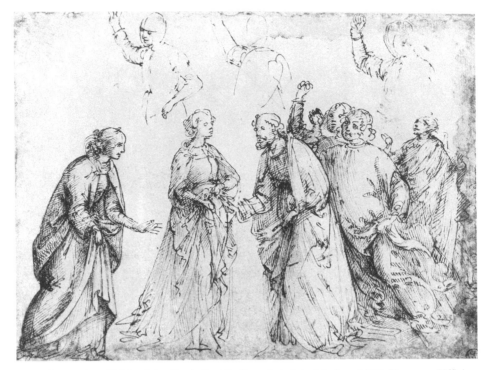

51. Domenico Ghirlandaio: Study for *The Betrothal of the Virgin*, *c*.1490. Florence, Uffizi

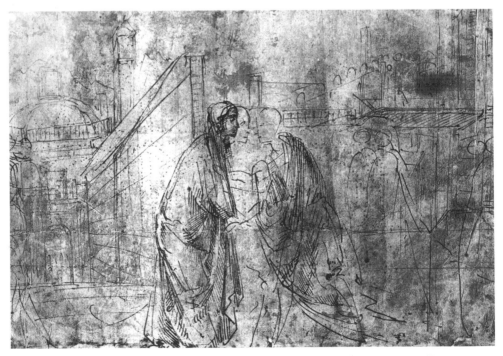

52. Domenico Ghirlandaio: Study for *The Visitation*, *c*.1490. Florence, Uffizi

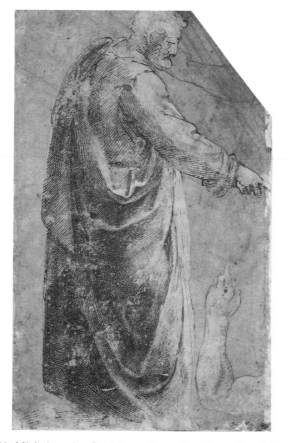

53. Michelangelo: *Saint Peter*. Copy after Masaccio, *c*.1493.
Munich, Staatliche Graphische Sammlung

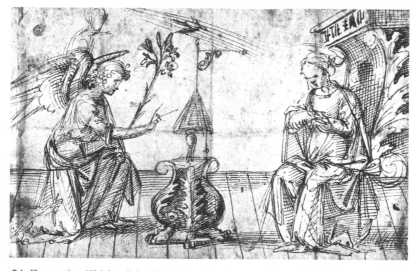

54. Domenico Ghirlandaio: Study for *The Annunciation*, *c*.1490. Florence, Uffizi

55. Michelangelo: *Battle Scene*, *c*.1506. Oxford, Ashmolean Museum

56. Michelangelo: *Christ in Limbo*, *c*.1532. Florence, Casa Buonarroti

taken *au pied de la lettre*. We need only compare one of Michelangelo's early drawings after Masaccio (Fig. 53) with the head of an angel by Ghirlandaio (Fig. 54) to agree with Degenhart that Michelangelo must have learned the elements of his language in Ghirlandaio's shop, however much he may have modified it later.[11]

It may be significant that, as we learn from Vasari, Michelangelo destroyed his studies in old age so that nobody could see how hard he had worked.[12] He obviously felt that the sketches he made for himself were of no concern to posterity. Even so we should be grateful that he did not succeed in destroy-

ing all of them. If we want to look over his shoulder against his will, as it were, we must not concentrate on the finished figures, but on the first indications, which are sometimes found on the margin of a group and remain incomplete. The battle scene in Oxford (Fig. 55) shows once more his ability to visualize the structure of a body in motion right from the beginning. At least one critic has suggested that this figure must have been drawn from a lay-figure,[13] but this seems to me wholly unlikely, all the more so as we find similar examples elsewhere. The group of Christ in Limbo in the Casa Buonarroti (Fig. 56), for instance, shows the same mastery in the instantaneous grasp of the body in motion. Every single stroke betrays the tenseness of the master's concentration. There are no tentative flourishes of the pen. His hand obeyed his analytical intellect right from the start.

THE GRACEFUL LINE: RAPHAEL

This specific character of Michelangelo's drawing style can be thrown into relief by comparison with that of Raphael, his younger rival. We are fortunate in possessing a large number of Raphael's drawings, which he created more or less for himself but which are rightly famous as testimonies to his mastery. No doubt the secret of their beauty eludes rational analysis, but perhaps it is possible to indicate at least one of their qualities in relation to our theme. What I have in mind is the perfect balance between the two elements I mentioned in connection with cursive writing: the motor impulse, which can result in the graceful gesture and even flourish, and the attention to the distinctness or legibility of the form. In Raphael's drawing for a Madonna and Child in the British Museum (Fig. 57) you can see how his pen circled before he disciplined it to circumscribe the desired forms. What is so miraculous is the interpenetration of these calligraphic movements and the resulting representations in the various images of the Mother and Child. He uses a minimum of angular outlines for distinctive features, as in the profiles of the Virgin; nearly everything else is bounded by curves which yet yield the required form and expressive movement. A drawing in the Albertina (Fig. 58), closer to a finished composition, is at the same time even more calligraphic. Note in particular the sweeping lines indicating the Virgin's right foot, which we infer from the context. We have a right to enjoy this masterpiece without attending to the tell-tale features, but it may be worth considering, in my context, how such an image might strike us if it confronted us as a finished composition. Picasso's distortions would scarcely look more radical.

Raphael's abbreviated flourish is wholly different from those impatient hints which we have seen in Leonardo's drawings, for instance in that other sketch of the Madonna with the cat (Fig. 59), in which the arm is added without any articulation. You do not have to be a graphologist to sense how

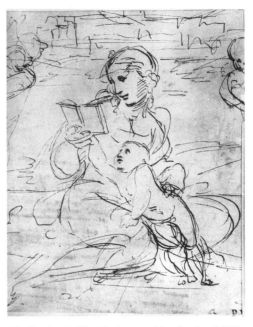

57. Raphael: Studies for a Madonna and
Child, *c.*1508. London, British Museum

58. Raphael: *The Madonna with a Book*, *c.*1509.
Vienna, Graphische Sammlung Albertina

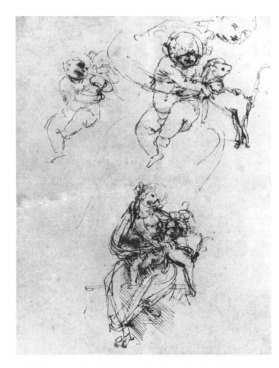

59. Leonardo da Vinci: Studies for the *Madonna
with a Cat*, *c.*1481. Bayonne, Musée Bonnat

60. Raphael: Studies for the *Disputà*,
*c.*1511. Oxford, Ashmolean Museum

these procedures of the artist also reflect his character. Raphael, whose character was proverbially graceful and amiable, lived on the best of terms with his hand. It is moving to see him on one of the sheets where he meditated the composition for the Stanza della Segnatura, combining sketches for a love sonnet with ideas for the frescoes (Fig. 60). Poetry obviously came less easily to him than drawing. Having cancelled some lines he jots down various rhyme words in search of a fit; but in drawing, his skill guides him supremely in building up the human form from his graceful curves. The unforgettable nude is written down in a few strokes of the pen, and mark how the body under the drapery of the man is again composed of swelling curves, including the exaggerated calf of the leg. What he intended to make of the incipient curves on the right, below the foreshortened schema of a head, we shall never know.

There is a passage in Lessing's play *Emilia Galotti* in which a painter poses the question whether Raphael would have become an equally great artist if he had been born without hands. The question answers itself: Raphael's natural bent for co-ordinated movement certainly also influenced his eye and his imagination. Without this interaction between eye, hand and mind nobody can grow into a master.

FROM INVENTION TO EXECUTION: TWO SEVENTEENTH-CENTURY MASTERS

It is not my intention to examine all the other masters for their drawing procedures. I certainly do not underrate the debt which art history owes to collectors and connoisseurs who have devoted themselves to the study of drawing, men such as Vasari, Mariette, Berenson, Jakob Rosenberg, Popham and Philip Pouncy, but as far as I can see their interest mostly focused on other aspects of drawing. Only Bernhard Degenhart, whom I have already mentioned, took as his subject what he called 'the graphology of drawing', but following the trends of his time he decided to concentrate more on national characteristics than on the psychology of creation.

No art historian is likely to ignore those sketches and projects which have been preserved in the corpus of a master's work. Thus, anyone working on Domenichino will naturally concern himself with the rich body of drawings preserved at Windsor Castle. But he will not necessarily focus his attention on the first germs of the artist's inventions, as we can find them on one of the drawings for the famous painting destined for St Peter's, *The Last Communion of Saint Jerome* (Fig. 61).

Domenichino first marks the position and the scale of the heads which, following a widespread usage, he notes down as ovals, giving one of them also a nose and two eyes (Fig. 62). Here one is tempted to agree with those who

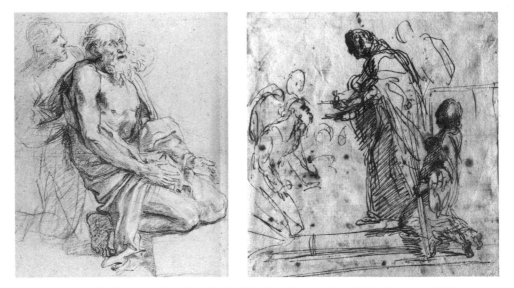

61 and 62. Domenichino: Studies for *The Last Communion of Saint Jerome, c.*1614.
Windsor Castle, Royal Library

regard representation as a branch of semiotics. After all, we have seen how artists had acquired the skill to write down the elements of the human figure by heart, as it were, because it was taken for granted that an apprentice would spend years drawing from plaster casts and from the model, so that it became as automatic to him as the playing of scales and arpeggios to the pianist. Thus Domenichino was able to indicate the figure and the pose of the saint with a few strokes of the pen before he proceeded to study the expression and the position from a model. Around one of these studies after the model he grouped further figures, which he can hardly have drawn from nature (Fig. 63). But while Leonardo searched for the secret of human expression with scientific curiosity, the study by Domenichino rather suggests the activities of a theatrical producer attempting to induce in the actor the expression of devout ecstasy.

There is no Baroque painter whose work offers better opportunities of studying the road from idea to execution than Peter Paul Rubens. Where Rubens was concerned with fixing the subject matter of a composition, his stroke looks even more careless than that of Leonardo. Who could have guessed that these sheets (Figs. 64 and 65) are the work of one of the greatest virtuosi known to the history of art? In a sense what we see is a libretto of one of the scenes of the monumental Medici cycle in the Louvre celebrating the coming of age of Louis XIII. Such monumental canvases (Fig. 66) were regularly preceded by an oil sketch (Fig. 65) and it is these oil sketches which enable us sometimes to trace the geological layers of the master's creative process.

The sketch for *Hercules and Minerva repelling Mars* was first drawn in charcoal on a tinted ground (Fig. 67). The figure of one of the Furies driven to flight is indicated only in outline, as are the bodies of the victims of war, the head of the child and the baby that clings to its mother. The application of colour that followed shows how marvellously the master could make use of the potentiality of the medium. Apart from the local colour, as in the cloak of Mars, it is the white pigment that creates the effect of light and of gleam on the helmet and armour of the god of war. I believe it is here that the comparison between the medium of painting and that of writing fails to work. The colour white, after all, does not merely *signify* gleam, it has the *effect* of gleam when it is applied skilfully, and thus drawing merges with painterly illusion.

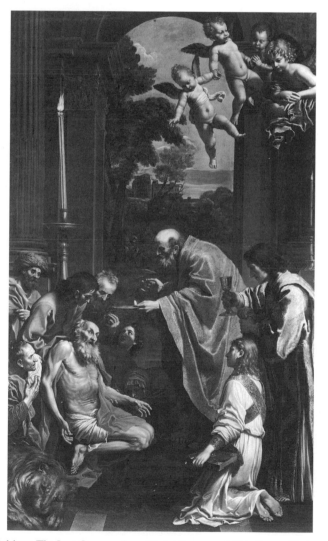

63. Domenichino: *The Last Communion of Saint Jerome*, *c.*1614. Rome, Vatican Museums

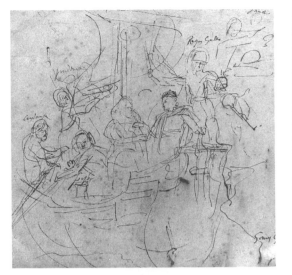

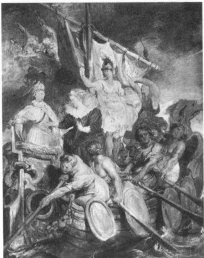

64. Peter Paul Rubens:
Drawing for *The Coming of Age of Louis XIII*,
c.1621.
Paris, Musée du Louvre

65. Peter Paul Rubens:
Sketch for *The Coming of Age of Louis
XIII*, *c*.1621. Munich,
Bayerische Staatsgemäldesammlungen

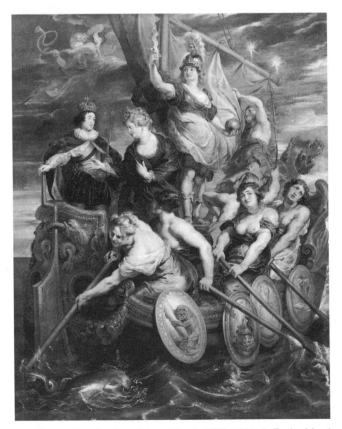

66. Peter Paul Rubens: *The Coming of Age of Louis XIII*, 1621–5. Paris, Musée du Louvre

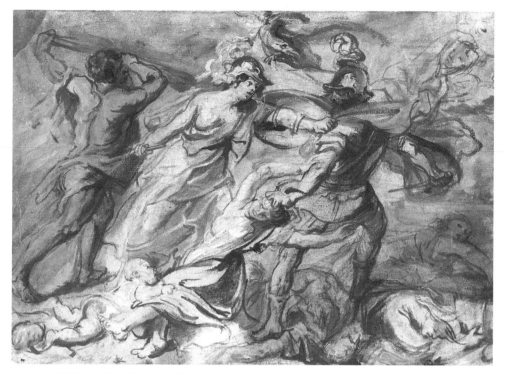

67. Peter Paul Rubens: Oil sketch for *Hercules and Minerva repelling Mars*, 1635.
Paris, Musée du Louvre

NOTATION AND SUGGESTION IN LANDSCAPE

We have all learned from Wölfflin that the Renaissance was linear and the Baroque painterly. Naturally he wanted to imply more by this distinction than the predominance of certain techniques, but we are entitled to ask what became of the pen – that precision instrument of drawing – when it had to yield to the soft crayon or even the brush. The broad and pliable medium will tempt the hand to rely on a mere suggestion of the context without, however, refusing to obey the eye when clear outlines are demanded.

In the masterly landscape drawings of Rembrandt the stroke is invariably adapted to the motif. In Figure 68 the building is outlined with firm clear contours; in suggesting the crowns of the trees he naturally gives only the general impression of branches in leaf, and here and there the hand permits free play to the brush, which indicates the leaves without articulating them. Strictly speaking I have no right within the context of my topic to show this wonderful drawing, because Rembrandt's landscape sketches are works of art in their own right rather than preparatory studies.

It is well known that the landscape paintings and marines of the great Dutch painters were not painted in front of the motif but in the studio,

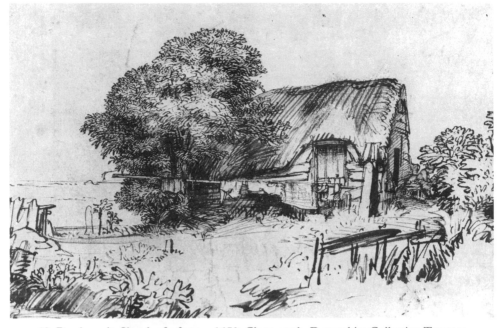

68. Rembrandt: Sketch of a farm, *c.*1650. Chatsworth, Devonshire Collection Trustees

69. Michael van Muscher (1645—1705): *The Artist in his Studio*. Collection of Lord Northbrook

70. J. M. W. Turner: Page from his Rotterdam Sketchbook, 1841. London, Tate Gallery

though they were often based on preparatory sketches. A charming painting by the seventeenth-century marine painter Michael van Muscher (Fig. 69) shows the artist at work: spread out on the floor are a number of drawings which he intends to use for his easel painting.

In any discussion of landscape painting the sketchbooks of Turner would offer rich material for the analysis of notation. His rapid drawings made in Holland in 1841 show him oscillating between concentration and relaxation (Fig. 70). The church is drawn in some detail, the crosses probably signify windmills, but the clouds are set down by his schooled hand with a few loose strokes.

VARIETIES OF SKETCHING: THE NINETEENTH CENTURY

The example of Turner has taken me into the nineteenth century, with its ever-increasing variety of styles, schools, methods and media. I can only pick out a few which may help me to round off my elementary typology.

No other artist I know has taken the method of modelling further than Daumier, in whose art the pen plays such a decisive role. Images seem to emerge from clouds of curved lines in this characteristic drawing of two lawyers (Fig. 71). Daumier liked, in fact, to model in clay, and one sometimes gains the impression that he let his figures grow from soft adumbrations, as if they emerged under his hand and only waited for a final touch to be fully brought to life.

It appears that in the art of his contemporary Delacroix we are entitled

71. Honoré Daumier: *Two Lawyers*, *c.*1866. London, Victoria & Albert Museum

occasionally to speak literally of penplay. We are told[14] that Delacroix enter-
tained his friends before dinner by drawing a number of different ovals on a
sheet of paper; he subsequently linked these ovals with a few deft strokes to
turn them into images of horses and people in various movements, as if by
magic. He claimed that both he and Géricault had learned the trick from
Baron Gros who, he alleged, had derived it from Greek and Etruscan art. I
would not pretend that the study for a war coffer in the Louvre (Fig. 72) was
produced in that way, but it conveys something of the idea.

On the other hand there are features in Delacroix's sketches that seem to
me to foreshadow a profound change in the construction of images. I mean
the rapid tracing of the fortuitous contour of the whole crouching figure, as
in his drawing for a group of judges from Morocco (Fig. 73). This wish to see
the human figure as a solid shape rather than to articulate it into its elements
may have been prompted by the cloaks these men wear, but it becomes char-
acteristic of the style of certain masters of the century, notably Jean-François
Millet. His man with a wheelbarrow of 1852 in the Louvre (Fig. 74) is an
impressive example. We find the same tendencies in many of Pissarro's
beautiful sketches, which also emphasize the general outline of the figure
rather than its structure (Fig. 75).

This novel interpretation of Leonardo's advice – 'do not articulate too
much' – comes to an unexpected climax in the drawings of Manet, in which

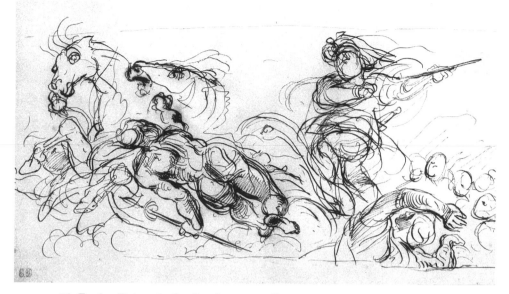

72. Eugène Delacroix: Studies for a war coffer, *c*.1835. Paris, Musée du Louvre

73. Eugène Delacroix: Studies for a group of judges, *c*.1835.Paris, Musée du Louvre

74. Jean-François Millet: *Man with a Wheelbarrow*, 1852. Paris, Musée du Louvre

75. Camille Pissarro: Studies of female peasants gleaning, *c.*1875. Oxford, Ashmolean Museum

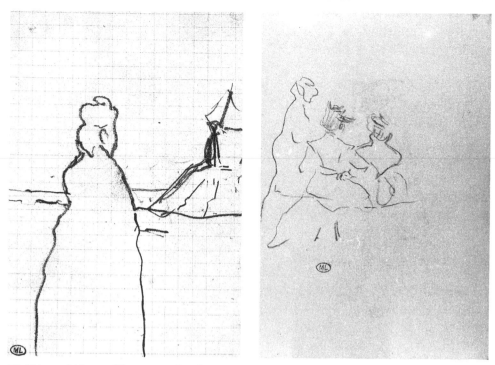

76. Edouard Manet: *Woman on a Beach*, 1869.
Paris, Musée du Louvre

77. Edouard Manet: *Three Women*, 1869.
Paris, Musée du Louvre

the anatomical articulation sometimes has to yield entirely to the impressive silhouette (Fig. 76). In his drawings of women on a beach (Fig. 77) he sometimes sacrifices legibility in favour of the rapid grasp of the general impression. Even Leonardo might have shaken his head and Michelangelo would scarcely have known what to make of it.

THE CREATIVE GESTURE: THE TWENTIETH CENTURY

Thus we arrive at the further swing of the pendulum from the observing eye and the controlling hand of the Impressionist to the pleasure of the pure motor impulse which is manifested in the drawing. It seems to me that no other artist had more share in this new orientation than Auguste Rodin. As an indefatigable observer of nature, he peopled his studio with models which he drew while they moved freely about (Fig. 78). These drawings were much admired at the turn of the century. It was said that the artist did not even look at his drawing pad but only at the model, and that he thus conveyed the impression of movement without slavishly imitating nature. The hand had again gained dominance over the eye.

The hand maintains this dominance in many of Picasso's drawings, in which that great Proteus of our century has shown how an image can be both totally wrong and yet undeniably right. What gives us such pleasure in this

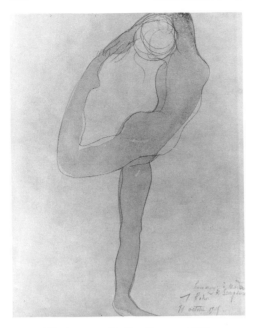

78. Auguste Rodin: *Dancer*, 1905.
Washington, D.C., National Gallery of Art,
Gift of Mrs John W. Simpson

79. Pablo Picasso:
Model with a Monkey, 1954.
Brush drawing

drawing (Fig. 79) is the impression of spontaneity, which yields to the impulse of the artist regardless of schema and routine. We here witness the culmination of the development I have tried to trace in broad outlines, for this is precisely what distinguishes the artistic ideal of our century from those of earlier periods. The work of art is not only expected to be original, it should also be totally free of any acquired skill or drill, of any impersonal element.

It is only an apparent paradox to suggest that the value attached to personal 'handwriting' received a new impulse through the growing contact with the Far East, particularly with Chinese and Japanese ink painting: nowhere is this link between script and image more obvious than in that millennial tradition in which calligraphy enjoys at least as much esteem as does painting. It is true that the Far Eastern painter, such as for instance Hakuin Ekaku of the early eighteenth century (Fig. 80), acquires his apparent freedom only at the end of a long and strict discipline, which he must first have mastered in order to follow his momentary inspiration without doing violence to the function of the sign. What the West has tended to take over is merely the value attached to the unbridled gesture.

I mentioned at the beginning of this essay the spectrum that extends between the extremes of a rigid drill and free improvisation. The opposite pole from that of drill has been reached where automatism has been raised

80. Hakuin Ekaku (1685–1768): *Bodhidhama Seated on Grass*.
Claremont, California, Sanso Collection

81. Gordon Onslow-Ford: Illustration from his book
Painting in the Instant, London, 1964

into a principle, as in the writings of the founder of Surrealism, André Breton. A book by the English painter Gordon Onslow-Ford called *Painting in the Instant*, from which I show a page (Fig. 81), is dedicated to Breton among others.[15] Here we have reached the ultimate contrast to the art of ancient Egypt. To quote only a few lines from the text: 'while painting the instant, there is no pre-image in mind. The painting grows bit by bit, each bit leading to the next . . . it is a direct manifestation of the unknown through the painter as an instrument.' It does not surprise us to read that the author is a mystic, trained in the doctrines of Zen Buddhism.

One may respect these efforts without believing that they can have much chance of success, since they are based on the fallacy that any spontaneous movement by the hand will reveal the content of the unconscious directly and without elaboration. It is this basic misconception, I think, which has led our art schools to neglect the collaboration of eye and hand. It is my belief that we do not want to produce 'Raphaels without hands' able immediately to make their most intimate dreams visible, but that, on the contrary, we want to 'train the hand that obeys the intellect' – as far as that can ever be possible.

Plato in Modern Dress:
Two Eyewitness Accounts of the Origins of Cubism

In 1898 the German weekly *Jugend* published a satirical cartoon by Rudolf Wilke representing a bearded, pipe-smoking artist showing a mysterious configuration of abstract lines to a critic (Fig. 82); the dialogue underneath must strike any historian of twentieth-century art as uncannily prophetic.

> Critic: Ah, very interesting dear master: but what does it actually represent?
>
> Painter (solemnly): That is my sanctum. You know I don't show it to everyone; only to people of the highest degree of intellectual culture, people of whom I know that they have read and understood the great philosophers, that, most of all, they thoroughly know the occultists and mystics, and then the ancient Indian literature, the teachings of Brahma, Buddha and Confucius. It is neither more nor less than the metaphysical line of my personality.
>
> Critic (dumbfounded): Ah, ah, a very good likeness, a very good likeness![1]

Ten years were still to pass before reality caught up with the satirist, that is, when Annie Besant, the champion of Indian theosophy joined forces with the

82. Rudolf Wilke: *Das Neueste!* From *Die Jugend*, 46, 1898

Contribution to a volume of essays in honour of André Chastel in 1987

Englishman C. W. Leadbeater to publish a book of abstract configurations under the title *Thought-Forms*.[2] It was this book in its turn that largely inspired Wassily Kandinsky's famous manifesto of non-representational painting, *On the Spiritual in Art*, of 1911, which makes the bearded artist of Wilke's cartoon look in retrospect like a typical follower of the Munich Expressionist movement *Der blaue Reiter* (The Blue Rider).

It may be no accident, however, that this prophetic cartoon of 1898 is datelined from Paris. For at that time it was no longer news in France that certain artists wished to steep themselves in 'occultists and mystics...ancient Indian literature . . . Brahma, Buddha and Confucius'. In 1891 Paul Ranson had founded the mystical sect of the Nabis among Gauguin's followers at Pont-Aven and produced his programmatic painting of Christ and Buddha.[3] The tradition of Neo-Platonic philosophy that had devalued the world of the senses in favour of the realm of ideas was no longer rejected by progressive artists as it had been by the Impressionist generation,[4] and this radical reversal had been communicated to the wider public by the poet Aurier in the *Mercure de France*. Discussing Gauguin's painting of *Eve* he wrote: 'It is, one might almost say, Plato interpreted in three dimensions by a savage of genius.'[5]

Why the hesitation before the trumpet call? Possibly because the name of Plato had become associated with the cult of ideal beauty first embodied in the antique. As a 'savage of genius' Gauguin had spurned the classical tradition, but had presented a new 'plastic' interpretation of Plato unencumbered by academic idealization. Thus the new 'metaphysics of art' could be summed up in the formula: 'Platonism minus sensuous beauty' – where the ideal could and should be replaced by the mystery Gauguin had enjoined his apostles to seek. Not that his search is alien to another Neo-Platonic trend – it had been the creed of the Areopagite and his 'apophatic' theology that celebrated the Divine through negation rather than imitation, and even saw in the shock of the monstrous a way towards higher insights.[6]

The extent to which such philosophical ideas have influenced creative artists will always remain a matter of controversy. To be sure, few artists are philosophers who care for the technicalities of such abstruse doctrines. But this need not deter them from seizing on slogans and values that enable them to rationalize their defiance of existing conventions; and once the public has been won over by the critics, they in their turn will feel emboldened to continue on that path under the aegis of a fashionable ideology.

That this was at least a possibility during the period of crisis at the turn of the century is not merely a matter of speculation. We know that it worried the greatest master of the age, Paul Cézanne, who expressed himself on the

matter in no uncertain terms to Christian Bernard, a former member of
Gauguin's entourage: 'The artist should despise any opinion that does not
depend on intelligent observation. He must be suspicious of the poetic spirit,
which so often causes a painter to digress from his true path – the concrete
study of nature – and spend too long speculating on the intangible . . .' (12
May 1904); and again, less than two weeks later, on 26 May, he wrote: 'The
poet expresses himself through abstractions, whereas the real painter conveys
his feelings and perceptions through colour and line.' [7]

What disturbed the old master was of course the element inherent in all
versions of Platonic doctrines, the dismissal of sense perception as incapable
of revealing the Truth. Yet it was precisely this element that recommended
the Platonic tradition to those artists who continued to search for an alterna-
tive to Impressionism, which was felt to have had its day.

What role did this mood play in the rise of the most radical of these
alterna-tives, the origins and development of Cubism? To ask this question is
to enter into a welter of controversy and contradictory views which have been
expounded in an ever-growing literature. [8] In contributing two texts to this
debate I have no desire to break new ground. After all, one thing is not con-
troversial: many critics who were sympathetic to the avant-garde fell back on
their memories of Platonic aesthetics to make Cubism more palatable to their
readers. Time and again in the articles and pamphlets of the period the rejec-
tion of illusionism is equated with the achievement of a higher truth, a more
real reality,[9] though few critics went as far as the English writer Middleton
Murry, who proclaimed as early as 1911 that Picasso had at last realized the
kind of art Plato had been after when he dismissed mimesis as a mere 'copy
of a copy'.[10]

No doubt assertions of this kind could be as flattering to artists of the
twentieth century as they were to the masters of earlier periods, but they
could hardly be very helpful. It is pleasant to be cheered on one's way while
turning one's back on sense perception, but which way, exactly, lies the
Absolute?

Here, as always, we must surely distinguish between the critics who com-
ment on the painters' progress from the sidelines, and the artists themselves
who face the empty canvas, brush in hand. What was it that prompted
Picasso and Braque to adopt the idiom that came to be known as Cubism?

I rashly joined in this debate when writing *Art and Illusion*. I had been
struck by certain similarities which I believed I could discern between Cubist
methods and the views propounded by the German sculptor Adolf von
Hildebrand in his immensely successful book *Das Problem der Form in der
bildenden Kunst* (The Problem of Form in the Visual Arts).[11] Hildebrand's
book concerned itself with the 'physiology of artistic vision'. Not that he ever

advocated anything like Cubism. On the contrary, he was a classicist who stressed the need for clarity in the images created by artists, and this clarity, he postulated, could be perceived only at a certain distance, when binocular vision, eye movements and memories of touch ceased to dominate perception. It was, however, in elaborating this contrast that Hildebrand wanted to bring home to the reader the almost chaotic confusion that reigns in what he called proximal vision, unless it is dominated by the mind.

> The more closely the beholder approaches an object, the more eye movements will be required, and the less coherent will be his visual impressions. In the end his visual impressions will be limited to one point shifted into sharp focus while the spatial relations between these discrete points will be merely experienced as an act of movement. At that moment vision has turned into real groping so that the resultant ideas are no longer visual memories but memories of movements . . . the visual elements in the perception of shapes are really of an abstract nature: they only represent movements to us, and disregard the real visual experience.[12]

Reading this introspective analysis of our perceptions with the methods of Cubism in mind, I asked myself whether there could not be a connection between the two. I remembered the two young German art-lovers who had come to Paris on the eve of the rise of Cubism, Wilhelm Uhde and Daniel-Henry Kahnweiler, and I was bold enough to write to the latter, who wholly denied this possibility. I mentioned this fact in a note in *Art and Illusion*.[13] Kahnweiler's urbane and informative reply, however, is of sufficient interest to publish it here for the first time.[14]

2 February 1959

Dear Professor Gombrich

I have read your letter of the 31st with interest. Here are the answers to your questions:

1. At that time I did not know the book by Hildebrand 'Das Problem der Form'. I only read it in Bern during the First World War.

2. I do not have the impression that Uhde knew it. After all he was not a professional art historian. What is certain is that Apollinaire, Salmon, etc. did not even know Hildebrand's name.

3. No, these problems were not discussed by the artists.

I think I must tell you, dear Professor, that you have a wrong idea of the situation at that time. There never was any question of discussing problems. It is true that the camp followers may have debated among themselves using

*ridiculous slogans such as 'the fourth dimension', 'the world is a spiral', etc.
But the really creative artists worked, painted and merely <u>afterwards</u> gave
brief explanations about the motivations of their work: that is all. The idea of
discussions with Uhde is wholly mistaken. It was the painters alone who
created Cubism. They were by no means well read, they knew neither the
philosophy of art nor other theoretical writings. Naturally they did not know
mathematics either. Dear old Princet was – as I have frequently written – the
employee of an insurance company and the nickname 'Mathématicien' was
simply a joke in our circle. May I add that in my opinion the problems which
Hildebrand treats – proximal and distant perception etc. – have nothing to do
with the problem of Cubism. I readily remain at your disposal if you have
other questions to ask me.*

 I am

 Yours sincerely

 (signed) Daniel-Henry Kahnweiler

 *P.S.: Do you think that Hildebrand's ideas are close to Cubism? I would
rather think the opposite. 'The oppressive quality of the solid': the Cubists
absolutely did not feel this to be oppressive.*

In this forceful and authoritative account Kahnweiler is seen to hold fast to
the belief that he had always held, that the mystical and mystifying talk that
surrounded the first Cubist experiments was confined to *Nachläufer*, camp
followers, whose ideas did not merit attention. The true masters, that is to
say Picasso and Braque, did not take their starting point from the discussion
of problems; they painted first and gave 'brief explanations' of their
motivation only when asked.

Considering that the two artists have often been described as unwilling to
talk about their work at all, this piece of information is not without interest,
but it does not tell us what explanations they ever volunteered.

It is here that another text seems to me of some value, although it has been
rather studiously neglected by writers on the subject because of its openly
hostile and satirical tone. I am referring to the reminiscences of Leo Stein
(Fig. 83), Gertrude Stein's brother, who knew Picasso well during this
period, though he thought less of him than he did of Matisse, who was his
idol. Not that he had any doubt about Picasso's immense talent, verve and
resourcefulness, but he had less respect for him as a person, let alone as an
intellect. His description of Picasso's conversion to Cubism may indeed give
offence to those art historians who see in that movement one of the turning
points in the history of European art, but it is, after all, the account of a con-
temporary eyewitness we have no right to ignore.

83. Pablo Picasso: *Portrait of Leo Stein*, 1906.
The Baltimore Museum of Art, Cone Collection

This, then, is what Leo Stein published in 1947, some four decades after the event he described:

A revolutionary moment succeeded. Picasso began to have ideas. Bergson's creative evolution was in the air with its seductive slogan of the *élan vital*. There was a friend of the Montmartre crowd, interested in mathematics, who talked about infinities and fourth dimensions. Picasso began to have opinions on what was and what was not real, though as he understood nothing of these matters the opinions were childishly silly. He would stand before a Cézanne or a Renoir picture and say contemptuously, 'Is that a nose? No, this is a nose', and then he would draw a pyramidal diagram. 'Is this a glass?' he would say, drawing a perspective view of a glass. 'No, this is a glass,' and he would draw a diagram with two circles connected by crossed lines. I would explain to him that what Plato and other philosophers meant by 'real thing' were not diagrams, that diagrams were abstract simplifications and not a whit more real than things with all their complexities, that Platonic ideas were worlds away from abstractions, and couldn't be pictured, but

he was bent now on doing something important – reality was important whatever else it might be, and so Picasso was off.[15]

Whatever we may think of the tone of this account, its basic veracity can be confirmed from independent sources. We know, first of all, that such a conversation did take place between Picasso and Leo Stein, for we have a letter from Picasso to Kahnweiler, dated 13 June 1912 (but obviously referring to an earlier episode), in which the artist complains that Stein had ridiculed him when he wanted to explain what he was doing at the time: 'I remember one day when I was in the middle of working [on a painting] Matisse and Stein arrived and began joking with each other. Stein said to me (I had been trying to explain to him what I was doing): "But this is the fourth dimension," and immediately burst out laughing.'[16]

Secondly, it so happens that the only remark by Picasso quoted in Kahnweiler's book *Der Weg zum Kubismus*[17] also refers to his dissatisfaction with the traditional rendering of noses. Apparently Picasso said that it was not possible from a painting by Raphael to find out the distance between the tip of the nose and the mouth; he wanted to paint pictures which made this possible. Needless to say, such pictures exist, they are called profiles, though to measure the distance we have to know that the painting (or silhouette) is 'natural size'. The safest method of answering all these questions is of course to create the type of wax figures exhibited at Madame Tussaud's, but it was hardly such an image Picasso wanted to produce.

Finally, there is another account by Kahnweiler, in which he also confirms Stein's memory of the way Picasso used to criticize the normal method of representing a glass: 'If I want to paint a glass, Picasso said to me in about 1909, I would draw a circle on my canvas to show its volume, but it might be that, because of this circle, I would have to make a square, so that this shape wouldn't be the only one on the canvas.'[18] Nor was Stein entirely off the mark when he thought of diagrams, for Kahnweiler continues in the same article to recall that in 1908 Picasso had told him that he wanted an engineer to be able to construct the objects depicted in his paintings.[19] Maybe the search for alternative methods of representation had led him to books on isometric drawings or similar devices which he wished to incorporate in his paintings. In any case one can sympathize with Stein's irritation as he tried to explain that such drawings did not represent the Platonic ideas, for Platonic ideas could not be pictured. But was he also right in suspecting a link between the fashionable ideas of Bergsonianism, of the Fourth Dimension and the perennial philosophy of Plato?

He surely had a case, at least if one accepts Whitehead's famous dictum that the whole history of Western philosophy is a series of footnotes to Plato.

Plato, of course, had taught that we are all prisoners in the dark caves of our senses unless and until the philosopher makes us turn round and leads us to the light of Truth. It may be argued that Kant strengthened and fortified this prison by claiming that we cannot but perceive the world in terms of space and time and that therefore reality, *Das Ding an Sich*, must for ever be hidden from us. Here the Bergsonian analysis promised an escape from the prison, for if we spurn the guidance of Reason and take refuge in Intuition we can bypass the spurious reality of space and time and take hold of that essential ground of things Bergson called *la durée*.[20] In this interpretation, admittedly a very partial one, the search for the fourth dimension, to which Stein referred, can also be seen as an attempt to break out of the Platonic–Kantian prison of three-dimensional space.[21]

How much of this entered into Picasso's explanations of what he was trying to do with noses or glasses we cannot tell on the evidence, but any of these philosophies might have furnished him with a handy stick with which to beat the defenders of traditional realism. And while Picasso may have avoided going beyond particular instances, we know, again on the testimony of Kahnweiler, that another of the leaders of Cubism was less averse to philosophy. I am referring to Juan Gris, whose art Kahnweiler cherished almost above that of the others and of whom he wrote in a late article, 'he showed himself to be a Neo-Platonist in everything he wrote,'[22] mentioning in particular his link with the occultists and his faith in the representation of ideas.

Kahnweiler surely knew what he was talking about. But he himself was no Neo-Platonist. He called himself a Neo-Kantian.[24] By this he meant first of all that he accepted the devaluation of sense perception. Unlike the Platonists, however, he did not believe that we could ever glimpse the ultimate truth. Reality was unknowable. But the conclusion he drew from this conviction was more Hegelian than it was Kantian.[24] What we accept as reality changes with the ages, and the agents of that change are the artists who impose their vision on us.

Such ideas have been expressed by others,[25] but what is remarkable in Kahnweiler's formulations is the degree to which he took them literally. Thanks to the catalogue of the exhibition at the Centre Pompidou in 1984 with its excellent essay by Werner Spies, the life and opinions of this influential dealer are now easily accessible. It becomes clear that he never deviated from opinions he expressed early on and repeated and refined throughout his long life: painting is a mode of writing, *une écriture* on a flat surface, making use of *signs* to transmit an emotional experience. All painting styles derive from pictograms – much as Chinese writing – and must be read to be understood.[26] The history of art tells us that these signs which were employed by successive styles changed with the spirit of the times but were always accept-

ed by the artists' contemporaries as faithful representations of reality.[27] No wonder, for it was art that determined the way the world was seen by successive generations; this, indeed, is the biological function of art.[28] 'Hedonism', the pure enjoyment of shapes and colours, has no place in Kahnweiler's system. He was never reconciled to 'abstract' painting.[29]

It is likely that Kahnweiler arrived at his convictions by a process of extrapolation from the history of Impressionism. It was known that Impressionist paintings were at first hard to read for a public not used to the new methods, and that the uninitiated saw only dabs and patches of painting where the trained observer saw the intended image emerge. Once he had learned the language, however, the beholder also had acquired a new way of seeing nature. Monet had taught him to see violet shadows which – so it was believed – nobody had ever seen before.[30]

Kahnweiler's book *Der Weg zum Kubismus* is intended to persuade us that Cubist paintings could and should be read exactly like earlier representations of nature, and if read correctly would result in a perfectly convincing mental image of the motif. True, Kahnweiler conceded, we cannot expect this style to be 'assimilated' at once by beholders who are not yet familiar with this novel language. In the end, however, the assimilation will take place, and to speed it up Kahnweiler insisted that Cubist pictures should always be furnished with descriptive titles, such as 'playing cards and dice', for in this way the relevant memory images will fuse more easily with the painting. Where this fusion fails, Kahnweiler believed, the beholder will merely notice the shapes on the canvas and see geometric shapes instead of the intended rendering of objects (Fig. 84). This misunderstanding is due to a breakdown of those associations which alone lead to the projection of objects, but experience has shown – according to Kahnweiler – that this geometrical impression disappears completely as soon as familiarity with the new methods leads to the correct process of 'reading in'. Like names or titles, the insertion of 'real objects' – attributed to Braque – serves the beholder in Kahnweiler's view to mobilize memory images and assists him to combine the remembered stimulus with the schematic form into a complete object. He would come to see it – we can extrapolate in our turn – as he can now see an Impressionist painting.

Looking back on these hopes some thirty-five years later, Kahnweiler was forced to explain why they did not come fully to fruition: 'Cubism was the authentic expression of its time, but only a minority were capable of understanding the artists, of penetrating their world. There will never be more than a few who can respond from the depth of their being to these works of art.'[31] No Cubist style dominated this century, and our age does not seem to have learned to see the world in Cubist terms.

84. Pablo Picasso: *Le Bock* (The Glass of Beer), 1909.
Villeneuve d'Ascq, Musée d'Art Moderne, Gift of Geneviève and Jean Masurel

Soberly speaking, of course, there never was a chance of this happening. The view that 'seeing' is an acquired skill that undergoes constant modifications cannot stand up to examination. Indeed it is wholly bizarre to maintain in all seriousness – as Kahnweiler did throughout his life – that mankind's glorious gift of sight has always been subservient to the dictates of the artists and their master, the all-powerful Spirit of the Age.[32]

We shall never know to what extent Kahnweiler's eccentric opinions and expectations turned him into a vicarious artist who, by his faith, encouraged Picasso and Braque to develop and continue their visual adventure into the unknown. No doubt it was pleasant for them to receive the plaudits of Neo-Platonic mystics who hailed their work as higher realities, but it must have been even more exhilarating to be supported by a dealer and mentor who was convinced that in backing radical novelty he was giving voice to the *Zeitgeist*. Neither he nor his artists read the 'signs of the times' at all correctly, when they took refuge from science and technology in the *selva oscura* of Neo-Platonism. But though the images they there created were hailed as symbols of progress, their mystical views rather tended to be ignored. Even less was it

realized to what extent these anti-academic firebrands still looked for justification to the Neo-Platonic theories of art which had always enjoined the artist to shun the 'slavish' imitation of nature.

When in 1924 Erwin Panofsky published *Idea*,[33] his classic study of the Neo-Platonic theory of art, he showed himself aware of the popularity of this trend among the artists and critics, alluding, in particular, to the vogue of the term 'cosmic' in German writings on art. Considering that an account of Wassily Kandinsky's ideas has been aptly called 'the Sounding Cosmos', Panofsky's reference to the vogue of the term 'cosmic' in the writings of the artists of his period seems as fully justified, as is their characterization as followers of the Platonic tradition. Thus Kandinsky's friend and associate Franz Marc wrote of his longing 'to show an unearthly mode of existence that dwells behind everything, to break the mirror of life to enable us to look into Being'.[34] As happened in the past, this universal longing could enter into many combinations. Paul Klee's philosophical utterances, for instance, reveal him more as an Aristotelian who saw the artist as a true rival of creative nature, while Mondrian justified his strivings as a search for the secrets of cosmic harmonies.[35]

No doubt Panofsky was right in perceiving the continuity between these trends and the Neo-Platonic tradition. Had he known Wilke's cartoon he might have reminded us that the reliance on the wisdom of the East has its precedent in the notion of the *Prisca Theologia*, the esoteric knowledge that Platonic writers attributed to the Egyptian priests and to Zoroaster.[36]

If any aesthetic creed can be said to have stood the test of time it is the doctrine that gives licence to the artist to create his own world. But we can only value this freedom if we acknowledge the objective existence of reality. Strangely enough, Erwin Panofsky does not seem to have perceived this point. There is little difference between the views he expressed at the end of *Idea* and those of Kahnweiler. He argued that the conflict between Idealism and Naturalism was grounded on a misconception, since the underlying philosophical problem was in principle insoluble. This relativist conclusion has meanwhile become widely taken up by critics and historians. Neither in science nor in art are we allowed to speak of progress towards certain statable aims, for everything is in flux.[37]

No wonder that those who have adopted this stance have refrained from asking searching questions about the claims and aims of Cubism. Admittedly, if Leo Stein's rationalism rather than Kahnweiler's relativism had convinced Picasso and Braque, we would have missed the Cubist episode. This would be a pity, for fallacious ideas can result in admirable pictures. But where would the art historian be, if he felt obliged to endorse every ideology that has ever blossomed into art?

Kokoschka in his Time

As anybody will testify who was lucky enough to meet O.K. (as Kokoschka was always called), he was irresistible. Even photographs of him convey something of this personal magnetism. In his self-portraits (Fig. 85) he looks rather like a yeoman farmer, the very image of sturdy strength and self-reliance, but his clear-cut features were always in motion and disclosed a mind of unusual liveliness and sensitivity. He was a spellbinder and he knew it. A splendid raconteur, his conversations would range widely, for he appeared to have read everything and to have met everybody. He laid down the law with disarming self-confidence but one could not be angry with him while his charm worked, even when, as sometimes happened, he strained one's credulity or one's tolerance.

It was the final of these exhilarating meetings I had with him when he came to London for the last time in 1970 that suggested to me the topic of this

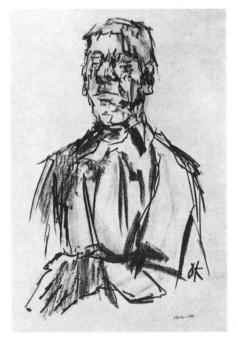

85. Kokoschka: *Self-Portrait*, 1965.
Lithograph

Lecture given at the Tate Gallery, London, in July 1986

lecture: 'Kokoschka in his time'. I still can hear his voice in my mind when he said: 'This is the daftest age that ever was' (*Das ist die dümmste Zeit die's je gegeben hat*). When I asked him why, he replied: 'Because everything went much too fast.' By everything, of course, he meant technological progress and social change. Those who have looked into his autobiography know how intensely he deplored these developments: 'The machine had ousted the craftsman. Precious things were no longer made by hand and the products of the conveyor belt influenced taste.'[1] And elsewhere in the same book he says that technical progress had found the masses psychologically unprepared, and that this tension was bound to lead to an explosion.[2]

I have never believed in the facile cliché that the artist expresses his age, let alone that he is duty bound to express his age. It is true that Kokoschka's contemptuous dismissal of the intellectual and artistic trends of his age has provoked understandable resentment. Orthodoxy demands that if an artist does not express his age he must at least express the future, and Kokoschka was apprehensive about the future. His failure to conform to the stereotype seemed all the more puzzling as he was known to have been a revolutionary artist in his youth, and a revolutionary, in terms of '1066 and All That', must of course be a Good Thing, while a *retardataire* is surely a Bad Thing. I have marked enough exam papers in art history to have learned this lesson. But history is more than one-dimensional and those whom Clemenceau called 'les terribles simplificateurs' will never be able to do it justice.

If there was a period that was emphatically not one-dimensional it was that first decade of our century when Kokoschka first appeared on the scene in Vienna – that Vienna which has recently become the subject of so much informed and uninformed comment, splendidly and succinctly dismissed by Richard Calvocoressi in a brief paragraph of his introduction to the catalogue of the Kokoschka exhibition at the Tate Gallery.[3]

As is well known, the young artist at that period found mentors and models in two figures prominent in Vienna's intellectual life, Adolf Loos (Fig. 86) and Karl Kraus (Fig. 87). What strikes us as we approach them from the perspective of the present is that they were somehow over life-size – at least they saw themselves as standing head and shoulders above the milling crowds. What might be called the religion of the genius that had given rise to the cult of Wagner and the philosophy of Nietzsche in the preceding century had a tremendous effect on these men, as it had on Arnold Schoenberg, with whom Kokoschka was also in contact. But however much these men were convinced of their own importance and of their own mission, their self-esteem applied only to their stature and status among their contemporaries, whom they largely despised. It never applied to the past. They all in their different ways derived the right to dismiss the present from their respect for

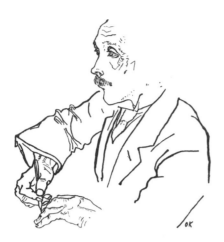

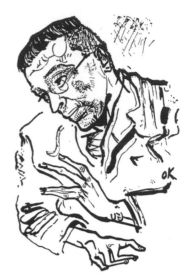

86. Kokoschka: *Adolf Loos*. Drawing published in *Der Sturm*, 30 June 1910

87. Kokoschka: *Karl Kraus*. Drawing published in *Der Sturm*, 19 May 1910

the traditions they found threatened by their age. Perhaps this description does not quite fit Schoenberg, though he too demanded a mastery of the musical tradition, but their nostalgic respect for the past makes it impossible to characterize Adolf Loos or Karl Kraus as revolutionaries in the stereotyped sense of the word.

Allow me to document this assertion with a few passages from the writings of Adolf Loos[4] of whom so many people know only that he considered ornament a crime – which of course he never did. In one of his articles of 1910 Loos takes us to the shores of a mountain lake:

> The sky is blue, the water green and a profound peace reigns everywhere. The mountains and the clouds are reflected in the lake and so are the houses, farms and chapels. They stand as if they had not been built by human hands. They look as if they had issued from God's own workshop . . . and everything breathes beauty and calm – and then, what is that? What is it that disturbs this peace like an unnecessary screech? In the midst of the houses of the peasants, which were not made by them but by God, there stands a villa. Was it designed by a good or a bad architect? I do not know. I only know that peace, calm and beauty have gone. . . .

> The peasant wanted to erect a house for his family and his animals and he succeeded no less than his neighbour or his ancestor did, just as every animal succeeds that is guided by its instinct. Is the house beautiful? Indeed as beautiful as the rose and the thistle, the horse and the cow.

And then I ask again: why does an architect, a good one like a bad one, rape the lake? The architect, like nearly all city dwellers, lacks culture. He lacks that self-assurance that the peasant has because he has culture. The city dweller is a *déraciné*. I call culture that harmony between the inner and the outer man which alone guarantees sensible thought and action. I propose to give a lecture soon on why the Papuans have culture and the Germans not.[5]

Returning to his conception of culture in another lecture of the same year Loos explains: 'Our culture rests on the knowledge of the all-surpassing greatness of classical antiquity. We have derived the technique of thought and of feeling from the Romans and from the Romans we have our social outlook and the discipline of the soul.'[6]

In 1913, outlining a proposal for a school for builders, Loos announces that in contrast to the teachings of the Polytechnic, he wants to teach his own doctrine: tradition. 'We abandoned tradition at the beginning of the 19th century – that is where I want to begin again.'[7] And to crown it all he explicitly advocated in 1924 that the students of architecture should learn to master the grammar of classical ornament: 'Classical ornament brings discipline to the formation of our utensils, it disciplines us and our shapes.'[8]

A few years earlier, in 1920, Kokoschka, who was then 34 and teaching in Dresden, wrote an inspiring letter, which may sound a little less puzzling after you have heard the true convictions of Loos. Kokoschka had been asked by the anxious father of one of his students whether the young man had any chance of a career in art, and he replied that he did not want to hide the risks of disappointment and of failure, 'but', he continued, 'I must not close the door to a person who believes that he alone among many thousands will find a path to what the enlightened call the Divine. Indeed, as a true teacher I even want to encourage anyone who is ready to stake his life, so that the imagination of the Divine should not remain without a priest, and life not without the greatness of classical antiquity' (*damit die Phantasie des Göttlichen nicht ohne Priester bleibe und das Leben nicht ohne die Grösse der Antike*).[9] Like Loos, Kokoschka never lost his respect for the European tradition that is grounded in ancient Greece.

I believe that even Karl Kraus, that other outsize figure whom Kokoschka couples with Loos in his autobiography, occupied a somewhat similar position on the intellectual map of Vienna. Loos had castigated the modern movement of Art Nouveau for its rootless affectation and praised the healthy craft traditions in leatherwork and tailoring for their unselfconscious mastery. Kraus contrasted the natural language of the people with the journalistic clichés of a meretricious press and never ceased to express his

veneration for the poets and playwrights of the past – Goethe, Raimund, Nestroy and Stifter – whose natural instinct for language would shame his corrupt age.

Kraus is certainly an immensely complex figure, whose position on the map is not easy to define, but what matters to me is that he too cannot be simply classified as a revolutionary, let alone as a progressive. He was progressive, as was Loos, in his championship of sexual emancipation, but this championship chimed in with his partisanship of nature against artifice and convention. He went far indeed in shocking his age by siding with the prostitute against the police, but he was no utopian in this or any other sense. His most famous work, *The Last Days of Mankind*, should not be read as an attack on the State. It is an attack on inhumanity, on the disgusting and indeed horrible divorce between the sufferings caused by the war and the journalistic orgies of patriotic rubbish and unfeeling gloating. In this, again, Kokoschka was and remained his disciple, as you will remember when thinking of his reaction to the Second World War.

But, to repeat, Kraus was not a revolutionary. In his perceptive book on Kraus, Hans Weigel[10] has put together a number of passages from Kraus's satirical pamphlet, *Die Fackel*, in which the writer expresses his genuine respect for the head of the monarchy. Thus he wrote in 1900: 'One knows very little of the Emperor but the general impression one receives is that he represents the type of true nobility. . . . He has the reactions of a true gentleman.'

Perhaps I should say a word here about that much-discussed topic – Vienna at the turn of the century. Austria, of course, had been a feudal state for centuries; indeed it was the last survival of a feudal society. It was governed by an aristocracy and a civil service with a high sense of duty and an unselfconscious culture that centred on the court. In his novel *The Man Without Qualities*[11] Robert Musil has left us a marvellous portrait of that part of Austrian society. At the other end of the scale, of course, there was rural Austria, the Austria of the mountain lakes and the villages that Loos exalted as models of natural culture. But the modern age had not stopped short at this almost static social hierarchy of a feudal survival. Industrialization had come with all the disruptive influences Kokoschka deplored. Between the upper crust of the privileged and the rural population there was a gap and into this gap there streamed the new elements which were needed by the new age. Vienna had become the magnet for immigrants in search of a better life. A large portion of the workers in industry and the minor crafts were of Czech origin. The coveted positions in commerce and intellectual life, which were beyond the reach of the ordinary working man, untrained in modern skills, and not sought by members of the conservative establishment, naturally

attracted many Jews from the various provinces of the multi-national monarchy.

Karl Kraus, himself a Jew from the backwoods of what is now Czechoslovakia – as were Sigmund Freud and Gustav Mahler – responded to this situation with passionate intensity. He was wholly on the side of the old established Jewish families who preached and practised assimilation. His respect for the cultural tradition of language and of style made him wince at the slightest solecism or breach of decorum perpetrated by immigrant journalists, who became the target of his merciless satire. Hence he was frequently driven to a position that seemed inconsistent with his origin and his outlook. He hated Zionism because it opposed assimilation and he took pleasure in shocking the *bien pensants* who took it for granted that Dreyfus was innocent. Such contrariness was part of his nature. Even so, his followers and admirers could never forgive him for what they considered his betrayal of their cause when, in the final years of Austria's independence, he denounced the Social Democrats and sided with the semi-Fascist government of Dollfus. I was never a 'Krausianer' and I hold no brief for Kraus in this or in any other matter, but I do not think he was inconsistent. At the time when the Nazis had unleashed their unspeakable terror beyond Austria's frontiers he rightly considered resistance to that evil the demand of the hour. The glib and irresponsible talk of civil war he found in the press of the socialist emigrants was as abhorrent to him as had been the patriotic phraseology he had pilloried in *The Last Days of Mankind*.

I suppose I have said enough and more than enough to illustrate my point that in the Austria of Kokoschka you could be a non-conformist without being a revolutionary. Man's inhumanity to man, the parroting of slogans and the surrender of the individual conscience are not the monopoly of one party.

Needless to say it is this determined and even defiant individualism that marked Kokoschka's career as an artist in an age he considered daft and inhuman. This individualism was the one creed that had united opposing trends and styles of art long before Kokoschka was born. Its manifesto was not drawn up by an artist but by a novelist. I am thinking of the eloquent words Emile Zola wrote in support of Manet in 1866:

For the public – and I do not use the word here in any derogatory sense – a work of art is a suave thing that moves the heart in a sweet or terrible way . . . for me . . . a work of art is rather a personality and individuality. I have the profoundest contempt for the little skills, the meretricious flatteries, for anything study can teach . . . what I seek in front of a picture above all is a man and not a painting . . . Like everything else art is a human product, a human secretion.[12]

It so happens that exactly forty years later another great novelist entered the arena to proclaim his views about art. I believe that Tolstoy's perverse and passionate pamphlet *What is Art?* had a greater effect than art historians are sometimes ready to concede. Written in the years after Tolstoy's conversion to the simple life, the pamphlet rails against the art scene of the *fin de siècle*, against the artificiality and heartlessness of latter-day virtuosi in poetry, music and art. This kind of aestheticism disgusted him. 'Art', he writes, 'is a human activity consisting in this, that one man consciously, by means of external signs passes on to others feelings he has lived through, so that other people are infected by these feelings and also experience them.'[13] But if art is the transmission of feelings, how can this be taught in schools? For Tolstoy the very existence of folk art proved that art schools were unnecessary, if not harmful. What was needed was a return from artifice to simplicity.

The effect of this kind of pronouncement would perhaps have been less lasting if it had not coincided with the impact of another technical development – the rise of photography. Opinions are divided about the effect of photography on art, but I belong to those who believe it can hardly be overrated. As I sometimes like to put it, painting, image-making, had lost what biologists call its ecological niche in society. Just as we have witnessed the ousting of the red squirrel by the grey squirrel in our day, so the photographer was slowly taking over the functions that had once belonged to the painter. And so the search for alternative niches began. One alternative lay in the decorative function of painting, the abandoning of naturalism in favour of formal harmonies; another in the new emphasis on the poetic imagination, which could transcend mere illustration by evoking dream-like moods through haunting symbols. Not that the two were incompatible: they sometimes fused in the *oeuvre* of individual masters of the *fin de siècle*. One of them, of course, was Gustav Klimt, whose controversial paintings dominated the art scene in Vienna at the time when Kokoschka attended art school, around 1900.

It is easy to see, and has often been said, that Kokoschka's first works stood under the spell of the highly stylized art of Klimt – indeed his early picture book, *Die Träumenden Knaben* (The Dreaming Youths) (Fig. 88), was dedicated to the master. It is equally easy to see that even in these early years the artist was trying to emancipate himself from the somewhat mannered decorative style that forms part of Art Nouveau in Austria. Instead of the sinuous curves and the sophisticated arabesques of Klimt's style, Kokoschka's art is angular and even awkward. He had opted against the arty refinement of *Sezession* even before he had come into contact with Adolf Loos, who never ceased to attack it.

Like other art students before and after him, Kokoschka was not happy

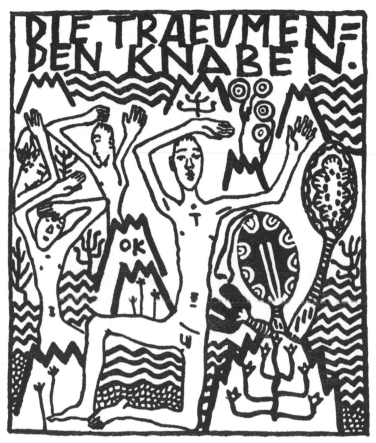

88. *Die Träumenden Knaben* (The Dreaming Youths).
1908. Detail of title-page

with the courses he had been asked to attend. In one of the first letters we have from his hand the 20-year-old complains that he misses any effort to support individuality and to allow it to mature: all they are after are good marks and what he calls 'system mongering'. He hoped to get a special studio.[14] We know from his autobiography what he looked for. Alternatives to the dreary discipline of the life class were much discussed at the time. Auguste Rodin was known to ask his models to move around his studio, as he liked to draw their bodies in motion, in rapid strokes, without even looking at the pad (see Fig. 78). Kokoschka believed in the value of this method and advocated it all his life. When, at his invitation, I visited his School of Seeing in Salzburg in 1954, he insisted on this discipline, though I well remember that as soon as he had turned his back the students implored the model to hold a pose for a little while so that they could draw it. I am still not sure that what Kokoschka demanded can really be done, but he so preferred spontaneity to drill that he was ready to put up with a certain amount of clumsiness (Fig. 89).

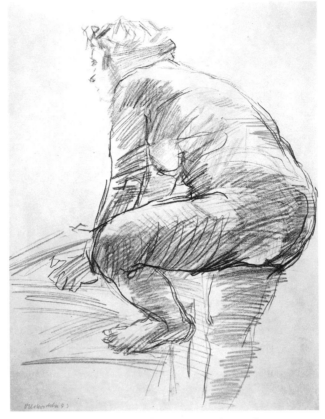

89. Kokoschka: *Nude with back turned.*
Salzburg, 1953. Private Collection

In this insistence on spontaneity and immediacy, two of the tendencies of
the nineteenth century I have outlined came together – the cult of individu-
ality formulated by Zola and the rejection of artifice for which I quoted
Tolstoy. For the leading twentieth-century aesthetician Benedetto Croce, art
was only art as long as it was spontaneous, the natural response to an
emotional impulse. There was much of this philosophy also in Karl Kraus's
attitude to language, in his hatred of the cliché and his championship of
spontaneous expression.

This was the tendency which, during Kokoschka's formative years, had
drawn attention to the art of the child. There was an exhibition in Vienna in
1902 of child art, to which the critic Ludwig Hevesi devoted an enthusiastic
article. 'These works', he wrote,

have given me pleasure, surprise and even fright. One gazes into an
abyss which has no name, into the dark depths of beginnings from
which there arises something like a protoculture. . . . What strikes one in
all these works is an independence which one would wish many a

grown-up artist to have. As soon as a child knows that it is permitted, it dares everything without even knowing that it is daring.

The article concludes that the inborn artistic instincts of the child have to be cultivated instead of methodically suppressed, as was the case at school.[15] America was far ahead in this respect.

But Austria was soon to take the lead, and in another article, of January 1903, Hevesi reported enthusiastically about a novel experiment. Two teachers, the sculptor Karl Strasser and the painter Franz Cizek,[16] had organized a vacation course lasting only thirty days and were exhibiting the astounding results of this venture. The students had all been beginners and there had been no intention of turning them into sculptors and painters. The aim was only to achieve a more intimate understanding of nature. None of their studies after live plants and animals had taken more than three hours but that was sufficient for the student to give his personal impression. Hevesi speaks of an impressionistic method in which line plays no part:

> You start with a brush. Subsequent corrections are frowned upon. Instead students are encouraged to repeat from memory what they have studied and the result clearly reveals the difference of their temperaments. The sanguine and the melancholic produce very different images and the more interesting the motif the more clearly one can discern these various individualities in their work, which indeed begins to reveal artistic charm.

The article concludes again with the hope that this system would be adopted. This would secure the natural education of the eye and of the hand and would provide the foundation for healthy artistic developments: '...may this experiment have given us a glimpse into the future!'[17] It did. Indeed that School of Seeing at Salzburg still reflected the convictions of these pioneers.

Ludwig Hevesi, from whose articles I have quoted at such length, was later to blot his copybook with Kokoschka's admirers by writing a somewhat supercilious piece about the artist's first exhibits at the Kunstschau of 1908.[18] In fact, the article is bantering rather than aggressive, and closes with the opinion that the artist had already moved beyond this present phase. Hevesi can no more be easily pigeon-holed than can Loos or Kraus. In an article of 1905[19] about the Art Nouveau villa of a wealthy collector by the name of Wärndorfer, he gives a more characteristic insight into the tastes and preferences of artistic Vienna. He reflects on the paradox that Vienna, which was famous in the nineteenth century for the sweetness of its culinary and artistic products, had become the capital of a new trend, the trend for the austere

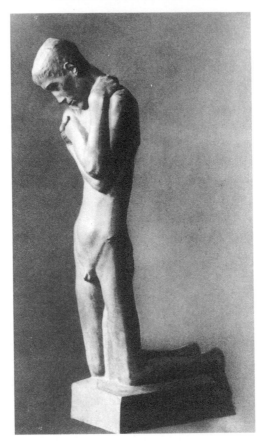

90. Georg Minne: *Kneeling Boy*, 1898.
Marble. Private collection

and the astringent, what he calls *herb*. It was in Vienna, Hevesi claims, that
the intransigent Belgian sculptor Georg Minne first attracted attention. In
his own country Minne's haggard figures, with their suffering bodies and
their expressiveness (Fig. 90), had met with no response, but in Vienna he
was given his first commissions. Let me recall that Kokoschka too mentioned
in his autobiography that Minne's art made an especial impression on him.[20]

What surprised me is that for Hevesi the art of Gustav Klimt belonged to
the same category of the austere and the astringent, the anti-sweet. He calls
it 'extra dry like a champagne for men'. Wärndorfer owned one of Klimt's
most controversial paintings, which he kept behind a curtain to shield it from
profane eyes. It is the painting entitled *Hope I* (Fig. 91) which appeared on
the cover of the catalogue of the Vienna exhibition at the Centre Pompidou.[21]
Hevesi describes it as a deeply moving masterpiece and speaks of the
sacredness of the subject, a modern version of Dürer's *Knight, Death and the
Devil*. It is the symbolic and expressive character of Klimt's compositions
that captivated Hevesi. It was a trait that also marked Kokoschka's artistic

outlook: witness the 'veneration' he expressed for Max Klinger when he visited him in Leipzig.[22]

In my introduction to the Kokoschka exhibition at the Tate Gallery in 1962[23] I quoted Hevesi for his remarks written in 1906 on Klimt's portraits of women, 'wherein not the body only, but the soul, the temperament seems to be revealed, wherein one sees not only the coursing of the blood through the veins but the very disposition of the nerves.'[24] We may find it hard to see Klimt's portraits in that light (Fig. 92), but Hevesi's comments describe Kokoschka's portraits, which he began to paint some three years later. We often hear how shocking they were found to be, but they must also have fulfilled an expectation which was in the air. After all, as I said earlier, photography had begun to occupy the ecological niche that had once

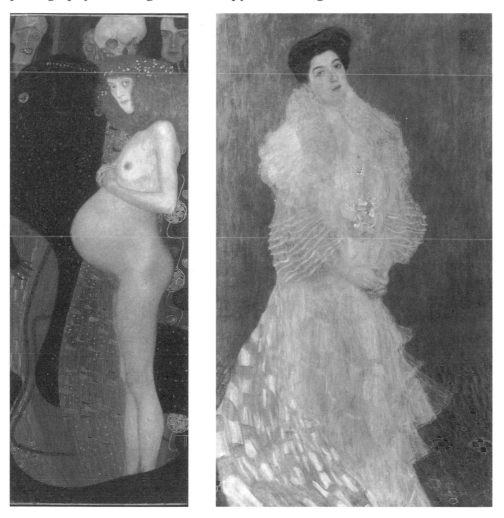

91. Gustav Klimt: *Hope I*, 1903. Ottawa, National Gallery of Canada
92. Gustav Klimt: *Hermine Gallia*, 1904. London, The National Gallery

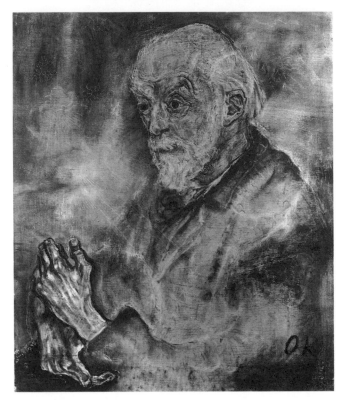

93. Kokoschka: *Auguste Forel*, 1910. Swiss psychiatrist and entomologist
(1848-1931). Mannheim, Städtische Kunsthalle

belonged to the portrait painter. More was now demanded than an accurate
likeness if the painted portrait was to hold its own.

Kokoschka's marvellous series of early portraits (Fig. 93) does indeed give
us more, but what exactly this more consists of is not so easy to formulate.
Many critics have yielded to the temptation of linking them with Sigmund
Freud's probings of the human soul, but it so happens that I was present
when Kokoschka came across such a remark in a dràft that had been sent to
him and he nearly threw a tantrum. 'Again this Freud!', he shouted. I took
the opportunity of asking him whether he had known about Freud in these
years and he said, 'Of course not.' I cannot guarantee that he was right, but
frankly I find very little similarity between Kokoschka's portrayals of human
beings and Freud's theory of neuroses.

It is true that the first thing I remember hearing about Kokoschka in
Vienna was that he was painting souls rather than bodies, but this seems to
me a natural rationalization of the lack of conventional likeness. What makes
his portraits memorable is rather their dramatic intensity; he seems to
enhance his sitters and take them out of their humdrum existence. No doubt
he was endowed with a special gift´of empathy; as we have seen he was par-

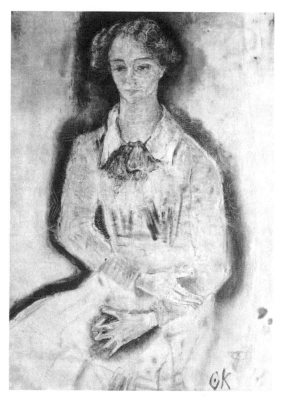

94. Kokoschka: *Lotte Franzos*, 1909.
Washington, D.C., Phillips Collection

ticularly responsive to movement and it was his sitter in motion whom he tried to capture in what he called 'memory images'. Whether these images always revealed the essence of the sitter I would not dare to say because I am not sure that people have essences. However, I was once in the position to test his diagnostic powers. Some years ago I had been asked to review Edith Hoffmann's monograph on Kokoschka for the BBC Third Programme and came across her characterization of the portrait of Lotte Franzos (Fig. 94), painted in 1909. The author writes: 'here again Kokoschka shows his particular gift for the rendering of "personal attitude" – in this case youthful coyness, the reserve of the middle-class woman who neither could nor would let herself go, and perhaps the pensiveness of one who has unexpectedly discovered that respectability is not everything.'[25] Now it so happens that my mother had known Lotte Franzos quite well in those days, and without saying why I wanted to know, I asked her to describe her to me. She described her as precious (*preziös*); she could not let herself go but she considered herself very free. I then showed my mother Edith Hoffmann's characterization based on Kokoschka's portrait and she accepted it as quite correct. What more can you ask for?

There can be no doubt that Kokoschka in those days thought of himself as uniquely endowed with visionary gifts. We know that he greatly resented it when similar claims were made for the painter Max Oppenheimer, whom Loos had dismissed as a 'swindler'.[26] I have spoken earlier of the faith in the powers and the duties of the genius, which was taken for granted at that time in artistic circles. Like many others, Kokoschka certainly believed that he had no right to censor the words and images that he felt welling up from the depth of his being. Shortly before his mental breakdown in 1889 Nietzsche in his *Ecce Homo* had described what it felt like for a genius to be inspired. He speaks of the sensation of being merely the mouthpiece of a higher power, 'the feeling of revelation in the sense that something suddenly becomes visible and audible with indescribable certainty . . . One hears one does not seek, one takes and does not ask who it is who gives . . . I never had the slightest choice.'[27] The creative act has no truck with critical reason. It is a creed which inevitably carries the risk of landing the artist in obscurity and solipsism.

In speaking of Kokoschka in the context of his time, the attraction which this heady doctrine had for him cannot be omitted. Some of the products of his youth, notably his play *Murderer, Hope of Women*, are pretty crazy in all conscience. It is all the more important not to yield to the temptation of regarding these outpourings as symptoms of his mental condition. We know from his correspondence that even the wildest paroxysms of his passion for Alma Mahler never rendered his letters incoherent.

I think one can say with hindsight that the demotion of reason in the philosophies of Nietzsche, Bergson and other thinkers of the age was to have dire consequences. It certainly increased the appeal of Nazi ideology, which spoke of 'thinking with the blood'.

Kokoschka himself was immune to this appeal, but the traumatic experience of the First World War also reinforced his deep-rooted distrust of rationality. In a turbulent manifesto published in 1920 under the title 'On the Awareness of Visions',[28] he stridently attacked an attitude of mind he called *Zweckdenken* (roughly 'purposive thought') and he contrasted this devilish cancer of mankind with its opposite, which he called *Der Sinn* ('sense' or 'meaning'). Invoking many of the great mystics, the Jewish Chassidim, Saint Francis of Assisi, Meister Eckehart, Swedenborg, Saint Teresa and indeed the Holy Virgin, Kokoschka pleaded for the power of the imagination:

Is it possible that Leonardo conquered the world with a smile? Is it a miracle that the whole of my beloved Austria sang in the sweet throat of Mozart? . . . Every small child that plays with a doll in the cradle will make you understand that in a sense everything is a divine apparition, and thus I am seized by holy wrath . . .

I no longer find Mozart's Austria. Deforested and pillaged, it is now a state for English and other immigrant commercial travellers. Woe to me the homeless. This superstitious belief in the future is really a blasphemy . . .

If your politicians took me seriously, those whom I find more terrible than all previous priests, I would make a serious proposal for the establishment of eternal peace. Sell the state for thirty pieces of silver to English shareholding companies and give them your airy faith in it as a free bonus, but leave us human beings our homeland here on earth.

The piece rises to a climax in a denunciation of that mutual hatred he had witnessed in the war: 'We all sing the same song: / Our enemy has been crushed / Liberté, Egalité, Fratricide! / His homeland has been demolished./ His joys have changed into suffering. / His wife and his children are starving to death. / Hurrah and cheers!'

The sentiment recalls Karl Kraus, and like Kraus, Kokoschka never committed himself to one political party. As early as March 1919 he had written in a letter:

I say again that all this newspaper and propaganda stuff is nothing but brutality, the revolution-mongers work with the same means as the conservative militarists: hatred, slander, ambition, the vocabulary is the same, what changes is only the heads which roll in the sand . . . one must shut one's ears and only dream of future man, otherwise one's heart will break. Let the dream bear the name of humanity [*Humanität*].[29]

Kokoschka never abandoned that dream, however much his art may have changed over the years.

This essay, of course, is not directly concerned with Kokoschka's artistic production; all I am trying to do is to place his personality and his art into the framework of his time. The samples I have given of his style and thought in the early 1920s obviously reveal his proximity to the Expressionist movement, but he never liked being called an Expressionist because his non-conformist nature rebelled against all such labels. He was not alone in doubting the aptness of this description. Here my witness is Hans Tietze, the Viennese art historian who was my teacher in the 1930s and who had been an ardent champion of the modern movement prior to the First World War. It was at that time that Kokoschka painted the moving double-portrait of Hans Tietze and his wife Erica which now hangs in the Museum of Modern Art in New York (Fig. 95).

In 1925 Tietze described Kokoschka as an outsider to Expressionism. He attributes that position to Kokoschka's Austrian origin. 'Even in his Dresden

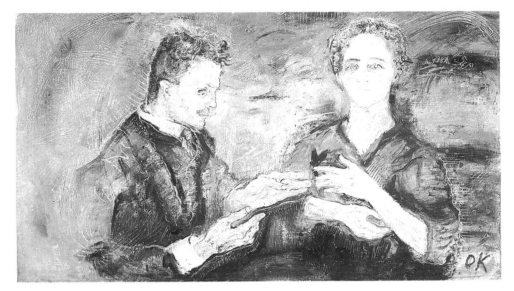

95. Kokoschka: *Hans Tietze and Erica Tietze-Conrat*, 1909.
New York, Museum of Modern Art, Abby Aldrich Rockefeller Fund

years when he was closest to the German spirit of the north he remained wedded to the milder, possibly more feminine, character of his home-land . . . What he has created after his return to Vienna is even more per-meated by the sweet sap of the soil and the warm memory of his early days.'[30] I might not have quoted these remarks if I had not seen in the British press an image of Kokoschka as an uncompromising savage, which seems to me an utter misunderstanding.[31]

There was nothing savage in Kokoschka's decision to devote himself to that wonderful series of cityscapes which is unique in the history of art (Fig. 96). The task enabled him to combine that immediacy of response in which he believed with an intense glorification of the city as a living organism. From the point of view of this essay these masterpieces mark the full assertion of Kokoschka's faith in the unique importance of the artist's personal visual experience.

It was this faith, of course, that I heard him preaching at the Salzburg School of Seeing (Figs. 97 and 98). In my introduction to the 1962 exhibi-tion at the Tate I attempted to paraphrase what I had often heard him say a few years earlier at the School: 'Open your eyes, look and remember that this particular light, these exact colours and this unique gesture will never, never combine again. Nothing can hold this moment of life unless you seize it with your brush.'

I find that I also jotted down a few of his actual remarks to the best of my ability. 'Remember,' he said of the model,

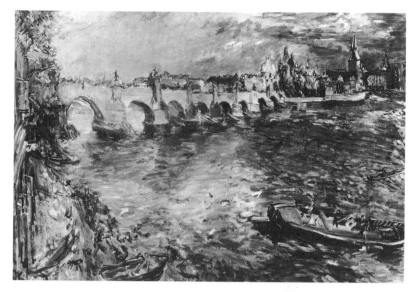

96. Kokoschka: *Prague, the Charles Bridge*, 1934.
Prague, National Gallery

this is an individual human being who stands in front of you, not just
anyone. You must first see this unity and seize it, and that has to be
learned. Then you build it up in colour like a child who builds in colour,
one here, one there, as if you were to build a sculptor's armature. What
are the distances in relation to that unity? How far does it extend into
depth? The expression is everywhere. The expression is for me the guide
to the understanding of the whole, I oscillate with my eyes backwards
and forwards until I get the points of reference . . . the line is always
wrong, never the essential, that is my experience: you can only draw
after you have painted for fifty years. . . . Remember a child taking its
first step, how far is it to mother, will I fall? Now I have adjusted your
eyes like an oculist . . .

And speaking of a student's work he exclaimed,

look, she already takes a second leap, she already enjoys the colour, she
can make music with colour until it starts to sing. . . . She is too good to
be employed anywhere, she will have to become a typist. . . . The whole
world is against this, only the wrong party is on my side, the academy
which wants to support me, and I will have none of this.

Obviously Kokoschka was anxious to remain a defiant non-conformist as
Loos and Kraus had been, though both of them had pitted their faith in the
wisdom of tradition against the corruption of their age. Was Kokoschka's

97 and 98. Kokoschka teaching at the School of Seeing in Salzburg, 1954.
Photographed by the author

stance just an expression of his contrariness? The more I reflect about it, the
less do I think so. To him, and to his mentors, the sacred heritage of our
culture could be jettisoned only at our peril. It may be that he had formed this
conviction by himself, having discovered the grandeur of the Austrian
Baroque painters, the life-giving power of Greek sculpture or the mastery of
Velázquez who, as he said, made him feel quite small.[32] But maybe his faith
also derived, at least in part, from a philosophy of art that had nothing to do
with either Expressionism or Impressionism. I refer to the writings of Conrad
Fiedler, who enjoyed such a high prestige at the turn of the century, when
Kokoschka first went to art school.

In his book *The Origins of Artistic Activity* Fiedler argued for the centrality
of visual experience. Just as only language can enable man to articulate and
clarify his thoughts, so painting alone will turn the confused impression of
the external world into a clarified and valid image. According to Fiedler,
'only that artistic activity will be sound and genuine in which everything the
artist does will be derived from the sense of sight, where the whole artistic
process is nothing but a mode of seeing that is governed not only by the eyes
but by the whole man.'[33]

If Kokoschka had absorbed this philosophy in his youth it becomes under-standable that he considered the devaluation of the senses a crime against humanity.

Even Kokoschka's admirers have often felt alienated by the way he spoke of his greatest rival, Picasso, and have been tempted to attribute this ob-session to jealousy. To be sure, he was but human, but in the last analysis his attitude towards Picasso may be described as *odium theologicum*. The way the School of Paris broke the link with the visible world would have appeared to him as a betrayal. The gulf that separates that school from all Kokoschka believed in only became clear to me when I read the writings of Daniel Kahnweiler, the patron and champion of Cubism.[34] Kahnweiler propounded the view that all styles of painting were systems of signs, pictographs which had nothing direct to do with the way we see the world. Indeed he believed that it is from these signs alone that we acquire our sense of sight. He seriously thought that we would one day all see the world in Cubist terms.

I have discussed elsewhere the extent to which the leading theories of twentieth-century movements were dominated by the rejection of sense per-ception that ultimately derives from Plato.[35] Kokoschka had a right to feel isolated, but perhaps this sense of isolation contributed to his mood of defiance, to the strength of his conviction and to his passionate love of the gift of sight. He had become a man with a mission, and I think his life's work shows that he could announce to posterity: 'mission fulfilled'.[36]

Image and Word in Twentieth-Century Art

The relation between images and words, between works of art and their captions or titles, has undergone many changes in the history of art, but only in the twentieth century did it become a problem, for here it touched on one of the dominant concerns of the period – the ideal of purity and the constant search for a renewal of this ideal through the breaking of former taboos.[1]

Works of art which perfectly embody theoretical issues are not necessarily the best of their time, and I make no such claim for Mel Ramsden's *Secret Painting*, which I found in Ursula Meyer's *Conceptual Art* (1972). It shows a black square next to the following caption: 'The content of this painting is invisible; the character and dimensions of the content are to be kept permanently secret, known only to the artist.' I need hardly enlarge on the quest for purity expressed in this work, a purity so perfect that it shuns contact with the tainted world of reality or any prying eyes. But in order to attain this purity the artist had to join the movement loosely known as conceptual art, which breaks the taboo on another kind of purity, the freedom of the image from the intrusion or indeed the contamination of words.

The ideal which is here challenged, the ideal of a visual art which has been purged of words, has at least two roots in the history of criticism. One of them can easily be demonstrated by showing what happens if the taboo is radically defied, as in a painting of 1928–9 by Magritte entitled *Phantom Landscape* (Fig. 99). There is an obvious clash between the written word 'montagne' and the naturalistic image of the woman, for any naturalistic image creates its own virtual space around it, while any written word is conceived to stand out against a neutral surface. The word is not written on the face, but on the picture; it seems an intrusion hovering somewhere in our field of vision.

There are many ways in which even naturalistic images can reach an accommodation with the written word. In *Landscape* by Metzinger (Fig. 100) there is no clash whatever between the spatial landscape and the word 'Avis' you read on it, for here the word appears in quotation marks, as it were; it is part of the representation of a noticeboard which keeps the two worlds apart. Nor need I dwell at length on the fact that the overthrow of unified space in this century allowed free entry to the written word which partook of the

The Hilla Rebay Lecture at the Solomon R. Guggenheim Museum, New York, October 1980

spatial ambiguities so important to the Cubist style. Picasso's *Woman with Guitar, 'Ma jolie'* (1911–12; New York, Museum of Modern Art) is a famous example of this mixing of media, a mixing which even takes in music, for the words were those of a popular song which obviously sounded in the artist's mind when he was thinking of his pretty Eva. Soon the artistic potentialities of lettering as a device which compels one to attend to the plane rather than to the simulated depth of the picture led him to collage. But the main point of collage is, after all, that we do not attend to the words but to the form. Reliance on the meaning of words and texts betokened the servitude to ulterior aims of commerce or entertainment that characterized the mixed media of advertisments or of comics. The very success of these devices made them suspect. The image needed the word and the word the image, as if they could not manage on their own.

An ancient Greek author must have had this in mind when he wrote that in earlier centuries archaic artists had to write on their pictures 'this is a horse', 'this is a cow', to make them intelligible.[2] He was right in that archaic art had not yet rejected writing, but I have also indicated the reason; these images could easily fraternize with the written word even though the words imparted more relevant information than the sarcastic author realized. On most Greek vases of the black figure style (seventh and sixth centuries) the names of the participants in any scene are added to explain the illustration.

With the banishment of writing from the picture space, this kind of

99. René Magritte: *Phantom Landscape*, 1928—9. Private Collection

100. Jean Metzinger: *Landscape*, c. 1913—14. New York, Solomon R. Guggenheim Museum

information had to go on to the frame; the image had to be given a title. Briefly and schematically I would suggest that the title is a by-product of the mobility of images, even if it is only a later nickname, like the 'Spinario', or 'The Blue Boy'. The image fixed firmly in its liturgical or decorative setting can more easily dispense with words; it may have a subject, like the 'Last Supper' or the 'Apotheosis of Venice', but not a name.

Thus, when he began to create for a market and for collectors, the artist faced the task which poets, playwrights, novelists and authors have always had to face – they had to find a name for their creation, as parents have to do for their offspring, children for their pets, and firms for their brands. Considering the all-pervasive role which naming plays in our lives we pay very little attention to the types of names we encounter – commemorative names such as 'The Solomon R. Guggenheim Museum', transparent ones such as 'The Metropolitan Museum', or descriptive ones like 'The Cloisters'. For the artist the function of the name was from the beginning a dual one. Sending his work to a show or selling it to a collector he must be able to refer to it, and so must dealers and owners, but given this demand for a title he can also use it to tell his public what mattered to him, and when his work is published the title will go with it. Chardin's moving painting of a girl saying grace, *Le Bénédicité*, was exhibited under that name in the Salon of 1740, and a typical print after Fragonard of a young woman carving letters into a tree was published in 1787 with the title *Le Chiffre d'Amour* printed underneath.

The authentic source for the title is of course the catalogue, and it is certainly rewarding to turn the pages of the Victorian *Academy Notes* of 1877.[3] One would have needed this printed companion to be reassured at no. 960 that 'Baby's better', and to understand that the villain with the sword in no. 962 is 'Waiting for the King's Favourite' (Fig. 101). An artist like Landseer certainly wanted us to see the lively dogs in his painting in the light of the title, *Looking for Crumbs from the Rich Man's Table* (c.1859; London, Wallace Collection).

Of course it was the fact that such pictures could not stand alone, that they had to be complemented by an explanatory title, that accounted for the reaction against anything that smacked of anecdote. Studying the two-volume catalogue of the Guggenheim Museum collection by Angelica Zander Rudenstine, one finds that among the 252 paintings from 1880 to 1945 there is not one comparable title.[4] One also notices, however, that titles have not become redundant to any of the three parties concerned, the artist, the collector, or the public. The twentieth century added a new generic appellation to the categories familiar from earlier periods. Instead of Landscapes and Still Lifes we now find a name such as *No. 160b (Improvisation 28 [?])* by Kandinsky (Fig. 102). I picked this one because the

101. M. E. Staples: *Baby's better* and Lancelot J. Pott: *Waiting for the King's Favourite*, from *Academy Notes*, edited by Henry Blackburn, London, 1877, p. 62

title is followed by a question mark. Kandinsky may have made an error in numbering, calling two of his Improvisations '28', thus putting the utilitarian function of the name at risk, though not, of course, the artistic one addressed to the public, which implies that the work requires no other information. A good many works even discard the generic title and rely on what may be called code names, such as the construction by Moholy-Nagy entitled *A II. 1924* (Fig. 103). Naturally this wordless title will inevitably recall the category of technical models and similar products of our age. Not that this usage has ousted what might be described as the visual description, of which Balcomb Greene's geometrical abstract *Criss Cross* (1940; New York, Solomon R. Guggenheim Museum) is a good example. It is not always easy to say where visual description ends and subject titles begin. Witness the first entry in the catalogue, a painting by Josef Albers of 1937 entitled *b and p* (Fig. 104). It is easy to recognize the letters, but without the title one might not have thought of them.

Thanks to the care bestowed on this catalogue one can frequently see how pictures have changed their names and appreciate that even in this century artists are by no means always indifferent to the title under which their works are presented to the public. We read that the painting by Miró of 1925 (Fig. 105) had often been exhibited under the generic title of 'Painting' or

103. Laszlo Moholy-Nagy: *A II. 1924*, 1924.
New York, Solomon R. Guggenheim Museum

'Composition' but in his correspondence with the Guggenheim Museum the artist objected: 'Le titre marqué de Composition me semble gratuit, j'aimerais que vous mettiez Personnage.'[5] He obviously wanted us to look for a figure or at least a presence in his composition. The reaction of Chagall to the various titles given to his painting of 1913 (Fig. 106) is even more interesting because he challenged earlier interpretations. The picture had been variously listed as 'Landscape' and as 'Burning House', but Chagall protested: 'C'est calme, mon tableau, Rien ne brûle. C'est la grande extase.' Accordingly the cataloguer chose the subject description *The Flying Carriage*.[6]

But if we are interested in the relation between image and word a study of this or any catalogue will soon convince us that such terms as 'subject' or 'description' are misleading if they suggest that they merely repeat in words

104. Josef Albers: *b and p*, 1937. New York, Solomon R. Guggenheim Museum
105. Joan Miró: *Personnage*, 1925. New York, Solomon R. Guggenheim Museum

what the image shows us. The obvious cases in point are landscapes and portraits. Whether or not the artist painted from the motif or from his imagination, his intention may have been to represent a particular tree or just a tree, a particular man or just a man.

This, it turns out, is one of the crucial points to remember in the relation between images and words. Unlike images, language can make that vital distinction which has concerned philosophers since the days of Plato, the distinction between universals and particulars. Cézanne's painting of *c*.1899 in the Guggenheim Museum is described as *Man with Crossed Arms*, but we read that Venturi called it 'The Clockmaker'.[7] Clockmaker, too, is a universal, a sub-class of men or women who make clocks, but *the* clockmaker denotes an identifiable individual, someone in Cézanne's environment. In another case we may not regret our inability to find out, but we may note that Albert Gleizes took care to inscribe on his painting of girders that this was not 'a bridge' but *Brooklyn Bridge* (1915; New York, Solomon R. Guggenheim Museum), which had made a great impression on him.[8]

Let me say in a rough and ready way that language can specify, images cannot. It is an observation which stands in curious contrast to the fact that images are concrete, vivid and inexhaustibly rich in sensory qualities, while language is abstract and purely conventional. I suppose it is this conventional character of words to which Magritte wanted to draw attention in his witty comment on captions given to images. He startles us in *The Key of Dreams* (1930; New York, Sidney Janis Gallery) by captioning a handbag as

106. Marc Chagall: *The Flying Carriage*, 1913. New York, Solomon R. Guggenheim Museum

'le ciel' (sky); a leaf, 'la table' (table); a pocket-knife, 'l'oiseau' (bird); and then dismisses us with laughter by calling a sponge, a sponge.

There is an even more famous comment by Magritte on my topic of image and word; his series of paintings of a pipe with the caption 'Ceci n'est pas une pipe' (this is not a pipe).[9] I have heard this caption described as presenting a philosophical problem. Frankly, it is a problem which a first-year student should not find hard to solve. This is not a pipe, it is a picture of a pipe. It is true that captions tend to be elliptic and omit part of this statement. This is standard in the use of words where the context is obvious. If you pass a door where it says 'please ring' you won't take this to mean that anyone passing is entreated to ring the bell. The notice is an abbreviated form of the statement 'if you want to get in, please ring.' If there is a philosophical problem, then, it lies on a somewhat different plane: Magritte's words, like the expanded caption, form a statement; his image does not, because no image can be the equivalent of a verbal statement. I know very well that art critics have taken to describing brushstrokes as statements, but to me this seems a rather confusing metaphor. It is in fact the most abstract parts of speech which enable language to form propositions or statements, such words as 'this', or 'is', or 'not', which Magritte employs and which you could illustrate no more than the terms 'was', or 'will be', or 'if', 'when', 'therefore', 'all', or 'none' – in short the connectives, which form the cement binding the descriptive words of language together.

It is this fact with which the purist would have to contend if he wished to argue that words are always redundant in relation to the image, except perhaps as a utilitarian convenience for the purpose of labelling.

To me this is just another version of the doctrine of the innocent eye which I was at some pains to combat in my book *Art and Illusion*.[10] All perception

occurs in a context of memory and expectation; we always interpret what we see, even if it is a cloud or an ink-blot. It just so happens that for us the word 'pipe' is redundant because we recognize pipes, and it is hard to know what a pipe would look like to anyone who does not know where the mouthpiece is or, for that matter, that the contraption is not ten yards long and used in tropical Africa to spray swamps against the tsetse-fly.

Where the artist cannot rely on cultural knowledge, as he can with us when he paints a pipe, he has to offer instructions for use in the form of titles, be they anecdotal, descriptive of motifs or individuals, or, for instance, referential. I have in mind works which require the knowledge of a text or story, a kind of footnote for the uninitiated, like Holman Hunt's *The Scapegoat* (1854–5; Port Sunlight, Lady Lever Art Gallery), where we are asked to mobilize our memory of the Bible to see this animal not simply as a goat but as the sacrificial animal chased into the desert. Whistler gave a different and more revolutionary kind of instruction. By calling the portrait of his mother *Arrangement in Gray and Black: Portrait of the Artist's Mother* (Fig. 107), he wished the viewer to attend to the sensory qualities of colour and composition rather than going straight for the representation of a resigned old lady. Speaking in psychological terms the title was to influence the beholder's mental set. I regret having to use this term, which is an awkward translation of the German word *Einstellung*. Both words are metaphors taken from instruments which must be set, adjusted, or tuned to do their job, like a radio receiver. Perception is always a transaction between us and the world, and the idea that we could or should ever perceive an image without the preconception or expectations we derive from prior knowledge and experience

107. James McNeill Whistler: *Arrangement in Gray and Black: Portrait of the Artist's Mother*, 1871. Paris, Musée du Louvre

would resemble the demand that we should make an electric current flow from the positive pole without connecting the wire with the negative pole. The image is one pole, the title often provides the other, and if the set-up works, something new will emerge which is neither the image nor the words, but the product of their interaction.

Some time ago a malicious book was published under the title *Captions Courageous*, in which alternative titles were suggested for famous paintings. Whistler's mother would be captioned 'When's that no-good son of mine gonna send the rent money?' or, as the German version has it, 'Channel 2 isn't any better'.[11] What the title does of course is to change our mental set and our interpretation. It sets up a chain of associations: we are instructed to particularize and to imagine the fastidious lady dissatisfied with her son or the TV/radio programme. Up to a point this process of particularization is common also to all so-called anecdotal titles. The one I referred to earlier, 'Baby's better', makes us project the mother's fears and hopes into the little scene. By and large it was the Symbolists at the end of the century who reversed the trend and demanded not particularizing but generalizing inter-pretations.

When Carrière painted a mother hugging a pale child he called the paint-ing not 'Baby's worse', but *Maternité* (1879; Avignon, Musée Calvet); when Munch painted an adolescent girl he turned her into a symbol of *Puberty* (1895; Oslo, Nasjonalgalleriet; first version of 1886 destroyed) to be used in his ambitious 'Cycle of Life'. What matters to me in these generalized titles is the instruction to adopt a different attitude; we are asked to see the image as something solemn, not to say portentous, and to meditate on questions of life and death. Gauguin's famous painting with its title asking the ultimate questions: *D'où venons-nous? Que sommes-nous? Où allons-nous?* (1897; Boston, Museum of Fine Arts) fits in here, conforming to this mood. That it does not stand alone is shown by one of the least successful paintings by George Frederick Watts, entitled *Whence? Whither?* (Fig. 108). The paintings will not give an answer to these questions, the title is intended to be what we might call a 'mood setter' to induce a quasi-religious atmosphere. We are to think of prayer, if not to join in it, when standing in front of Hodler's paint-ing of a nude in a landscape with her arms outstretched, *Communion with Infinity* (1892; Basle, Kunstmuseum), or Rodin's folded hands called *La Cathédrale* (1908; Paris, Rodin Museum). We are enjoined to find the link between image and idea, a link which leads through metaphor. To speak of medieval cathedrals as 'prayers in stone' is a metaphor bordering on a cliché. By inverting the metaphor Rodin turned the image of praying hands into the likeness of a sacred edifice. Once the current has begun to flow between form and idea the two have become part of a higher unity.

108. George Frederick Watts:
Whence? Whither?, 1903–4.
Present location unknown

Many artists of the twentieth century have played variations on this game of circuit building, but now the title rather tends to serve as an instruction to connect the idea of a familiar thing with an unfamiliar configuration. Take one of the great pioneer works of twentieth-century sculpture, Brancusi's *Bird in Space* (Fig. 109). You might perceive it as many things, including a polished piece of material, but that is obviously not what the artist wanted. It is only when we follow the title that the shape takes flight, as it were. It becomes so charged with the intended meaning that it is hard to see it as anything else; despite the sober fact that birds rarely practise vertical take-off.

Admittedly, the instruction is not always so easy to follow. The wider the objective distance between the form and the idea, the greater the challenge to achieve the required projection or charge. No wonder that Picasso's first Cubist images appeared to refuse being transformed by association into a *Standing Nude* (1908; Boston, Museum of Fine Arts). What ensues, we might say, pursuing our metaphor, is the setting up of an alternate current oscillating between image and idea; we try to make the fit, and the very effort is part of the intended experience. There are works of Picasso's most 'hermetic' period, such as the elusive pattern of facets making up the *Accordionist* (1911; New York, Solomon R. Guggenheim Museum), which will not offer support for any permanent contact and may indeed be intended to remain ambiguous.

It seems to me a pity that these questions are so often obscured by quasi-moral demands of what the public ought to accept. I would rather submit these questions to psychological experiments. Take a very simple example such as Turnbull's sculpture entitled *Head* (Fig. 110). Would it not be

109. Constantin Brancusi: *Bird in Space*, 1923. Private Collection
110. William Turnbull: *Head*, 1957. Washington, D.C.,
Smithsonian Institution, Hirshhorn Museum and Sculpture Garden

interesting to show it to one set of volunteers with the title and to another labelled *Untitled*? We might then measure the length of time of inspection and perhaps also the eye movements of both groups to find out how the first handled the task of finding a head in the oval stone and whether they saw it recumbent or upright and squashed, and how the others came to terms with the shape in its own right, perhaps attending to its material, its surface, or to the toolmarks. Clearly the term 'untitled' is not merely a negative instruction. I do not recall having seen a flower piece or a landscape with that appellation. Like Whistler's titles, it is also an instruction to adopt a given mental set.

No art is more suited to test the effects of these instructions than the art of music. Here too we have the distinction between the generic titles of forms and opus numbers and the whole spectrum extending from the descriptive devices of programme music, such as the tinkling of bells at a sleigh ride, to less obvious evocations, as with some of Schumann's piano pieces with titles such as 'The Merry Peasant', 'Lonely Flowers', 'Child falling asleep' or 'Soaring' (*Aufschwung*). These are ideas which the music surely does not pretend to depict: the titles are again instructions for interpretation, instructions in this case both to the player and to the listener. If we are willing to go along with the composer's suggestion, we can perhaps build the required bridge between our idea of lonely flowers and the tones we hear, and finally fuse the two into a successful evocation. The example suggests that the role of the title

in evocation can also be described as one of differentiation, of making a vague
and general mood more specific by allowing our reaction to crystallize
around a definite idea without thereby losing in authenticity. I think we must
keep this function in mind when considering the quest for evocative images
or shapes in twentieth-century art.

I need not recapitulate the role which the example of music played in this
quest. Interest in synaesthesia, the link between the various sense modalities
which allows us to speak of loud colours or sweet sounds, reaches, of course,
very far back in the history of artistic theory, but in art it became dominant
only after the turn of the century, when the possibility of evocation became
the subject of experiments in Italy, France and Germany. Like Beethoven
with his sonata 'Les Adieux', Boccioni painted three compositions called
States of Mind (1911–12; New York, Museum of Modern Art) depicting 'The
farewells', 'Those who leave' and 'Those who stay behind'; he wrote that per-
pendicular lines, undulating and, as it were, worn out, may well represent the
languidness and depression of leave-taking.[12]

Utterances of this kind could be multiplied *ad libitum* from the writings of
artists and critics who have been convinced of their truth. I would not claim
that they are false, only that they are insufficient. It is no doubt true that
water contains hydrogen, but water does not consist of hydrogen only. It is
the process of combustion, which creates a compound between hydrogen
and oxygen, that results in the stuff we call water. Wavy lines are indeed
capable of entering into a compound evoking the idea of leave-taking, but if
all wavy lines did so, the world would be an even sadder place than it is.

Many decades ago when these problems were topical, a member of the
Gestalt School of Psychology arranged an experiment which ought perhaps
to be better known. Reinhard Krauss showed his subjects a display of several
configurations consisting of variously shaped lines and also gave them a list
of notions, asking them to match the lines to the words. It turned out that
their choice was by no means random. Nobody correlated a jagged line with
calm, or a softly undulating one with broken glass. But opinions differed
whether the jagged line was to be called 'Fury' or 'Thunderstorm' or
'Despair'. The shorter the list of alternatives the more chance there was of
unanimity. Without any list from which to choose, the task of interpreting the
abstract lines was hopeless.[13]

I once attempted to test this result in a very unsystematic experiment con-
ducted with a group of art students when I was teaching at the Slade School
of Art in London. I asked one of them to draw an abstract configuration on
the blackboard while we others had to write down the notion he had wanted
to suggest. I remember an exciting whirl of lines which, it turned out, was
meant to evoke the idea of a headache. None of us had guessed it and of

course it cannot be done. But once we were told we all agreed that it was a very convincing image. The idea and the lines readily combined into a new and fairly stable compound.

Only a mystic would disregard this experimental proof that there are no fixed equivalences in synaesthesia. It is no accident that the first systematic explorations of these phenomena claimed indeed some kind of metaphysical justification. I am referring to the theosophical books by Annie Besant and C. W. Leadbeater on the subject they called 'trained clairvoyance'. One of these books, *Thought-Forms*, published in 1905, purported to show the exact shape and colour of certain emotions, such as 'Sudden fright' and 'Angry jealousy'.[14] I would not claim that I would be unable to meet these suggestions half-way. The titles could certainly not be swapped round and carry the same conviction. But we all could think of a variety of alternative titles: 'Sudden fright' might perhaps represent 'Joyous rapture', and 'Angry jealousy' 'Disgust'. For the authors this criticism would surely have seemed quite pointless, since they believed that the real appearance of these soul-states or thought-forms had been revealed to them in a state of higher consciousness. You do not argue with the supernatural.

Sixten Ringbom has made a good case for the influence which these books and these creeds had on the development of Wassily Kandinsky.[15] What is here relevant to my subject is the fact that Kandinsky's faith in this precise linkage between tones, colours and emotions was so strong that he often disdained the aid of the word. His titles, as we have seen, alluded to musical forms such as improvisation or composition, which he numbered, or resorted increasingly to description, such as *Painting with White Border* and *Circles on Black* (1913 and 1921; both New York, Solomon R. Guggenheim Museum). They may be compared to Whistler's titles intended to make the beholder attend to what is there. This certainly remained an important purpose in Kandinsky's titling, despite the fact that both in his writings and in his art his interest shifted from what may be called trigger effects to the mutual interaction of formal elements in the emergence of self-supporting structures which mirrored cosmic forces. The title *Earth Centre* of 1921 (New York, Solomon R. Guggenheim Museum) hints at these preoccupations.

While the precise share of spiritualist ideas in Kandinsky's art may be conjectural, there is at least one work of the Blaue Reiter movement in which the title makes it explicit. I am referring to the painting by Franz Marc of 1913 entitled *Bos Orbis Mundi (Die Weltenkuh)* literally 'The World Cow' (Fig. 111). We know from one of the artist's letters that for him yellow represented the feminine principle, meek and serene.[16] Some such principle he saw embodied in the cow. Recalling the generalizing tendencies of the Symbolists' titles, such as the transformation of a mother and child into a

111. Franz Marc: *Bos Orbis Mundi (Die Weltenkuh)*, 1913.
New York, Solomon R. Guggenheim Museum

symbol of maternity, we might say that Marc's cow represents bovinity or cowness as a cosmic principle of a yet undiscovered mythology.

With these landmarks in mind it may be possible to plot the position on the map of history of the one artist who excelled both in the creation of images and in the mastery of words. I mean of course Paul Klee, whose titles stand out for their uniquely poetic and imaginative quality.

Born in December 1879, thirteen years after Kandinsky, Klee, who characteristically wavered between music and painting, grew up during the high tide of Symbolism in art. Franz von Stuck, whose classes Klee frequented in Munich, might be classified from my point of view as one of the generalizers whose portentous titles were much appreciated by the avant-garde. His most famous painting of a sultry nude entwined by a serpent, *Sin* (1893; Munich, Neue Pinakothek), not so much an illustration of the Fall as an embodiment of sensuality, seemed to my generation the very epitome of kitsch. Naturally the image is still connected with the classical tradition of allegorical personification, a tradition which has interested me in other contexts, because the personification can so easily be seen as a spiritual entity, the embodiment of an abstract principle in visible form.[17] There was another art student in Munich at that time whose friendship Klee later treasured, Alfred Kubin, whose early drawings show the future spiritualist searching for precisely such images free from the fetters of tradition: his *Argwohn* (Suspicion), drawn in 1898 (Fig. 112), is such a visualization still rooted in the high seriousness of Symbolism.

It is interesting to watch Klee emancipating himself from this mood in early works in which he transforms this literary mode into a personal idiom. I am thinking of his etching entitled *Perseus, Der Witz hat über das Leid gesiegt*

112. Alfred Kubin: *Suspicion*, 1898. Vienna, Graphische Sammlung Albertina
113. Paul Klee: *Perseus, Wit has triumphed over Suffering*, 1904.
Bern, Kunstmuseum, Paul Klee-Stiftung

(Perseus, Wit has triumphed over Suffering) (Fig. 113). Suffering, of course, is embodied in the mythical figure of Medusa, whose head Perseus cut off; the composition is what iconologists call a moralization of a Greek myth. Its underlying theme remained central to Klee's outlook on life. The following year he came up with the etching *Greiser Phoenix* (Aged Phoenix), a strange conceit and almost inexplicable till you remember what the phoenix did when he reached old age – he burnt himself to ashes in a fire and was rejuvenated in the flames. In other words, there is the same optimistic turn to the myth and mystery as in the previous etching.[18] Certainly in both works the referential titles are an integral part of the message.

Klee was 25 at the time and seven years were still to elapse before he made decisive contact with the modern movement in Paris and Munich. One influence, however, must have come earlier: the discovery of a kindred soul in the German poet Christian Morgenstern, whose famous nonsense verse (which he did not want to be called such) embodies the same philosophy of wit triumphing over suffering, the same mystical faith in renewal. I am speaking of Morgenstern's *Galgenlieder* – which might roughly be translated as 'Whistles in the Dark' – which were published in 1905, followed in 1910 by the sequence *Palmström*.[19] On New Year's Eve 1909 Klee had already noted in his diary with mock solemnity: 'With Morgenstern's *Galgenlieder* let the year be ended.'[20] Morgenstern, the son of a painter, was a mystic who wrote much serious poetry expressing the creed of Rudolf Steiner's version of theosophy, that anthroposophy that also captivated Kandinsky. He denied that his bizarre punning fantasies should be searched for deeper meanings, but the motto with which he prefaced *Galgenlieder* really anticipates the underlying philosophy of Surrealism and its precursors in its glorification of liberating free associations.[21]

Let the molecules career,
Leave them to their own confections!
Never fuss about corrections,
Ecstasies thou shalt revere.

It is not only this hint of ecstasies behind the screen of inconsequential playfulness that concerns the student of Klee, but also the fact that Morgenstern too created some images in a similar mood, which today we might call doodles, and used them as vignettes between his poems, giving them titles such as *Monarchenentrerevue* (roughly, Summit Meeting) (Fig. 114), or *Neugier* (Curiosity) (Fig. 115). Mark the simple means with which he here achieves what Kubin aimed at in his drawing of Suspicion.

These playful exercises in minimal art may have given Klee the courage to explore the potentialities of the scrawl or scribble to say as much as the more detailed images he had made before, just as Morgenstern's philosophy must have reinforced his faith in the validity of personal visions and dreams. They are the dreams which arise when controls are relaxed and ecstasy wins over the fussing and correcting. But they are more than dreams, they are intimations of a possible reality, manifestations of creative nature which work within and through the artist. A late drawing of 1939 makes this comparison explicit. It is titled *Wird es ein Mädchen?* (Will it be a girl?) (Fig. 116), and suggests the elements of form coming together and tending towards the mere suggestion of a head with closed eyes. The girl is taking shape.

Klee has told us in a famous passage of his lecture published under the title *On Modern Art* that he could not plan the outcome of his creative act any more than a parent can. He did not start from the theme, but from the form. Balancing his shapes, lines and colours he might discover an association which he could accept and even elaborate. 'There are occasions', he says,

114. Christian Morgenstern: *Summit Meeting*, vignette from *Galgenlieder*, 1905
115. Christian Morgenstern: *Curiosity*, vignette from *Galgenlieder*, 1905

116. Paul Klee: *Will it be a girl?*, 1939. New York, Solomon R. Guggenheim Museum
117. Paul Klee: *Dance you monster to my soft song!*, 1922. New York,
Solomon R. Guggenheim Museum

'when one is very glad to see a familiar face surfacing spontaneously from the configuration, and find that the images look at one cheerfully or sternly, more or less tense, consolingly or threateningly, suffering or smiling.'[22] Klee certainly attributed a kind of reality to these presences which his activity as an artist summoned or called up from the depth of creation. Indeed when we speak of evocation, in his case we may feel the magic overtones of the word. After all, his most quoted utterance says, 'Art does not reproduce the visible, but makes visible.'[23] Even so he was not a haunted man, as Kubin became. He had taken the measure of his ghostly visitors and remained in charge. There is a work which splendidly expresses Klee's own conception of his role. It is entitled *Tanze du Ungeheuer zu meinem sanften Lied!* (Dance you monster to my soft song!) (Fig. 117). The fierce monster of the tribe of the Medusa is overcome by the artist's gentle magic: it must dance rather than threaten, wit has triumphed over suffering.

I would suggest that he is helped in this dominance by the very act of naming, which is my theme; do not let us forget that in dealing with spirits it is most helpful to know their names, for the name gives us power. How many of them, from the highest to the humble Rumpelstiltskin, are anxious to withhold their names so as not to be enthralled! Klee the wizard is not deceived. He knows that this is *The Son of Ruebezahl* (1934; Bern, Felix Klee Collection), offspring of the mischievous sprite who haunts the forests of south-eastern Germany.

I would not claim that all Klee's titles can be interpreted as words of

power, for he opened his mind to all possibilities of formal experiments. Like the Futurists he attempted a portrayal of soul-states in his early drawing called *Sleep* (illustrated in *On Modern Art*), which can be read as a sleeper or as an abstract shape. Most of all, Klee exploited the humorous potentialities of play, though if we can believe him, there was an element of *schadenfreude* here, a touch of the gloating of an elect who looked at the folly of this world with some detachment. Everything was grist to his mill – words, signs and literary allusions – as in his light-hearted evocation of *The Bavarian Don Giovanni* (1919; New York, Solomon R. Guggenheim Museum), where the names of the sweethearts he seeks out are written all around the gabled houses. But from the point of view of titles, those purely formal works are most interesting which resolve a tension by giving an unexpected direction to our imagination. However wide the gap may seem at first, we can form the link and fuse image and idea in one indissoluble whole. What are we to make of these curves and these half-realized heads? Oh! of course, it is a *Peach Harvest* (1937; New York, Solomon R. Guggenheim Museum). Even one of the most puzzling titles in this collection will finally fuse with the image – *Als Schnee liegend* (Lying as Snow) (Fig. 118) – seems like the snatch from a weather report in the Alps, where precipitations over a certain height are reported as remaining as snow. Thus guided I see, or at least I fancy I see, the slow descent of the hovering creature preparing to settle down as snow on the ground underneath. Psychologists speak of the 'Aha' experience – oh yes, of course, that is it; I suggest that Klee's titles belong to the unique category of 'Aha' titles.

Naturally the fact that we experience this fit between image and word does not mean that there could be no other title which would fuse equally well.

118. Paul Klee: *Lying as Snow*, 1931. New York, Solomon R. Guggenheim Museum

119. Paul Klee: *In Angel's Keeping*, 1931. New York, Solomon R. Guggenheim Museum

One chemical element can enter into a variety of indissoluble compounds. We know that Klee sometimes invited friends for a christening session, asking them to suggest names for his latest compositions. It would have been immensely instructive to eavesdrop on these conversations. One could imagine, for instance, that the title *In Angel's Keeping* for his drawing (Fig. 119) would not have been the only one suggested, for one can also see something demonic and uncanny in the gesture we have now learned to interpret as protective and reassuring. But this, remember, is precisely the point. The word and the idea it conveys can serve differentiation, helping to specify the emotive content or feeling tone of the work. We all might enjoy the interplay of shapes in the design of his painting of 1938, with its suggestion of dancing signs and musical notes, but Klee's title adds another dimension – he calls it *Leicht trockenes Gedicht* (Somewhat Arid Poem) (1938; Private Collection), and far from spoiling our pleasure his gentle self-irony enlists our sympathy.

I frequently prefer to quote Klee's titles in their original German, because they are as untranslatable as all poetic language. It is the measure of his search for precision, for the exact nuance, that he often came up with a word for which there is no exact equivalent in English.

This sensitivity to nuance is part and parcel of Klee's unique effort to give the maximum precision to the import of his images. While he was striking out on this lonely road towards differentiation and articulation, a more powerful trend deliberately and successfully went in the opposite direction, seeking to stir up less articulate but more intense reactions which were felt to lie beyond the reach of words. It was Odilon Redon, a survivor of the Symbolist

movement, who said quite explicitly: 'The title is justified only when it is vague, indeterminate and even tending to create confusion and ambiguity.'[24]

Confusion and ambiguity are the characteristics of the dream, and if you could induce such a state you might open the gates of the psyche to the unnamed and the unnameable. I have referred to certain Symbolist titles as 'mood setters', intended to induce a surrender to what psychoanalysts call a regressive state. This is part of the programme of Romanticism which the Swiss painter Arnold Böcklin translated into his own idiom. His painting of a woman riding through a forest on a unicorn acquired fame under the title which his dealer Gurlitt invented – the title *Das Schweigen des Waldes* (The Silence of the Forest) (1885; Poznan, Muzeum Narodowe), a mysterious silence embodied in a haunting spectre. Böcklin's direct descendant here was de Chirico, striving to impress us with the message of the hidden menace of an important mystery. His title *The Enigma of the Hour* (1912; Milan, The Gianni Mattioli Foundation, Feroldi Collection) would seem to fit this prescription, setting the mood for a portentous but indefinite expectation, as does his *Nostalgia of the Infinite* (Fig. 120) which vaguely recalls Hodler's title, *Communion with Infinity* (see page 170).

But once it had become the acknowledged aim of the avant-garde to penetrate more deeply into the region of the elemental, undifferentiated psychological response, the direction was set towards those basic reactions which are rooted not in culture but in nature, reactions due to our biological inheritance; their name is known to all of us who have heard the debates on the modern media – they are called sex and violence. Once human beings regress to the state of sexual desire and animal fear, rational language loses its grip on the mind. Paradoxically, incoherent words could assist in inducing the receptive state of regression in which the precision of language no longer counted.

The more chaotic the image and the title become, the more chance there might be of achieving a knock-out, a state of bafflement in which controls are abandoned. Maybe the challenge – titles which the public read under the more hermetic of the Cubist paintings – prepared the way for the acceptance of catalogue entries of which they could make no sense. It was hard to know, and is still hard to know, where mysticism ended and mystification began. Before anyone rejects this observation as a slur on twentieth-century art, I hasten to add that the word mystification implies making a mystery if not a mystic, and that bafflement itself can become evocative of mystery, of the unfathomable and irrational. Most of us have heard of the nonsense questions on which initiates to Zen Buddhism are asked to meditate, the so-called Koans such as the problem of the one-hand clap. Perhaps they prepare the seeker after truth for deeper insights into the inscrutable nature of reality.

120. Giorgio de Chirico: *The Nostalgia of the Infinite*, 1913–14.
New York, The Museum of Modern Art
121. Marcel Duchamp: *The Passage from Virgin to Bride*, 1912.
New York, The Museum of Modern Art

Remember the harsh words from Goethe's Faust about that enigma of the Christian dogma, the Trinity:

> I know it well, the book was my addiction;
> I wasted many an hour over its pages,
> For a complete and perfect contradiction
> Remains mysterious alike to fools and sages.[25]

By all accounts it was Marcel Duchamp who launched art on this path of puzzlement. The theme of his famous painting *The Passage from Virgin to Bride* (Fig. 121) has its precedent in Gauguin's Symbolist painting entitled *The Loss of Maidenhood* (1890?; Norfolk, Virginia, Chrysler Museum). The title was known, though the painting was lost at the time when Duchamp produced his version, which is much more overt in its use of sexual metaphor suggested by the half-organic, half-mechanical shapes. In Duchamp's *The bride stripped bare by her bachelors, even (The Large Glass)* (1915–23; Philadelphia Museum of Art) violence joins sex in the regressive appeal of contraptions which have kept commentators busy. I happen to know of a folk custom still practised in the wilds of Scotland where the groom's bachelor friends regard it indeed as their privilege to strip the bride after the wedding.

Duchamp, of course, merely teases us with this salacious title and baffles us with the half-mechanical suggestions of *The Large Glass*. It was Picabia who picked up the clue of the sexualization of mechanisms in titles which are anything but enigmatic. He inscribed his picture of a sparking plug copied from a catalogue of engine parts 'Portrait d'une jeune fille américaine dans l'état de nudité' (Portrait of a Young American Girl in the State of Nudity) (Fig. 122). If one wants to, however, one can even here point to a precedent for the metaphor from a less explicit age, the group by the German sculptor Reinhold Begas of the late 1880s entitled *The Electric Spark* (Fig. 123). Maybe the Picabia is preferable. I do not think there is a precedent for Picabia's notorious messy splash entitled *La Sainte Vierge*,[26] except, of course, in the sphere of language, where similar profanities are common currency.

What marks Picabia's position in the history of the title is the painting labelled with an unintelligible name, *Udnie, jeune fille américaine (danse)* (Udnie, Young American Girl (Dance)) (Fig. 124). 'Udnie' looks like an anagram and a good many solutions have been proposed, including most recently I.D.N.U.E., Isadora Duncan naked.[27] I must leave it to specialists to judge whether this is likely. In any case Virginia Spate, to whom this sugges-

122. Francis Picabia: *Sparking Plug* (*291*, no. 5–6, July–August 1915), New York
123. Reinhold Begas: *The Electric Spark*, *c*.1887. From an old photograph

124. Francis Picabia: *Udnie, Young American Girl (Dance)*, 1913.
Paris, Musée Nationale d'Art Moderne, Centre Georges Pompidou

tion is due, writes of Picabia's titles in her recent and most thorough book on Orphism:

> His paintings are objects which arouse associations of so fleeting and tenuous a kind that they are impossible to define, and although the titles also draw the mind in pursuit of the association, it is impossible to resolve title and form. Thus, when one confronts these paintings, one is confronted by a conceptual void, and it is only in this void that one can attain full consciousness of the forms as the enigmatic creation of a complex, unknowable, but completely real individual.[28]

Remember my formula that in this century the striving for new forms of purity goes together with the breaking of earlier taboos. I hardly need document this fact in considering Dada, whose main targets were, after all, bourgeois morality and rationality. In a world where madness and cruelty are rampant, as they were then and still are, I could think of more important enemies to fight, but I concede that there are moments in our lives when our minds run so much on pre-established rails that the shock of derailment can be experienced as liberating. If, in the middle of a lecture, I suddenly produced a hosepipe and drenched the audience with water, they would

remember the event to the end of their days and be prepared for the unexpected always to happen. It has only been my bourgeois morality which has restrained me from making the experiment.

There are many surrealist titles which, despite the continued quest for the cleansing power of chaos, contain a referential element leading us to the text of Freud. I am thinking of Max Ernst's nightmarish *Oedipus Rex* (1922; Private Collection) with its tormented fingers which we can associate with sexual organs, or Tanguy's *Mama, Papa is wounded!* (1927; New York, Museum of Modern Art), which also combines phallic motives with an Oedipal title. Nobody has striven more consistently than Miró to suggest the workings of the Freudian primary process in titles mixing sexual and seemingly inconsequential associations, such as *Le crépuscule rose caresse le sexe des femmes et des oiseaux* (The Rose Dusk caresses the Sex of Women and of Birds) (Fig. 125). I would hardly expect an 'Aha' response as in the case of Klee, so I hope I shall cause no offence if I propose to call this kind not 'Aha' but 'Oho' titles.

There is at least one of Miró's titles which I should like to call descriptive

125. Jean Miró: *The Rose Dusk caresses the Sex of Women and of Birds*, 1941. New York, Pierre Matisse Gallery

126. Hilla Rebay: *Animato*, 1941–2. New York, Solomon R. Guggenheim Museum

in a new way: it is the painting inscribed 'Photo: This is the colour of my dream' (1925; Private Collection). The image is used to communicate a private experience but in a perfectly rational way. Salvador Dali tried something similar with his *Dream caused by the flight of a bee around a pomegranate, one second before awakening* (1944; Thyssen-Bornemisza Collection), but unless Dali's dreams always look like Dalis I wonder if one can believe him or is even meant to do so.

Some of the traditions which formed at the beginning of our century could be traced right through to the present day. The links with music might be exemplified through Hilla Rebay's painting entitled *Animato* (Fig. 126), an evocative title which I should like to interpret as much as an instruction as a description. The tradition of the defining metaphor which harks back to Klee might be exemplified by such works as Mark Tobey's *The Edge of August* of 1953, the search for the representation of states of mind by Arshile Gorky's *Agony* of 1947 (both New York, Museum of Modern Art). An ironic revival of the Victorian reference title is represented by Georges Matthieu, who likes to give his gory abstract tangles of brushstrokes titles such as *The Death of Attila*, or *Le Bon Duc Philippe apaisé par son fils le Comte de Charollais*. Picabia's verbal coinage has found a more cautious successor in Barnett Newman's title *Onement 1*. As Harold Rosenberg wrote: 'Onement is not really a word; and though its meaning is quite clear – the state of being one – it designates a condition that is ineffable . . . Onement adds an aura of indefiniteness to oneness.'[29] Be that as it may, Barnett Newman has remained one of the most determined practitioners of the baffling title, designed to set our mind

circling around his images composed of intensely coloured horizontal bands. His *Vir heroicus sublimis* (1950–1; New York, Museum of Modern Art) is a case in point. Here I merely want to remind you of the range of possibilities open to the artist in this century; Mark Rothko, for instance, unlike Newman, has taken the road that leads from Whistler via Kandinsky to the modern sensory title. Such appellations as his *Dark on Brown, No. 14* are meant to induce a contemplative mood by preventing the mind going off at a tangent. Against this aim, which is common to many of the artists we call 'abstract' or 'non-objective', we have experienced the reassertion of words in what is called 'pop art' and the type of conceptual art with which I began. Finally there is an artist of our time who has found new ways of turning the word itself into an image of its meaning.[30] I am speaking of course of Saul Steinberg. His drawing of *Now!* (Fig. 127), which always rushes ahead, contains a warning to any historian who ventures to deal with the 'now' in art.

127. Saul Steinberg: *Now!* From *The Inspector*, New York, 1973

The Wit of Saul Steinberg

The ingenious dedication which Saul Steinberg kindly wrote and drew for me when he sent me his volume *The New World* (Fig. 128) prompts me to take it as a starting point for this brief discussion of the artist's wit. Look at the drawing more carefully and you will see that it does not 'work out'. What appears at first sight as a sequence of stacked oblongs, superimposed or stuck into one another, turns out to be so cunningly devised that it would be impossible to construct such a configuration in real space. It so happens that I owe this generous gift to the words which I devoted to the artist in my book *Art and Illusion*: 'There is perhaps no artist alive who knows more about the philosophy of representation.' The tribute, incorporated in an article by Harold Rosenberg, was quoted to my delight on the dust cover of Steinberg's next book; hence his present, which illustrates and confirms my words with that economy of means which is one of the hallmarks of Steinberg's art.

128. Saul Steinberg: Dedication in the author's copy of *The New World*, New York, 1965

First published in Art Journal, *Winter 1983*

129. Saul Steinberg: Drawing from *The New World*, New York, 1965

It has often been said that the real or dominant subject matter of twentieth-century art is art itself. If that is the case, Steinberg's contribution to the subject must never be underrated. Without going over the ground again which I covered in my book, I may point out that the drawing which I chose here as my starting point offers a more illuminating comment on the essence of Cubism than many lengthy books.

Harold Rosenberg quoted Steinberg's remark: 'What I draw is drawing, [and] drawing derives from drawing. My line wants to remind constantly that it is made of ink.'[1] The reminder is made explicit on another page of *The New World* (Fig. 129), which shows the artist's pleasure in catching us in the traps of his visual contradictions. It would be otiose to point them out in detail. Indeed, one of the problems in writing about Steinberg's wit is precisely the fact that his drawings make their point so much better than words ever could. However, what may be said about the artist's remark is that even though he reminds us constantly, he never fully convinces us. Try as we may, what we see is not just ink. The little man who cancels himself (Fig. 130) remains pathetic and intriguing. The drawing proves, if proof were needed, that our reaction to pictorial representation is quite independent of the degree of realism. It is a function of our understanding and it takes an enormous effort to inhibit our understanding and see only ink.

Our reactions to certain linguistic statements offer an instructive parallel. I am thinking of the paradoxes of self-reference beloved of logicians, such as the standard example of the Cretan who asserts that 'all Cretans are liars.' We

130. Saul Steinberg: Drawing from *The Passport*, New York, 1954
131. Saul Steinberg: . . . *'And how is business?'* from *All in Line*, New York, 1948

132. Saul Steinberg: Drawing from *The Inspector*, New York, 1973

feel entrapped by the clash of incompatible meanings, for if he is right he must be wrong.

What must be one of the earliest of Steinberg's humorous drawings to be included in one of his volumes neatly illustrates the play between 'ink' and meaning in a joke that still relies on a caption (Fig. 131). What starts as a graph turns into a real force smashing through the floor. There is as yet no real paradox here, no more than in the metaphors of language, which we do not take literally, as when we say that prices 'rocket' or 'slump'. But in many of Steinberg's later drawings we cannot assign a meaning to his lines without running up against a contradiction, and contradictions are one of the many

humorous devices Steinberg uses to produce the shock of laughter, as when
we look at the mysterious table which is also the rim of a bathtub (Fig. 132)
– another visual joke worth many lengthy disquisitions about the reading of
images.

This process of reading is examined in many of the drawings in which the
artist explores the very limits of graphic signs. He shows us how the simplest
geometrical configurations will suddenly resemble a human head and exhibit
a definite individuality and expression, as is the case with the odious pair who
appear as the guests of a party (Fig. 133).

Needless to say, these explorations of what I have called 'the philosophy of
representation' have also taken Steinberg much further afield. In some of his
wittiest drawings we see him commenting on a time-honoured problem of
criticism, that of the proper relation between form and content. The general
heading under which this question has been discussed since classical an-
tiquity is that of 'decorum', the fitting of the right word or style to the right
subject matter, memorably summed up (as far as poetry is concerned) in
Alexander Pope's *Essay on Criticism*:

> 'Tis not enough no harshness gives offence,
> The sound must seem an echo to the sense:
> Soft is the strain when Zephyr gently blows,
> And the smooth stream in smoother numbers flows:
> But when loud surges lash the sounding shore,
> The hoarse, rough verse should like the torrent roar.
> When Ajax strives some rock's vast weight to throw
> The line, too, labours, and the words move slow.

133. Saul Steinberg: Drawing from *The New World*, New York, 1965
134. Saul Steinberg: Drawing from *The Passport*, New York, 1954

As I have indicated in the last chapter of *Art and Illusion*, attempts have not been wanting in the past to apply this doctrine to the visual arts, but we had to wait for a Steinberg to apply it with utmost simplicity. In many of his drawings it is again the line or the graphic medium which seems 'an echo to the sense'. His 'Family' (Fig. 134) shows us the father firmly modelled, the mother with undulating lines, the grandmother all but fading away between hesitant pen strokes, and, of course, the child drawn in the style of children's scribbles.

From here it is but one step to the representation of what are called our synaesthetic reactions, the depiction of one sense modality by another.[2] The sounds of 'Giuseppe Verdi' floating through the window (Fig. 135) do not leave us in doubt that it is early Verdi. As this example shows, there is no distinction in Steinberg's manipulation of 'ink' between representation and writing. He can incorporate all the means of visual communication in his images. To quote his words once more: 'I appeal to the complicity of my reader who will transform the line into meaning by using our common background of culture, history, poetry. Contemporaneity in this sense is a complicity.'[3]

The conventional device of a 'balloon' surrounding words or thoughts is used to delightful purpose in the image of the rocking-chair dreaming of being a rocking-horse (Fig. 137). The question mark, as so often in real life, takes off and pursues us, the conventional lines indicating its bounces (Fig. 136). But Steinberg has also used script and words more insistently, indeed

135. Saul Steinberg: Drawing from *The New World*, New York, 1965

136. Saul Steinberg: Drawing from
The New World, New York, 1965

137. Saul Steinberg: Drawing from *The New World*, New York, 1965
138. Saul Steinberg: Drawing from *The Inspector*, New York, 1973

more philosophically, in such compositions as Figure 138, where he contrasts the firm foundation of the words I AM with the ramshackle instability of I HAVE and the radiant triumph of I DO (see also Fig. 127).

Everybody will have his own favourites among Steinberg's ingenious visualizations, such as his mapping of time where we are shown the frontier of March and April, which is just being crossed by his favourite cat, or his parodistic manipulations of patriotic symbolism in his grand tableaux of political rhetoric.[4] Nor should we forget that he is not merely a master of line but can use all the means of *trompe-l'oeil* in his spoof picture postcards or his meticulous working drawings.[5]

At the end of Plato's *Symposium*, when the rest of the company had either

fallen asleep or gone home, we hear that Socrates was still arguing with Agathon and Aristophanes. Socrates was driving them to the admission that the same man could have the knowledge required for writing comedy and tragedy, at which Aristophanes and then Agathon began to nod, while Socrates walked off, apparently happy in the knowledge that he had won the argument. But has he? The idea persists that the comedian or caricaturist is a mere entertainer, hardly worthy of the attention of the superior persons who study and analyse the creations of serious 'artists'.

Unless I am much mistaken, Steinberg's work is not referred to in the standard books on twentieth-century art, nor does he seem to figure in the survey courses explaining and tabulating the various 'isms' said to make up the modern movement. Whether he resents this comparative lack of attention accorded him in the curriculum of art historians I do not know. But it seems to me that one of his drawings (Fig. 139) offers the best comment on this situation: a solemn procession of stereotyped greybeards is marching past a dull official building aptly inscribed as 'The National Academy of the Avant-Garde'. Maybe they will all be forgotten when Steinberg is still remembered with pleasure and gratitude.

139. Saul Steinberg: Drawing from *The Inspector*,
New York, 1973

A Master of Poster Design:
Abram Games

There are many reasons for welcoming this retrospective exhibition
dedicated to the life work of one of Britain's leading designers. The first of
them is the opportunity it will offer many of us to meet old friends, to renew
our pleasure in encountering some of his brilliant posters we had enjoyed in
the past (Fig. 140). Secondly, it will also enable visitors to become aware
of the artist to whom they have been beholden for so long. Few members of
the public try to read the signatures on the margin of the images appearing
on the hoardings; they remain almost as anonymous as were the products of
the craftsmen who created the porches and gargoyles of medieval churches.
Now, at last, we know how many of the witty inventions that struck us at the
time were the brainchild of one man, and so our fleeting appreciation is
transformed into lasting admiration.

Personally, I have yet another reason for welcoming this public tribute. It
so happens that my memory extends even further than the sixty years covered
by this exhibition. I vividly recall a conversation in the spring of 1930 when
I visited an exhibition of contemporary paintings in Berlin with a fellow
student. We were both a trifle disappointed and I tried to console her by re-
marking that what was really interesting in the art of our time was to be seen
on the hoardings rather than in such shows. 'You are funny,' she said, and
shook her head. I suppose she also shook her head much later when she
looked at my subsequent publications and discovered the posters and adver-
tisements I illustrated in *Art and Illusion* and in several of the essays collected
in the volume *The Image and the Eye* (including four splendid designs by
Abram Games).[1]

Even earlier, in 1949, I had opened my *Story of Art* by explaining that
artists were 'once men who took coloured earth and roughed out the form of
a bison on the wall of a cave; today they buy their paints and design posters
for the Underground' (I had to change 'Underground' into 'hoardings' in the
next edition, lest American readers suspected me of subversive tendencies).
In the conclusion of that book I expressed my regret that 'there still remains
an unhappy cleavage between what is called "applied" or "commercial" art
which surrounds us in daily life and the "pure" art of exhibitions and gal-
leries . . .' True, when writing a postscript in 1966, I had to acknowledge the

Foreword to an exhibition catalogue, 1978

efforts made by the movement called 'Pop Art' to bridge this gulf, but results
had not satisfied me. I felt and feel that the way commercial products such as
soup cans or doughnuts were celebrated by studio artists was not free of
condescension, a kind of 'slumming' that smacked of an ideological gesture
rather than an artistic concern. The developments I had admired for so long
are less self-conscious and much more inventive.

Many of my favourite designs testify to the fertility of the visual dis-
coveries made by the art of the studios in our century. They apply them to the
purposes of the market, much as the arts of previous centuries had been
harnessed to the service of power or of religion. Contrary to prevailing preju-
dices these departures from the principle of *l'art pour l'art* have frequently
proved a spur rather than a hindrance to the creative imagination.

What better proof can there be of this observation than the lifework of
Abram Games? It has been claimed, and rightly so, that he derived inspira-
tion from the experiments of the Surrealist movement, which flowered
during his formative period. Artists such as Max Ernst and Salvador Dali dis-
covered or developed the devices of visual punning, of deliberate ambiguities
and illogicalities in their juxtapositions of dreamlike images. But it may be
said (I hope without offence) that many of these works were pointless, and

140. Abram Games: *Jersey Deckchair*, 1958 141. Abram Games: *Trumans Beers*, 1951

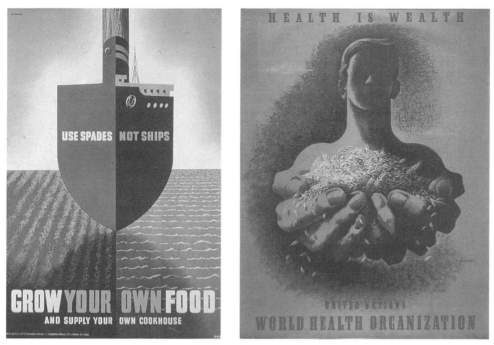

142. Abram Games:
Grow Your Own Food, 1942

143. Abram Games:
Health is Wealth, 1952

were indeed intended to be so; like the 'shaggy dog stories' of happy memory they aimed at defying the canons of reason to shake our complacency. In the art of Abram Games the very puzzlement caused by such arresting images is given an added purpose. We attend because we are momentarily baffled, and thus we are ready to seek for the message, which we will remember all the better for having discovered it in such a flash of recognition. These striking creations, in other words, exhibit to the full the quality of 'wit' as defined in the Oxford English Dictionary: 'the apt association of thought and expression, calculated to surprise and delight by its unexpectedness.' It is the artist's wit that makes us see the resemblance between a glass of beer and the shape of an exclamation mark (Fig. 141), between a spade exhorting us to 'dig for victory' and the outline of a ship (Fig. 142), or that exploits the distortions of a close-up photograph to enhance the appeal in favour of the World Health Organization (Fig. 143).

As with the other arts, so with the art of the poster: even when their immediate purpose has been forgotten, they continue to offer us delight and much food for thought – indeed, is that not the quality we are entitled to call timeless?

The Photographer as Artist:
Henri Cartier-Bresson

We live in a world of meanings. The sight of any human being, of any animal, plant or indeed of any object in our environment resonates in our mind, though we are rarely fully aware of these reverberations. It needs an artist to make us attend to the message of reality. Henri Cartier-Bresson is such an artist. It is fitting that we should honour him at the time of his seventieth birthday, for many of the images he has discovered on his way through life have joined the masterpieces of the past as points of reference and points of departure.

That he has technical mastery goes without saying. The depth and delicacy of the receding panorama from Basilicata is recorded with the same clarity as the foreground figures of the old man with his load of wood and the smiling woman further back (Fig. 144). He brings out the language of things, their textures, their shapes and their 'feel'. Think of the walls he has photographed in cities and in the countryside.[1] Some speak of squalor, some

144. Henri Cartier-Bresson: *Basilicata*, 1952

Introduction to an exhibition catalogue, 1978

145. Henri Cartier-Bresson: *Madrid*, 1933

of pride, others are mellow and crumbling. In this capacity to record 'physiognomic' qualities and thus to make reality speak, Cartier-Bresson has found the camera to be superior to the brush.

In painting, after all, the meaning of material objects remained for a long time subordinate to the symbols of the tribe. Only in some periods was it discovered that their significance could be enhanced by the power of the artist, whose personal vision of the physical appearance of Zeus, of the Buddha or of Christ could draw on his understanding of life. It was along this path that artists felt encouraged to take in an ever-widening aspect of reality, first as the setting of biblical or heroic events and later even in scenes of everyday life. But few of such 'genre' paintings could do entirely without a story, an amusing anecdote or at least an easily recognizable type – the swash-buckling soldier, the contented toper or the careworn beggar. Some, it is true, of the greatest masters moved out of this confined circle of easy significance to focus on the less obvious realities of their surrounding – masterpieces such as Vermeer's kitchen maid, Le Nain's peasant families or Velázquez' water-seller belong to the noble ancestry of Cartier-Bresson's best works (Fig. 145).

But here, as so often, it took the theory of art a long time to catch up with the practice of the masters. Great art demanded great themes, suitably idealized; realism could be condoned only in scenes of low life, preferably humorous ones. True, these hallowed rules of 'decorum' were increasingly corroded during the nineteenth century. Baudelaire's essay *The Painter of*

Modern Life contains many passages which could be applied to our artist, bu the master whom it celebrates, Constantin Guys, remained much too clos to the surface of high life to stand the comparison. Even Daumier, with hi unfailing instinct for the ridiculous and pathetic, remained ultimately a inventor of types rather than an observer of life, while the Impressionists wh tried to live up to Baudelaire's programme reacted so strongly against th 'anecdotal' element in painting that they tended to disregard a whole secto of human experience.

Any chronicle of the recovery of these aspects of reality would have to pa tribute to the documentary film and to the great masters of realism, such a René Clair and Jean Renoir. It was they who brought it home to us tha we could be made to share the tragedies, comedies and tragicomedies of lifi around us in any setting, as the types and roles which people are made tc play in society dissolved before our eyes to show the human being behinc the mask. Cartier-Bresson was in touch with this movement, having beer Jean Renoir's assistant during the filming of *La Règle du Jeu* before the war and some of his shots, such as the picnic by the Marne, bear the mark of this collaboration.

Yet it is no accident that Cartier-Bresson started life as a painter. For the painter who wants to record reality confronts a problem very different from that of the film-maker. By its very nature the motion picture comes closer to reality than any 'still'. The reason has to do with the nature of our visual experience. We live in a flux of events and our impressions never stand still. Whether we walk or merely move our head, whether we change our fixation or our focus, even a static object will always present to us a flow of continuously changing aspects. Moreover, our eyes and our minds can never fully register more than a fraction of these potential sights, for our focus is very limited and our attention demands concentration. It is only in recent years that we have begun to understand that this limitation is also a source of strength. It is in movement that objects reveal their shapes, and our perception must always draw on memories and anticipations to provide us with the orientation we need in order to survive. But for this very reason the experience of looking at a static picture differs radically from the sight of the real world. The picture, firmly locked within the four sides of its frame, does not change; we can examine it at our leisure and focus on each of its parts till they are all lodged in our memory. We may here look back to the panorama of Basilicata, which combines so many fixations. The most obvious case in point, however, is pictures of crowds, a genre in which Cartier-Bresson has also excelled. What would be a milling mass of humanity in real life can now be dissolved into an assembly of individuals, whether they share an emotion or try to opt out of it. It is true that in this respect there is less

difference between a painting and the mechanically produced image of the camera – except that the photograph is always likely to contain more information than any painting of any motif is likely to embody.

No wonder the camera is the chosen instrument of science and no wonder, also, that our cities and beauty spots are teeming with shutter-happy men and women eager to take home the views and situations which might otherwise elude their recollections. Their first priority, of course, is the familiar landmarks, the very sights which figure in the tourist brochure, the Piazza San Marco in Venice and the gondolas on the canals, in short anything distinctive that gives local colour to their picture, such as folk costumes or picturesque types which impart a sense of place and could not be 'anywhere'. Ironically, in trying to preserve the particular they remain on the level of the general, the stereotype. But let them point their camera instead at suburban streets, petrol stations or ordinary shoppers and, more likely than not, the result will be as dull as the motif was, even more different from Cartier-Bresson's memorable images than the pictures the naïve tourist takes home.

The master's secret, of course, is not realism but selection. What he has said many times is that he waits for 'the right moment'. One is reminded of the reply which the child Yehudi Menuhin gave, when someone asked him how he could play all that music with his little fingers? – 'I put them in the right position.' What is the right moment? It is the moment, we must infer, when the language of reality becomes distinct and distinctive, not in the

146. Henri Cartier-Bresson: *Sifnos, Greece,* 1961

obvious cliché but through the mutual elucidation and articulation of all the sights within the frame. The capacity to integrate them Cartier-Bresson owes no doubt to the discipline of painting. As a painter – and he still spends most of his days drawing and painting – his outlook owes much to the formal purism of his teacher, André Lhote. Nearly all his pictures exhibit that visual balance, that secret geometry of a formal composition which counteracts the impression of the merely fortuitous and the contingent. The chairs stacked in the garden of the Tuileries by some piles of chopped wood or the felled and gathered wood in the forest make a memorable pattern suffused with autumnal moods. But only rarely does Cartier-Bresson fail also to give a touch of animation to the geometrical relationships he discovers in his motifs.

He must often have been lying in wait at such a spot with the camera ready for the moment when life entered the scene and completed the design at just the right point – as in his shots of Mediterranean villages with their narrow roads, their cubic houses and angular steps, which demand the vicarious experience of movement (Fig. 146). His beautiful picture of the Palais Royal (Frontispiece) would not be what it is if the lines of the buildings and of the trees were not enlivened by the tiny figures of people which occupy the right place at the right moment, just as the monotony of the Dutch landscape is brought to life by the two endearing pigs with their eager look (Fig. 147).

No doubt Cartier-Bresson, with his alertness to the effects of incongruity, owes much to the other artistic movement of his youth whose influence he

147. Henri Cartier-Bresson: *Holland*, 1953

148. Henri Cartier-Bresson: *Silifké, Turkey*, 1965

has acknowledged – Surrealism. André Breton's notorious formula of the 'accidental encounter of an umbrella and a sewing machine on an operating table' was intended to stress the value of the unexpected in making us pause and look. The photograph of an old grubby bucket on an upturned capital in a village of Asia Minor in a setting of poverty and depression is surrealist in its incongruity (Fig. 148), but it is more than that, because it is not a dream but the plain and unadorned truth. In administering this kind of jolt Cartier-Bresson often draws on the cultural symbols which are immediately intelligible. The few crowded crosses of a little cemetery hidden in the woodlands add a note of melancholy to the radiant landscape (Fig. 149).

This is by no means the only one of his images to show his preoccupation with death as a background to life. His photograph of another cemetery would not be what it is, had he not waited till a sleek car streaked past to provide the contrast. Elsewhere we find the picture of a funeral cortège passed, in the other direction, by smiling urchins driving a wheel, or a shot of a man sitting calmly in a tram in Zürich taking a finished gravecross to its destination. Often it is the facial expressions of the people which provide the tension, as with the row of sad women sitting dejectedly in the ornate hall of an oriental ruler or the sad young visitor in a Moscow museum staring at a splendid uniform.

One of Cartier-Bresson's favourite methods of pointing a meaning without sacrificing realism is the inclusion in his picture of man-made images and of

149. Henri Cartier-Bresson: *Province of Quebec*, 1964

inscriptions. Posters stand him in good stead: an old woman is shown under an advertisment for umbrellas; in one of his earliest successes a poster for women's underwear is 'blinded' by a flybill and serves as an ironical foil to the blinking woman in the foreground. In India, China and Samarkand he found the right juxtaposition between murals or wall-posters and the foreground scenes of social reality. The Parisian lawyers in front of the theatrical statue in the Law Courts must have been as irresistible as they are unforgettable, but few juxtapositions are more pointed than the cross with the inscription 'Jesus is Coming' in a scene of unbearable squalor and desolation.

Naturally there are many pictures which stand in no need of such props, because their message immediately strikes home: the arm extending from the bars of a prison in New Jersey, the cruel record of a monkey in a scientific torture chamber (Fig. 150), and the many scenes of poverty Cartier-Bresson photographed on his travels to the States, to Mexico and to India. He knows as well as anyone how to point a telling contrast: a wealthy couple in a car are seen behind poor street-sellers; an old woman saws wood with three girls looking on, a picture which shades over into wistful humour. Indeed, not everything is tragic or portentous in his photographs. Cartier-Bresson can bring out the humour of a situation, as in the picture of a bank manager in his office just entered by his secretary (Fig. 151), the couple kissing across the table with the dog watching jealously, the elderly lady looking with marked

150. Henri Cartier Bresson: *Berkeley, California*, 1967

151. Henri Cartier-Bresson: *A bank executive and his secretary, New York*, 1960

disapproval at the girl in a miniskirt next to her in a restaurant, or the two dogs trying to enter a house.

Not that Cartier-Bresson's pictures are always of that easy kind which 'tell their own story'. He would not be the artist he is, if he did not respond to the mystery as well as to the humour and poetry of life. It is significant that he suggested for the cover of the catalogue of this exhibition[2] the intriguing picture of a carnival scene, which leaves us wondering what is make-belief, and what is truth. The group must have aroused his sense of mystery as much as the sight of the masked boy with his gun on a tenement roof, a night-marish scene which may still be quite innocent (Fig. 152). In real life, of course, we would not have had to wait long till the question had resolved itself – what is it all about? The enigmatic effect, then, is also due to the medium. The arrested image remains suspended and unresolved, and its very isolation from the flux of events both enhances its impressiveness and veils its significance.

Cartier-Bresson must have discovered this dual quality of the photograph very early in life. The earliest picture in the exhibition, dating from 1929, shows a striking picture of a man on the pavement with a woman walking past

152. Henri Cartier-Bresson: *Courtyard of a hotel in the rue de la Boetie, Paris*, 1953

154. Henri Cartier-Bresson:
La Villette, Paris, 1929

throwing a glance at him (Fig. 153). Is she the unhappy wife of a drunkard? Is her reaction one of pity, anger or despair? We shall never know, but we cannot easily dismiss the scene from our mind. Whether poignant, tense or humorous, the pictures of human encounters he has collected always seem to transcend the momentary situation and tempt us to spin out the story – the gossiping women in Thessaly, the old men in Peking, the conversation with a deaf man in an inn in Yugoslavia, the leisurely talk across a fence, and the two well-dressed women among their vegetable crates in Les Halles could all teach a theatrical producer how real people interact.

Not that we should jump to the conclusion that we now know them: one of the most striking images in the exhibition is that of a handshake with a jovial farmer (Fig. 154) – or so we think, till we happen to hear from the photographer that only a few minutes after he took the picture the farmer chased him with a pitchfork. There is always an unplumbed depth.

Cartier-Bresson has contrived to hint at this depth in observing human beings in all their loneliness. More than once he has photographed a woman sitting on a bench as if forlorn and unhappy. The woman under the tree (Fig. 155), the woman in Hyde Park, appeal to our imagination, and so do the men

154. Henri Cartier-Bresson: *Beauce*, 1955

sadly or happily sitting at table and the man in a rocking-chair. There is soli-
tude even in a crowd, as exemplified by the sad brooding man in an Indian
refugee camp. There is deliberate withdrawal, as with the pictures of readers
absorbed in their books or papers, like the woman in a New York subway, the
charming girl reading on horseback, or the two men in Moscow pushing
prams, with their noses in their papers.

 The ultimate withdrawal is sleep, and there are many moving pictures of
sleepers. The most touching of them all is the figure of an Indian sleeping in
the shadow of an elaborate structure (Fig. 156), pointing the contrast
between two worlds, but there is also the famous shot of a man lying among
the litter beneath the waiting crowd at the time of the Coronation of George
VI, and that of the worker in a Hamburg factory stretched out for a nap on
the workbench. From these scenes of self-oblivion and self-absorption the
transition is natural to Cartier-Bresson's conception of the art of portraiture.
There is no marked difference between the anonymous figures of his scenes
and the portraits of named and often famous individuals; witness his charm-
ing shot of the sculptor Giacometti crossing the street in a downpour (Fig.
157). Clearly here too he will not force matters, but will wait for the 'right
moment'. He tells us that in confronting Ezra Pound in his tragic old age he
made only six pictures during a session lasting for an hour and a half, but the
resulting portrait remains in the memory.

Two observations may still be added. The fearless honesty which marks all Cartier-Bresson's works makes one certain that he never concealed his purpose. Nor is he afraid of showing us the reaction of the people to the camera. The urchins are grinning and mocking him, the Cuban soldiers and the Sardinian peasants look at him as he looked at them.

It is known, moreover, that he not only refuses to pose a person, he will not even cut or crop any of his pictures, which must include all he had on the film. Artists like to impose such rules on themselves, which enhance the challenge by increasing the difficulty. But one can see why the restriction remained dear to the photographer. Sensitive as he is to the language of things, he does not want to silence any message his Leica has received and recorded. If that were necessary he would discard the picture.

We do not know and should not ask whether that happened often or rarely. What we must marvel at is the degree to which he must have been favoured by luck. It needed not only a good eye, but also an extraordinary coincidence to find a man sleeping under a grafitto which almost echoes his expression; but the luck of a lifetime is surely the famous shot of the jumping man in a downpour outside the Gare St-Lazare trying to avoid getting his feet wet (Fig. 158). Note the posters in the background, echoing his leap. It would be

155. Henri Cartier-Bresson:
Woman under a tree, 1952

156. Henri Cartier-Bresson:
Ahmedabad, India, 1967

 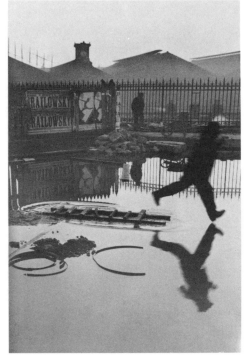

157. Henri Cartier-Bresson:
Alberto Giacometti, 1961

158. Henri Cartier-Bresson: *Man jumping,*
Gare St-Lazare, Paris, 1932

witty if it were a drawing. But here, as always, our confidence in the authenticity of the record adds another dimension.

There is little indeed that can be preserved on the long way from the picture to the verbal comment, but what can be expressed is our gratitude for the opportunity of seeing these pictures which the master himself has selected for purchase by the Victoria and Albert Museum. And as with all art, we are even more grateful for the permanent enrichment they can provide. After a visit to a gallery of paintings we often notice that for a short span of time we have become more sensitive to nuances of colours and shapes, as if our eyes had been opened to an aspect of the world to which they had been blind. Cartier-Bresson's images will also enhance our sensitivity to the tones and textures of reality, but they will do more; they will make us look at people and situations anywhere with a heightened sense of sympathy and compassion. He is a true humanist.

Notes

AN AUTOBIOGRAPHICAL SKETCH

1. See *Adolf Busch*, a centenary volume edited by Irene Serkin-Busch, with a preface by E. H. Gombrich, Walpole, New Hampshire, 1991.
2. *Klassiker der Kunst in Gesamtausgaben* is a series of monographs illustrating the complete *oeuvre* of individual masters, published in the early years of this century (Deutsche Verlags-Anstalt, Stuttgart and Leipzig). *Knackfuss Künstler Monographien* cover a wider range, with fuller text and more selective illustrations (Verlag Velhagen, Klasing, Bielefeld and Leipzig).
3. M. Dvořák, *Kunstgeschichte als Geistesgeschichte, Studien zur abendländischen Kunstentwicklung*, Munich, 1924.
4. H. Schrader, *Phidias*, Frankfurt am Main, 1924.
5. W. Waetzoldt, *Deutsche Kunsthistoriker*, 2 vols, Leipzig, 1921–4.
6. J. Strzygowski, *Early Church Art in Northern Europe, with Special Reference to Timber Construction and Decoration*, London, 1928.
7. J. Schlosser, *Die Kunstliteratur: ein Handbuch zur Quellenkunde der neueren Kunstgeschichte*, Vienna, 1924. The comprehensive bibliography in the Italian edition, *La Letteratura Artistica* (1935), was brought up to date in 1956 by Otto Kurz. There is now also a French edition.
8. E. H. Gombrich, 'Eine verkannte karolingische Pyxis im Wiener Kunsthistorischen Museum', *Jahrbuch der Kunsthistorischen Sammlungen in Wien*, Neue Folge VII, 1933, 1–14.
9. A. Riegl, *Stilfragen*, Berlin, 1893. See also E. H. Gombrich, *The Sense of Order: A Study in the Psychology of Decorative Art*, Oxford and Ithaca, New York, 1979, pp. 180–90.
10. K. von Amira, *Die Dresdener Bilderhandschrift des Sachsenspiegels*, Leipzig, 1902.
11. See my 'Ritualized Gesture and Expression in Art' in *The Image and the Eye*, Oxford, 1982, pp. 63–77.
12. The chapter dealing with the Palazzo del Tè and other extracts were published under the title 'Zum Werke Giulio Romanos' in the *Jahrbuch der Kunsthistorischen Sammlungen in Wien*, Neue Folge VIII, 1934, and IX, 1935. See also my two essays on Giulio Romano in *New Light on Old Masters*, Oxford, 1986, pp. 147–70.
13. E. Kris, *Die Gemmen und Kameen im Kunsthistorischen Museum; Beschreibender Katalog*, Vienna, 1927. See also my essay on Kris in *Tributes*, Oxford, 1984, pp. 221–33.
14. E. H. Gombrich and E. Kris, *Caricature*, Harmondsworth, 1940, and E. H. Gombrich and E. Kris, 'The Principles of Caricature' (1938), included in E. Kris, *Psychoanalytic Explorations in Art*, New York, 1952.
15. See my *Aby Warburg: An Intellectual Biography*, Oxford, 1986.
16. See my article 'The Warburg Institute, A Personal Memoir', *The Art Newspaper*, 2, November 1990, p. 9.
17. Olive Renier and Vladimir Rubinstein, *Assigned to Listen*, with a preface by E. H. Gombrich, BBC Publications, London, 1986.
18. 'Botticelli's Mythologies' in *Symbolic Images*, London, 1972.
19. *The Story of Art*, London and New York, 1950 (15th edition 1989).
20. A. W. Mellon Lectures in the Fine Arts, given in 1956.
21. *Art and Illusion: A Study in the Psychology of Pictorial Representation*, London and New York, 1960.
22. *The Sense of Order*, op. cit., Note 9.
23. See my broadcast series, 'The Primitive and its Value in Art', published in *The Listener*, 15 and 22 February and 1 and 8 March 1979.

THE EMBATTLED HUMANITIES

1. It was Sir John Pope-Hennessy.
2. Sir Keith Joseph was Secretary of State for Education from 1981 to 1986. His address 'Why teach History in School?' was given to the Conference of the Historical Association in London, 10 February 1984, and published in *The Historian*, Spring 1984.
3. University Grants Committee, *Circular Letter*, 16/1983, point 15.
4. Letter by the British Academy, 25 March 1984.
5. 'The Future of the University', the AUT response to the UGC questionnaire, April 1984.
6. See his Commemoration Address at the Imperial College of Science, 25 October 1984.
7. Published in *The Nineteenth Century*, November 1988, pp. 617–23, see R. A. C. Oliver, 'Education and Selection' in S. Wiseman, ed., *Examinations and English Education*, Manchester, 1961.
8. A proposal to increase student fees met with such opposition at that time that it had to be withdrawn.

RELATIVISM IN THE HUMANITIES

1. 'Was hat dich nun von uns entfernt?'
 Hab immer den Plutarch gelesen.
 'Was hast du denn dabei gelernt?'
 'Sind eben alles Menschen gewesen.'
 Johann Wolfgang von Goethe, *Sämtliche Werke*. *Jubiläumsausgabe in 40 Bänden*, Stuttgart, 1902–7, Vol. 4; p. 73; with commentary.
2. Georg Wilhelm Friedrich Hegel, *Vorlesungen über die Philosophie der Geschichte*, *Werke*, 20 vols, Frankfurt am Main, 1969–79, Vol. 12; p. 17.

3. Friedrich Meinecke, *Die Entstehung des Historismus*, Munich, 1936. I have translated *Historismus* as 'historism' to avoid confusion between this belief in the incommensurability of historical periods with the belief in the existence of compelling 'laws of history', which Popper has called 'historicism'. Unhappily his optimism proved unfounded when he wrote, in *The Poverty of Historicism* (London, 1957), pp. 3–4: 'I have deliberately chosen the somewhat unfamiliar label "historicism". By introducing it I hope I shall avoid merely verbal quibbles; for nobody, I hope, will be tempted to question whether any of the arguments here discussed really or properly or essentially belong to historicism, or what the word "historicism" really or properly or essentially means.' On p. 17 of the same book the author warns against the confusion I wished to avoid.

4. Cato wollte wohl andere strafen;
Selbander mocht' er gerne schlafen.
Goethe, op. cit.

5. For the following see also Maurice H. Mandelbaum, *History, Man and Reason: A Study in Nineteenth-Century Thought*, Baltimore, 1971, and W. Brückner, 'Der Mensch als Kulturwesen' in *Wie erkennt der Mensch die Welt?*, ed. M. Lindauer and A. Schöpf, Stuttgart, 1984, pp. 177–95.

6. See Hans Erich Bödecker, 'Menschheit' in *Lexikon geschichtlicher Grundbegriffe*, ed. Otto Brunner, Werner Conze and Reinhart Koselleck, Stuttgart, 1982, pp. 1063–1128.

7. Wilhelm Dilthey, 'Der Aufbau der geschichtlichen Welt in den Geisteswissenschaften', *Gesammelte Schriften*, ed. Bernhard Groethuysen, Leipzig and Berlin, 1927, Vol. 7, p. 251. See also Gerhard Bauer, '*Geschichtlichkeit*': *Wege und Irrwege eines Begriffs*, Berlin, 1963.

8. See Hans-Georg Gadamer, *Wahrheit und Methode: Grundzüge einer philosophischen Hermeneutik*, Tübingen, 1965.

9. See Harold Bloom, Paul de Man, Jacques Derrida, Geoffrey Hartman and J. Hillis Miller, *Deconstruction and Criticism*, New York, 1979. For further bibliography and criticism see also M. H. Abrams, *A Glossary of Literary Terms*, 4th edn, New York, 1981.

10. Norbert W. Bolz, '"Odds and Ends": Vom Menschen zum Mythos' in *Mythos und Moderne: Begriff und Bild einer Rekonstruktion*, ed. Karl Heinz Bohrer, Stuttgart, 1982.

11. M. H. Abrams, 'Literary Criticism in America: Some New Directions' in *Theories of Criticism*, ed. M. H. Abrams and Jessie Ackerman, Occasional Papers of the Council of Scholars of the Library of Congress, no. 2, Washington, D.C., 1984.

12. Karl Popper, *Conjectures and Refutations: The Growth of Scientific Knowledge*, London, 1963; *Objective Knowledge: An Evolutionary Approach*, Oxford, 1972; and *Unended Quest: An Intellectual Autobiography*, London, 1976. For the problem area of this essay see his *The Poverty of Historicism*. For bibliographies see *The Philosophy of Karl Popper*, ed. P. A. Schilpp, La Salle, Ill., 1974, and *A Pocket Popper*, ed. David Miller, London, 1983.

13. See Peter Winch, 'Understanding a Primitive Society' in *American Philosophical Quarterly 1*, 1964, pp. 307–24; reprinted in *Rationality*, ed. B. R. Wilson, Oxford, 1970, where other contributions to this debate can be found. See also *Rationality and Relativism*, ed. Martin Hollis and Steven Lukes, Oxford, 1982.

14. Irenäus Eibl-Eibesfeldt, *Die Biologie des Menschlichen Verhaltens: Grundriss der Humanethologie*, Munich, 1984.

15. See my 'Art and Scholarship' in *Meditations on a Hobby Horse*, London, 1963.

16. Wilhelm Worringer, *Der Geist der Gotik*, Munich, 1910, pp. 10, 50.

17. It was M. H. Pirenne, the author of *Optics, Painting, and Photography*, Cambridge, 1970. See also my *Art and Illusion*, London and New York, 1960.

18. Karl Popper, 'The Myth of the Framework' in *The Abdication of Philosophy and the Public Good: Essays in Honour of P. A. Schilpp*, ed. Eugene Freeman, La Salle, Ill., 1976.

19. Erich Auerbach, *Mimesis: Dargestellte Wirklichkeit in der abendländischen Literatur*, Bern, 1970; in English, *Mimesis: The Representation of Reality in Western Literature*, trans. Willard R. Trask, Princeton, N.J., 1953.

20. See E. D. Hirsch, Jr, *The Aims of Interpretation*, Chicago, 1976, esp. p. 32.

21. *The Literary Works of Leonardo da Vinci*, ed. J. P. Richter, 2 vols, Oxford, 1939, Vol. 1; p. 385.

22. See Heinz Hartmann, Ernst Kris, and Rudolph M. Loewenstein, 'Some Psychoanalytic Comments on "Culture and Personality"' in *Psychological Issues 4*, no. 2, 1964, pp. 86–116.

23. Uns ist ganz kannibalisch wohl
Als wie fünfhundert Säuen.
Goethe, *Faust 1, Sämtliche Werke*, Vol. 13; pp. 66, 94.

24. Zufrieden jauchzet gross und klein
Hier bin ich Mensch, hier darf ich's sein.
Goethe, 'Vor dem Thor' in *Faust 1, Sämtliche Werke*, Vol. 13; p. 40.

25. Deine Zauber binden wieder,
Was die Mode streng geteilt,
Alle Menschen werden Brüder,
Wo dein sanfter Flügel weilt.
Friedrich Schiller, *An die Freude*.

26. See Justin Stagl, *Kulturanthropologie und Gesellschaft*, Munich, 1974, p. 120.

27. See my *The Sense of Order*, Oxford, 1979.

28. See the section subtitled 'Technology and tradition', pp. 67-70 below, in my essay 'Approaches to the History of Art'.

29. For these problems see also my articles 'Visual Metaphors of Value in Art', 'Expression and Communication', and 'The Cartoonist's Armoury' in *Meditations on a Hobby Horse*, as well as 'Verbal Wit as a Paradigm of Art: The Aesthetic Theories of Sigmund Freud (1856–1939)' in *Tributes*, Oxford, 1984, pp. 93–115.

30. See L. E. Marks, *The Unity of the Senses: Interrelations among the Modalities*, London, 1978, and C. E. Osgood, 'The Cross-Cultural Generality of Visual-Verbal Synaesthetic Tendencies' in *Behavioural Science*, 5, 1960.

31. See also Note 7 of the section subtitled 'The problem of explanation', pp. 62-7 below, in 'Approaches to the History of Art'.

32. Seid mir tausendmal willkommen,
Ihr mein Trost und Sonnenschein!
Ach, was Segen, Heil und Frommen
Kömmt mit euch, mein Licht, herein!
Welch ein Glanz bricht durch mein Haus
Jetzt mit güldnen Strahlen aus!

Alles beut euch dar die Hände,
Nichts bei mir ist so erstarrt,
Das nicht lächle; ja die Wände
Merken eure Gegenwart,
Eure, die ihr sie in Gold
Bald hernach verkehren sollt.
Simon Dach, *Gedichte*, ed. Walther Ziesemer, 4 vols,

Halle, 1936–8, Vol. 1, no. 49; with commentary. I
have here modernized the spelling.

33. On the legitimate role of the imagination in the
humanities, see also my address to the American
Academy of Arts and Sciences, 'Focus on the Arts
and Humanities' in *Tributes*, Oxford, 1984, pp.
11–27.

RELATIVISM IN THE HISTORY OF IDEAS

1. See my memoir of George Boas in *Tributes*, Oxford, 1984.
2. When I gave the lecture 'Focus on the Humanities' printed in *Tributes*, op. cit., Professor Kuhn subsequently criticized my statement that he did not believe in progress, and I added a footnote to this effect. In a series of lectures at University College, London, entitled 'The Presence of Past Science' (November 1987), Professor Kuhn questioned the usefulness of the term 'relativism', but reasserted his belief in the progress of science.
3. See my rejoinder to M. Krieger in *Critical Inquiry*, December 1984, Vol.II, No. 2, under the title 'Representation and Misrepresentation'.
4. For the influence of optimistic ideologies on the progress of science see e.g. K. R. Popper, 'On the Sources of Knowledge and of Ignorance', in *Conjectures and Refutations*, London, 1963, pp. 7ff. For a tragic instance of the impeding of progress see O. Kurz, *European Clocks and Watches*, London, 1975, pp. 49–51, on the destruction of the observatory built by Taqi ad-Din in sixteenth-century Constantinople.
5. See K. H. Veltman, 'Literature on Perspective. A select bibliography: 1971–84' in *Marburger Jahrbuch für Kunstwissenschaft*, 21, 1986, and also my contribution to the Catalogue of the Exhibition *Space in European Art*, Tokyo, 1987; reprinted in *Storia dell'arte*, 62, 1988, pp. 5–12.
6. The first mention appears to be a sermon by Fra Giordano da Pisa in 1306. See E. Rosen, 'The Invention of Eyeglasses' in *Journal of the History of*

Medicine and Allied Sciences, 1956.
7. See my *Symbolic Images*, London, 1972.
8. University of California Press, 1983.
9. *The Poverty of Historicism*, London, 1957, p. 149.
10. *Aby Warburg. An Intellectual Biography*, London, 1970.
11. Op. cit., p. 303.
12. See the previous essay in this volume.
13. *Aby Warburg*, op. cit., p. 194.
14. See my lecture 'Il gusto dei primitivi', *Memorie dell'Istituto Italiano per gli Studi Filosofici*, 11, Naples, 1985.
15. London, 1975.
16. See R. Gilman, 'The Mad Man as Artist: Medicine, History and Degenerate Art' in *Journal of Contemporary History*, 20, 1985, pp. 575–97; and Daniel Pick, *Faces of Degeneration, a European Disorder*, Cambridge, 1989.
17. H. Kalmus, *Genetics*, Harmondsworth, Middlesex, 1948, p. 160.
18. 'è cierto se tale negromanzia fusse in essere, come dalli bassi ingiegni e creduto, nessuna cosa e sopra la terra che al danno e servitio dell'omo fusse di tanta valitudine, perchè se fusse vero che in tale arte si avesse potentia di far turbare la tranquilla serenità dell'aria... qual battaglia marittima può essere che con tanto danno possa offendere il suo nemico?' See my 'Leonardo and the Magicians', in *New Light on Old Masters*, Oxford, 1986, p. 68.
19. See the end of Chapter I of *Tributes*, op. cit., and my lecture on 'Art History and the Social Sciences', in *Ideals and Idols*, Oxford, 1979.

RELATIVISM IN THE APPRECIATION OF ART

1. I have used the German translation from the Chinese original in Hans O. H. Strange, *Tschuang-Tse, Dichtung und Weisheit*, Insel Verlag, Leipzig, n.d.
2. I got to know this poem through the composer Lee-wei-ning, who set it to music. I am greatly indebted to Mr Glen Dudbridge of Oxford University, who located and translated it for me from *Po Chu-i chi* (Collected Works of Po Chü-i), Peking, 1979, ch. 36, p. 828. I may have gone a little far in attributing to the Chinese poet the philosophical views of Karl

Popper.
3. *De Rembrandt à Vermeer. Les peintres hollandais au Mauritshuis de La Haye*, 19 February – 30 June 1986, Galeries nationales du Grand Palais, Paris. Catalogue by Ben Broos, No. 10 (Inv. no. 1056).
4. Paul Valéry, *Tel Quel*, Paris, 1941.
5. Francis Haskell and Nicholas Penny, *Taste and the Antique*, Yale University Press, New Haven and London, No. 71, pp. 288–91.
6. I quote from the edition of 1912, pp. viii and 125.

APPROACHES TO THE HISTORY OF ART

1. K. R. Popper, *The Poverty of Historicism*, London, 1959, IV, 28.
2. Vasari, *Le Vite*, ed. Milanesi, XI, p. 93.
3. See my 'Art History and the Social Sciences' in *Ideals and Idols*, Oxford, 1979, pp. 131–66.
4. B. Berenson, *The Venetian Painters of the Renaissance*, New York, 1899.
5. Alois Riegl, *Die Spätrömische Kunstindustrie*, Vienna, 1901; *Gesammelte Aufsätze*, Vienna, 1929. For the

following see also my contribution to the XXV International Congress for the History of Art held in Vienna, published in English as 'Art History and Psychology in Vienna Fifty Years Ago', *Art Journal*, Summer 1984, pp. 162–4.
6. *Art and Illusion*, New York and London, 1960.
7. Cicero, *De oratore III*, 98. 'For it is hard to say why exactly it is that the things which most strongly gratify our senses and excite them most vigorously at

their first appearance are the ones from which we are most speedily estranged by a feeling of disgust and satiety. How much more brilliant, as a rule, in beauty and variety of colouring are the contents of new pictures than those of old ones! and nevertheless the new ones, though they captivated us at first sight, later on fail to give us pleasure – although it is also true that in the case of old pictures the actual roughness and old-fashioned style are an attraction. In singing, how much more delightful and charming are trills and flourishes than notes firmly held! and yet the former meet with protest not only from persons of severe taste but, if used too often, even from the general public. This may be observed in the case of the rest of the senses – that perfumes compounded with an extremely sweet and penetrating scent do not give us pleasure for so long as those that are moderately fragrant, and a thing that seems to have the scent of earth is more esteemed than one that suggests saffron; and that in touch itself there are degrees of softness and smoothness. Taste is the most voluptuous of all the senses and more sensitive to sweetness than the rest, yet how quickly even it dislikes and rejects anything extremely sweet! who can go on taking a sweet drink or food for a long time? whereas in both classes things that pleasurably affect the sense in a moderate degree most easily escape causing satiety. Thus in all things the greatest pleasures are only narrowly separated from disgust.' Translated by H. Rackham, Loeb's Classical Library, Cambridge, Mass., 1961.

8. 'The Logic of Vanity Fair: Alternative to Historicism in the Study of Fashions, Style and Taste' in *Ideals and Idols*, op. cit., pp. 60–92.
9. K. R. Popper, *The Open Society and its Enemies*, London, 1966, II.
10. Pliny, *Historia Naturalis*, XXXV, pp. 56–8.
11. See my *Heritage of Apelles*, Oxford, 1976.
12. 'Leonardo on the Science of Painting' in *New Light on Old Masters*, Oxford, 1986.
13. I Kings 5; 2 Chronicles 2, 13.
14. Vasari, *Le Vite*, ed. Milanesi, II, p. 413.
15. Vasari, *Le Vite*, ed. Milanesi, III, pp. 567–8. I have discussed both passages in 'The Leaven of Criticism in Renaissance Art' in *The Heritage of Apelles*, op. cit., pp. 111–31.
16. Dürer's letter to Pirkheimer of 7 February 1506 in K. Lange and E. Fuhse, *Dürer's schriftlicher Nachlass*, Halle, 1893, p. 22.
17. In *Ideals and Idols*, op. cit., pp. 131–66.
18. Loc. cit., Note 3.
19. J. H. Huizinga, *Dutch Civilization in the Seventeenth Century and other essays*, London, 1968, pp. 97ff., and my 'Reynolds Lecture', *Styles of Art and Styles of Life*, London, 1991.
20. 'Over een Definitie van het begrip Geschiedenis' (1929) in J. Huizinga, *Verzamelde Werken*, VII, Haarlem, 1950, pp. 95–103. I know of no English translation of this important essay. For a German version see J. Huizinga, *Wege der Kulturgeschichte*, Munich, 1930, pp. 78–88.

THE CONSERVATION OF OUR CITIES

1. The quotations from Ruskin are taken from the edition of his collected writings, *The Works of John Ruskin*, eds. E. T. Cook and A. Wedderburn, 39 vols, London and New York, 1903–12, in particular Vol. VIII, pp. 245, 246–7, 242, 243, 244–5 and 15; and Vol. XII, pp. 429, 431 and 428.
2. Organized by the International Council of Monuments and Sites.
3. The ceremonies at Ise are described by Yasuta da Watanabe in *Shinto Art: Ise and Izumo Shrines*, New York and Tokyo, 1974.
4. For the attitude to the ruins of Rome see, for example, Erna Mandowsky and Charles Mitchell, *Piero Ligorio's Roman Antiquities*, London, 1963.
5. For the satire *Simia* against Bramante see Ludwig Pastor, *Geschichte der Päpste im Zeitalter der Renaissance*, Vol. III, 2, p. 921.
6. Prächtiger als wir in unserem Norden
Wohnt der Bettler an der Engelspforten,
Denn er sieht das ewig einz'ge Rom!
Ihn umgiebt der Schönheit Glanzgewimmel,
Und ein zweiter Himmel in den Himmel
Steigt Sankt Peters wunderbarer Dom.
An die Freunde, 1802
7. Wir, wir leben: Unser sind die Stunden,
Und der Lebende hat Recht.
8. See also my lecture 'The beauty of old towns' in *Reflections on the History of Art*, ed. R. Woodfield, Oxford, 1987, pp. 195–204.
9. Liut unde lant, da ich von kinde bin erzogen,
die sint mir frömde worden, recht als ez sie gelogen.
Die mine gespilen waren, die sint traege unt alt:

vereitet ist daz velt, verhouwen ist der walt.
Wan daz daz wazzer fliuzet als ez wilent floz,
Für war ich wande min unglücke wurde groz.
10. Charles Burney, *The Present State of Music in Germany* (London, 1775), ed. Percy A. Scholes, Oxford, 1959, p. 196.
11. Translated into German by Victor Klarwill (Rikola, 1921), on which my English translation is based.
12. For the statutory protection of historic buildings see, above all, Stephen Tschudi Madsen, *Restoration and Anti-Restoration*, Oslo, 1976, a book to which I owe a great deal. A good general account is given in the article 'Monument' in the 13th edition of the Encyclopedia Brittanica, 1927. See also Friedrich Mielke, *Die Zukunft der Vergangenheit* (with detailed bibliography), Stuttgart, 1975; François Berce, *Les premiers travaux de la commission des monuments historiques*, Paris, 1979; Ludwig Schweiner, *Karl Friedrich Schinkel und die erste Westfaelische Denkmäler-Inventarisation*, Recklinghausen, 1968; Herbert R. Lottman, *How Cities are Saved*, New York, 1976. Authoritative on development in Britain is N. Bolting, 'The Law's Delay: Conservation Legislation in the British Isles' in Jane Fawcett, *The Future of the Past*, London, 1976. The Civic Trust also produces a number of useful booklets.
13. Leicht beieinander wohnen die Gedanken,
Doch hart im Raume stossen sich die Sachen.
Wallensteins Tod, II, 2.
14. See Adolf Ciborowski, *Warsaw, a City Destroyed and Rebuilt*, Polonia Publishing House, c.1963.

WATCHING ARTISTS AT WORK

1. Princeton and London, 1960.
2. W. A. Berry, *Drawing the Human Form*, New York, 1977.
3. For the history of the psychological study of children's drawings see George Boas, 'The Cult of Childhood' in *Studies of the Warburg Institute*, London, 1966, pp. 79 ff. The best access to the later psychological literature is offered by Rudolf Arnheim, *Art and Visual Perception*, London, 1956; see also Peter van Sommers, *Drawing and Cognition, Descriptive and Experimental Studies of Graphic Production Processes*, Cambridge, 1984.
4. Here I am thinking less of the relation between handwriting and character (graphology in the usual sense), but rather of the study of graphic processes, a line of research of which I owe my knowledge to Professor Colette Sirat. The special issue of the journal *Bibliologia* (No. 10, Brepols-Turnhout, 1990) devoted to the subject, *L'Ecriture: Le cerveau, l'oeil et la main*, edited by Colette Sirat, Jean Irigoin and Emmanuel Poulle, provides the best point of entry into this area of research.
5. In his Life of Titian, see *Le Vite*, ed. G. Milanesi, Milan, 1881. I have quoted the passage verbatim in *The Image and the Eye*, Oxford, 1982, p. 227.
6. 'Leonardo's Method for Working out Composi-

tions' in *Norm and Form*, Oxford, 1966, pp. 58–63. For the passage quoted see A. P. McMahon, *Leonardo da Vinci, Treatise on Painting*, Princeton, 1956, No. 261.
7. McMahon, ed. cit., No. 76.
8. McMahon, ed. cit., No. 64.
9. Michelangelo, *Le Rime*, ed. E. N. Girard, Bari, 1960. The translation in the text is mine.
10. Vasari, *Le Vite*, op. cit., VII, p. 270.
11. Bernhard Degenhart, 'Zur Graphologie der Handzeichnung' in *Kunstgeschichtliches Jahrbuch der Biblioteca Hertziana in Rome*, I, 1937.
12. Vasari, op. cit.
13. Ludwig Goldscheider, *Michelangelo Drawings* (London, 1951), agrees with an interesting suggestion by Fritz Baumgart that the artist here drew after a lay-figure. However, the character of the line seems to me to speak against this assumption. In contrast to these and other authors who dated this drawing around 1520, Michael Hirst in his *Michelangelo Draftsman* (Milan, 1988) proposes a date around 1506.
14. Jean Gigoux, *Causeries sur les artistes de mon temps*, Paris, 1885, pp. 81–2.
15. London, 1964.

PLATO IN MODERN DRESS

1. The designer Rudolf Wilke (1873–1909) was a frequent contributor to *Jugend* and *Simplicissimus*. A brief obituary by Ludwig Thoma is to be found in Eugen Roth, *Simplicissimus*, Hanover, 1954.
2. *Thought-Forms*, London and Benares, 1905. See also Sixten Ringbom, *The Sounding Cosmos*, Abo, 1970. For a full documentation of these trends underlying the evolution of abstract art see Maurice Tuchman, ed., *The Spiritual in Art, Abstract Painting, 1890–1985*, the catalogue of an exhibition initiated at the Los Angeles County Museum of Art, 1986, with many contributions by various authors.
3. Luigi Carluccio, *The Sacred and Profane in Symbolist Art*, Toronto, 1969, No. 115.
4. Sven Lövgren, *The Genesis of Modernism (Figura 11)*, Stockholm, 1959.
5. Henderik Roelof Rookmaaker, *Synthetist Art Theories*, Amsterdam, 1959, p. 158.
6. See my *Symbolic Images*, London, 1972, pp. 150–1.
7. *Paul Cézanne, Correspondance*, ed. J. Rewald, Paris, 1937. The translation in the text is mine.
8. For a recent survey with full bibliography see Mark Roskill, *The Interpretation of Cubism*, Philadelphia, 1984.
9. Many of these texts are now easily available in Edward F. Fry, *Cubism*, London, 1966.
10. *The New Age*, 23 November 1911; Roskill, op.cit., p. 53.
11. Strasbourg, 1893. Published in English as *The Problem of Form in Painting and Sculpture*, trs. by M. Meyer and R. O. Ogden, New York, 1937 (Garland Reprint, New York, 1978).
12. Loc. cit., p. 10. The translation in the text is my own.
13. I did not know at the time that Kahnweiler had criticized Hildebrand's theories extensively in an article in the review *Feuer*, No. 2–3, Weimar, November–December 1919, now available in

French in his *Confessions esthétiques*, Paris, 1963, pp. 84–102.
14. Sehr verehrter Herr Professor
Ich lese mit Interesse Ihren Brief vom 31. Hier die Antwort auf Ihre Fragen.
1) Ich kannte das Buch von Hildebrand 'Das Problem der Form' damals nicht. Ich habe es erst in Bern während des ersten Krieges gelesen.
2) Ich habe nicht den Eindruck, dass Uhde es kannte. Er war ja kein zünftiger Kunsthistoriker. Dass Apollinaire, Salmon u.s.w. nicht einmal den Namen von Hildebrand kannten, ist sicher.
3) Nein, diese Probleme wurden von den Künstlern nicht diskutiert.
Ich glaube Ihnen sagen zu müssen, sehr verehrter Herr Professor, dass Sie sich von der Lage damals ein falsches Bild machen. Es hat sich nie um Diskussionen von Problemen gehandelt. Die Nachläufer diskutierten wohl unter sich mit lächerlichen Schlagworten wie 'vierte Dimension', 'Die Welt ist eine Spirale' u.s.w. Aber die wirklich schaffenden Künstler arbeiteten, malten und gaben wohl *nachher* kurz Aufschluss über die Beweggründe ihrer Arbeit: das ist alles. Die Idee von Diskussionen mit Uhde ist völlig abwegig. Die Maler allein haben den Kubismus geschaffen. Sie hatten absolut keine Belesenheit sie kannten weder Kunstphilosophie noch andere theoretische Schriften über Kunst. Mathematik natürlich auch nicht. Der gute Princet war, wie ich es oft geschrieben habe, Aktuar einer Versicherungsgesellschaft und die Bezeichnung als 'Mathématicien' war einfach ein Witz in unserem Kreise. Das ich noch hinzufügen, dass meines Erachtens, die Probleme, die Hildebrand behandelt Nahund Fernbild u.s.w. nichts mit dem Problem des Kubismus zu tun haben. Ich stehe gern zu Ihrer Verfügung, wenn Sie mir noch andre Fragen zu stellen haben.
Mit verbindlichsten Grüssen

Ihr sehr ergebener
(signed) Daniel-Henry Kahnweiler. Bitte wenden.
PS: Sind Ihrer Meinung nach die Gedanken Hilde-
brands dem Kubismus nahe? Mir scheint eher das
Gegenteil. 'Das Quälende des Kubischen': die
Kubisten fühlten das absolut nicht quälend.

15. Leo Stein, *Appreciation, Painting, Poetry and Prose*,
pp. 140–1 of the paperback edition, Random House,
New York. I have not found this passage quoted in
any of the works on Cubism or on Picasso which I
consulted.

16. *Daniel-Henry Kahnweiler, marchand, éditeur, écrivain*,
ed. Dominique Bozo, Centre Georges Pompidou,
22 November 1984–28 January 1985, p. 34.

17. Munich, 1920.

18. *Confessions*, Paris, 1963, p. 211.

19. Ibid., p. 212.

20. Fry, op. cit., p. 38, note 9.

21. T. H. Gibbons, 'The "Fourth Dimension" in the
Context of the late Nineteenth Century and early
Twentieth Century Ideas of Occult Idealism',
Journal of the Warburg and Courtauld Institutes,
XLIV, 1981.

22. *Confessions*, p. 170; see also D. H. Kahnweiler, *Juan
Gris*, Paris, 1946, VII, n. 2.

23. *Confessions*, Introduction.

24. Ibid., p. 118, for Hegelian terminology.

25. See my essay 'The Father of Art History' in *Tributes*,
Oxford, 1984, pp. 51–69.

26. The most detailed exposition of this view is in Kahn-
weiler, *Juan Gris*, I, *Aesthetica in Nuce*. The following
references are not intended to be exhaustive, merely
to enable the reader to find some further formula-
tions in Kahnweiler's *Confessions*: pp. 119, 122, 147,
193, 197, 219, 228, 232.

27. *Juan Gris*, II, *Historia in Nuce*, and *Confessions*, pp.
109, 111, 127, 204, 219.

28. *Juan Gris*, I, and *Confessions*, pp. 114, 120, 150, 204,
219.

29. See the end of *Juan Gris*, I, and *Confessions*, p. 152.

30. *Confessions*, p. 120. It is sufficient to recall Goethe's
interest in coloured shadows to refute this often
repeated view. See also my essay 'Visual Discovery
through Art' in *The Image and the Eye*, Oxford, 1982,
in which I have tried to put these matters in perspec-
tive.

31. *Confessions*, pp. 149-50.

32. J. M. Nash in his perceptive article 'The Nature of
Cubism' in *Art History*, III, No. 4, December 1980,
pp. 435–7, connects this creed with the vogue of
Nietzsche's *Will to Power*, which is not, however,
mentioned by Kahnweiler. It was surely from Hegel
that Kahnweiler derived his conviction of the 'logical
necessity' governing every step in the evolution of
art, a conviction that made him eager to document
the exact date of every painting as a guide to its
understanding. See the essay by Werner Spies, pp.
17-44 of the catalogue cited above in note 16 .

33. Erwin Panofsky, *Idea, A Concept in Art Theory*, trans-
lated by Joseph J. S. Peake, Columbia, South Car-
olina, 1968, pp. 110–11.

34. Walter Hess, *Dokumente zum Verständnis der moder-
nen Malerei*, Hamburg 1956, p. 79.

35. Robert P. Welsh, 'Mondrian and Theosophy', in
Piet Mondrian, Centennial Exhibition, The Solomon
R. Guggenheim Museum, New York, 1971, pp.
35–62.

36. D. P. Walker, *The Ancient Theology, Studies in Chris-
tian Platonism from the Fifteenth to the Eighteenth Cen-
tury*, London, 1972.

37. I have criticized the implications of this view in my
essay 'Relativism in the Humanities: The Debate
about Human Nature'; see this volume pp. 36-46. I
returned to the critique of Panofsky's book in a con-
tribution to a conference on the notion of *Idea* orga-
nized by the Lessico Intellettuale Europeo in Rome
in January 1989 (ed. M. Fattori and M. L. Bianchi),
pp. 411-20.

KOKOSCHKA IN HIS TIME

1. Oskar Kokoschka, *Mein Leben*, Munich, 1971
(translated as *My Life*, London, 1974), p. 40.

2. Ibid., p. 63.

3. *Oskar Kokoschka 1886–1980*, Tate Gallery, London,
June–August 1986. Introduction and catalogue by
Richard Calvocoressi.

4. Adolf Loos, *Sämtliche Schriften*, ed. Franz Glück,
Vienna and Munich, 1962.

5. Ibid., pp. 302–3.

6. Ibid., p. 317.

7. Ibid., p. 323.

8. Ibid., p. 397.

9. Letter to Oskar Meyboden, 31 October 1920, *Oskar
Kokoschka Briefe II, 1919–1934*, ed. Olda Kokoschka
and Heinz Spielmann, Düsseldorf, 1985, p. 17.

10. *Karl Kraus*, Vienna, 1968, pp. 166–7.

11. *Der Mann ohne Eigenschaften* (1930–2), translated by
E. Wilkins and E. Kaiser as *The Man Without Quali-
ties*, London, 1953–60.

12. *Zola's Salons*, ed. F. W. Hemming and R. Niess,
Geneva, 1959, pp. 60–2.

13. Leo N. Tolstoy, *What is Art?* (translated by Aylmer
Maude), New York, 1960. The passages referred to
are on p. 51 and p. 175 of that edition.

14. Letter to Leon Kellner, 31 December 1906, *Oskar
Kokoschka Briefe I, 1905–1919*, ed. Olda Kokoschka
and Heinz Spielmann, Düsseldorf, 1984, p. 6.

15. Ludwig Hevesi, *Altkunst-Neukunst, Wien
1894-1908*, Vienna, 1909, pp. 449–54 (26 April
1902).

16. See the exhibition catalogue *Franz Cizek, Pionier der
Kunsterziehung* (1865–1946), Historisches Museum
der Stadt Wien, Vienna, 1985. In an essay of 1946
Kokoschka refers to Cizek as 'Mein alter Lehrer'
(my old teacher): 'Bild, Sprache und Schrift', *Oskar
Kokoschka: Vorträge, Aufsätze, Essays zur Kunst. Das
schriftliche Werk III*, ed. Heinz Spielmann, Ham-
burg, 1975, p. 29.

17. Hevesi, op. cit., pp. 454–7 (13 January 1903).

18. Ibid., p. 313.

19. Ibid., pp. 221–7 (26 November 1905).

20. *Mein Leben*, op. cit., p. 56.

21. *Vienne 1880–1938: L'Apocalypse Joyeuse*, Centre
national d'art et de culture Georges Pompidou,
Paris, February–March 1986.

22. Letter to Berta Patocka-Kokoschka, 16 December
1916, *Briefe I*, op. cit., p. 258.

23. *Kokoschka*, Tate Gallery (Arts Council), London,
1962, pp. 10–15, reprinted in *Oskar Kokoschka*,
Marlborough–Gerson Gallery, New York, 1966, pp.
7–9.

24. 'Art Revival in Austria', a special number of *The
Studio*, 1906.

25. Edith Hoffmann, *Kokoschka, Life and Work*,

London, 1947, p. 95. Lotte Franzos (1881–1957) may have been one of the first women to wear her hair cut short in the 'Reform' style.

26. Letter to Herwarth Walden, May/June 1911, *Briefe I*, op. cit., p. 20.

27. I quote from the Reclam edition, ed. K. Hildebrandt, p. 86.

28. I quote from *Manifeste Manifeste 1905–1933. Schriften deutscher Künstler des zwanzigsten Jahrhunderts*, I, ed. Diether Schmidt, Dresden, 1964, pp. 162–76. The passages cited are on pp. 166–8 and 173. The manifesto is reprinted under its original subtitle 'Vorrede zum "Orbis Pictus"' (Preface to *Orbis Pictus*), in order to distinguish it from a lecture of 1912 and an essay of 1917, both entitled 'Vom Bewusstsein der Gesichte' (On the Awareness of Visions), in Volume IV of Kokoschka's collected writings (Hamburg, 1976, pp. 9–29).

29. 9 March 1919, *Briefe I*, op. cit., p. 310.

30. Hans Tietze, *Lebendige Kunstwissenschaft*, Vienna, 1925, p. 27.

31. See especially William Feaver, 'Kokoschka: Up to his elbows in paint' in *The Observer*, 15 June 1986, p. 21; Waldemar Januszczak, 'The art at the end of Oskar's anger' in *The Guardian*, 11 June 1986, p. 9; and 'Chief savage: Andrew Graham-Dixon on the Kokoschka retrospective' in *Harpers and Queen*, June 1986, p. 228.

32. Letter to Alice Lahmann, 23 April 1925, *Briefe II*,

op. cit., p. 111.

33. Conrad Fiedler, *Schriften über Kunst*, Cologne, 1977, p. 214.

34. The explicit statement by Kahnweiler about his theory is to be found in his *Juan Gris. His Life and Work*, London, 1969, in the chapter 'Aesthetica in Nuce' (pp. 63–86). See also his *Confessions esthétiques*, Paris, 1963.

35. See my essay 'Plato in Modern Dress: Two Eyewitness Accounts of the Origins of Cubism' in this volume, pp. 131–41.

36. For other writings on Kokoschka by the author see : *Oskar Kokoschka*, Tate Gallery (Arts Council), London, 1962; *Kokoschka, Prints and Drawings* lent by Reinhold, Count Bethusy-Huc, Bethnal Green Museum (Victoria and Albert Museum), London, 1971; *Homage to Kokoschka*, Prints and Drawings lent by Reinhold, Count Bethusy-Huc, Victoria and Albert Museum, London, 1976; 'Gedenkworte für Oskar Kokoschka', *Orden pour le mérite für Wissenschaften und Künste, Reden und Gedenkworte*, XVI, 1980; *Orbis Pictus. The Prints of Oskar Kokoschka 1906–1976*, Santa Barbara Museum of Art, 1987; *Oscar Kokoschka*, Marlborough Fine Art Gallery, London, 1990. See also *The Story of Art*, Oxford, 1989, pp. 450–1, and 'The Mask and the Face: The Perception of Physiognomic Likeness in Life and in Art' in *The Image and the Eye*, Oxford, 1982, pp. 133–4.

IMAGE AND WORD IN TWENTIETH-CENTURY ART

1. This paper was originally given at the Solomon R. Guggenheim Museum in New York in October 1980 as the first of the annual Hilla Rebay lectures intended to examine 'significant problems in the theory, history and criticism of the visual arts in the twentieth century'. The theme I selected for this purpose, that of the titles of works of art, seemed to me at that time unduly neglected. The only relevant literature I found was a catalogue of the exhibition *Schrift und Bild* at the Stedelijk Museum in Amsterdam (1963) by Dietrich Mahlow; as often happens, others had also noticed the lacuna and there are now more discussions of the topic, the most recent to come to my knowledge being John Fisher's 'Entitling' in *Critical Inquiry*, II, 1984, pp. 286–98. To refer to them all in the text, however, would have destroyed the character of a piece specifically written for the occasion. I should like to thank Alice Leslie for her help in preparing the paper for publication.

2. Aelian, *Varia Historia*, X, 10; see J. Overbeck, *Die Antiken Schriftquellen*, Leipzig, 1868, p. 67.

3. *Academy Notes*, ed. Henry Blackburn, London, 1877, p. 62.

4. Angelica Zander Rudenstine, *The Guggenheim Museum Collection: Paintings 1880–1945*, 2 vols, New York, The Solomon R. Guggenheim Foundation, 1976.

5. Rudenstine, Vol. 2, pp. 519–20.

6. Rudenstine, Vol. 1, p. 61.

7. Rudenstine, Vol. 1, p. 51.

8. Rudenstine, Vol. 1, p. 158.

9. M. Foucault, *Ceci n'est pas une pipe*, Montpellier, 1973.

10. New York and London, 1960.

11. Bob Reisner and Hal Kapplow, *Captions Courageous: or comments from the gallery*, London and New York,

1959, p. 11; or *Das frivole Museum*, Frankfurt am Main, 1961: 'Das zweite Programm ist da auch nicht besser' (no page numbers).

12. 'Nella descrizione pittorica dei diversi stati d'animo plastici di una partenza, certe linee perpendicolari, ondulate e come spossate, qua e là attaccate a forme di corpi vuoti, possono facilmente esprimere il languore e lo scoraggimento.' Umberto Boccioni, Preface to the catalogue of the Exhibition of Futurist Painting, February 1912. Reprinted in *Umberto Boccioni: Gli scritti editi e inediti*, ed. Zeno Birolli, Milan, 1971, p. 20.

13. Reinhard Krauss, 'Über den graphischen Ausdruck' in *Beihefte zur Zeitschrift für angewandte Psychologie*, 48, Leipzig, 1930.

14. Annie Besant and C. W. Leadbeater, *Thought-Forms*, London and Benares, 1905.

15. Sixten Ringbom, 'Art in "the epoch of the great spiritual": Occult elements in the early theory of abstract painting' in *Journal of the Warburg and Courtauld Institutes*, 29, 1966, pp. 386–418; and *The Sounding Cosmos; A study in the spiritualism of Kandinsky and the genesis of abstract painting*, Abo, 1970.

16. Franz Marc, letter to August Macke, December 1910, *August Macke–Franz Marc Briefwechsel*, Cologne, 1964, p. 28. Quoted in Rudenstine, Vol. 2, p. 493.

17. See my *Symbolic Images, Studies in the Art of the Renaissance, II*, London, 1972.

18. Klee writes that 'the rhythm of failure with a 500 year periodicity is a sublimely comical notion' (20 March 1905). Paul Klee, *Tagebücher*, ed. Felix Klee, Cologne, 1957.

19. Christian Morgenstern, *Galgenlieder*, Berlin, 1905; *Palmström*, Berlin, 1910.

20. Paul Klee, *Tagebücher*, op. cit., p. 251: 'Mit Morgensterns Galgenliedern sei das Jahr [1909]

beschlossen.'
21. Christian Morgenstern, *Galgenlieder*, op. cit., p. 1:
Laß die Moleküle rasen,
was sie auch zusammenknobeln!
Laß das Tüfteln, laß das Hobeln,
heilig halte die Ekstasen.
22. Paul Klee, *Über die Moderne Kunst*, Bern, 1945, pp. 31–3.
23. *Paul Klee Notebooks*, Vol. 1, *The Thinking Eye*, ed. Jürg Spiller, London, 1961, p. 76. (From Paul Klee, 'Schöpferische Konfession', first published in *Tribüne der Kunst und Zeit*, XIII, Berlin, 1920, pp. 28–40.)
24. Odilon Redon, *La Vie*, Paris, 30 November 1912,

quoted by Virginia Spate, *Orphism: the evolution of non-figurative painting in Paris 1910–1914*, Oxford Studies in the History of Art and Architecture, Oxford, 1979, p. 364, n. 85.
25. Ich kenn' es wohl, so klingt das ganze Buch;
Ich habe manche Zeit damit verloren,
Denn ein vollkommner Widerspruch
Bleibt gleich geheimnisvoll für Kluge wie für Toren.
26. Published in *391*, no. 12, March 1920, Paris.
27. Spate, op. cit., pp. 381–2.
28. Spate, op. cit., p. 332.
29. Harold Rosenberg, *Barnett Newman 1905–1970*, New York, 1978, p. 51.
30. See the following essay in this volume.

THE WIT OF SAUL STEINBERG

1. Harold Rosenberg, *Saul Steinberg*, New York and London, 1978, p. 19.
2. See my essay 'Image and Word in Twentieth-Century Art' in this volume, especially p.173.

3. Rosenberg, op. cit., p. 22.
4. Rosenberg, op. cit., pp. 70, 172–3.
5. Rosenberg, op. cit., pp. 214-28.

A MASTER OF POSTER DESIGN

1. *The Image and the Eye*, Oxford, 1982, pp. 287–91.

THE PHOTOGRAPHER AS ARTIST

1. Most of the photographs mentioned but not illustrated in the text can be found in *The World of*

Cartier-Bresson, London, 1968.
2. Shown during the 1978 Edinburgh Festival.

SOURCES OF PHOTOGRAPHS

Gemeentelijke Archiefdient, Amsterdam: 12; Rijksmuseum-Stichting, Amsterdam: 6; Öffentliche Bibliothek der Universität Basel: 15; Archivi Alinari, Florence: 11, 39, 45, 52, 54, 56; taken from Yasutada Watanabe, *Shinto Art: Ise and Izumo Shrines* (1974) by kind permission of the publishers, Heibonsha Ltd, and the photographer Yoshio Watanabe: 9; British Crown Copyright/MOD reproduced with the permission of the Controller of Her Britannic Majesty's Stationery Office: 142; Copyright Henri Cartier-Bresson/Magnum Photos Ltd: Frontispiece, 144–158; Courtauld Institute of Art, London: 46, 68; FMR: 3 (photo Massimo Listri), 4 (photo Roberto Ponzani); Reproduced by kind permission of Abram Games: 140 (© Jersey Tourism), 141 (© Truman Limited), 143; Royal

Academy of Arts, London: 69; Reproduced by courtesy of the Trustees, the National Gallery, London: 92; Royal Commission on the Historical Monuments of England: 16; Warburg Institute, London: 10, 30, 34; photograph © The Solomon R. Guggenheim Foundation/photo Robert E. Mates: 100, 102–106, 111, 116–119, 126; Reproduced by kind permission of Saul Steinberg, New York: 127–139; Doucet/© Arch. Phot. Paris/SPADEM: 59; Musées Nationaux, Paris: 19, 22, 64, 66, 67, 72–74, 76, 77, 107; Soprintendenza Archeologica di Roma: 7; courtesy Sheffield City Libraries: 101; Edwin Smith: 13; Bildarchiv d. Öst. Nationalbibliothek, Vienna: 14, 58; Copyright reserved, Reproduced by gracious permission of Her Majesty The Queen: 33, 38, 40, 44, 61, 62.

Bibliographical Note

Details of the previous publications of the essays in this volume are as follows:

AN AUTOBIOGRAPHICAL SKETCH. Transcribed from the tape-recording of an informal talk given at Rutgers University, New Jersey, in March 1987 and published in the *Rutgers Art Review*, VIII, 1987, pp. 123–35.

THE EMBATTLED HUMANITIES: THE UNIVERSITIES IN CRISIS. Address given to the North of England Education Conference in January 1985 and published in *Culture, Education and Society* (University Quarterly), 39, 3, Summer 1985, pp. 193–205.

RELATIVISM IN THE HUMANITIES: THE DEBATE ABOUT HUMAN NATURE. Opening plenary address delivered in German at the Seventh International Congress of Germanic Studies in Göttingen in Aguqust 1985 and published in *Kontroversen, alte und neue*, Akten des VII. Internationalen Germanisten-Kongresses Göttingen 1985, Tübingen, 1986, Vol. 1, pp. 17–28. Translated by the author and published in *Critical Inquiry*, 13, Summer 1987, pp. 686–99.

RELATIVISM IN THE HISTORY OF IDEAS. Contribution to an international conference on the history of ideas given in Rome in October 1987 and published in *Storia delle Idee, Problemi e Prospettive* (Lessico Intellettuale Europeo), ed. M. L. Bianchi, 1989, pp. 2–12.

RELATIVISM IN THE APPRECIATION OF ART. Introduction to a volume of essays on paintings in the Mauritshuis, The Hague, *Gezicht op het Mauritshuis*, ed. H. R. Hoetink, Amsterdam, 1989, pp. 14–19 (in Dutch), pp. 190–3 (in English).

APPROACHES TO THE HISTORY OF ART. Introductory remarks made in Holland in May 1988 at a symposium organized by the Praemium Erasmiamum Foundation. Published in *Three Cultures*, ed. M. Bal et al., The Hague, 1989, pp. 161–75.

THE CONSERVATION OF OUR CITIES: RUSKIN'S MESSAGE FOR TODAY. Address given in German at the First International Congress on Architectural Conservation held in Basle in March 1983. I am indebted to Dr McEwan for the draft of the English translation. Published in a revised version in English and Spanish in *Composición Arquitectonica*, Bilbao, 2, 1989, pp. 115–37. An abbreviated version was published in *Christie's International Magazine*, VIII, 2, February 1991, pp. 2–5.

WATCHING ARTISTS AT WORK: COMMITMENT AND IMPROVISATION IN THE HISTORY OF DRAWING. The Gerda Henkel Lecture delivered in German at the Rheinisch-Westfälischen Akademie der Wissenschaft in Düsseldorf in March 1988 and published as *Wege zur Bildgestaltung, Vom Einfall zur Ausführung*, Westdeutscher Verlag, Opladen, 1989, pp. 5–21. English text revised by the author.

PLATO IN MODERN DRESS. TWO EYEWITNESS ACCOUNTS OF THE ORIGINS OF CUBISM. Contribution to a volume of essays in honour of André Chastel, published as 'From Careggi to Montmartre: A Footnote to Erwin Panofsky's *Idea*' in *Il se rendit en Italie. Etudes offertes à André Chastel*, Paris, 1987, pp. 67–77. Slightly revised.

KOKOSCHKA IN HIS TIME. Lecture given at the Tate Gallery in July 1986 and published in the Tate Modern Masters series, London, 1986, pp. 7–32.

IMAGE AND WORD IN TWENTIETH-CENTURY ART. The Hilla Rebay Lecture at the Solomon R. Guggenheim Museum, New York, October 1980, published in *Word & Image*, I, 3, July/September 1985, pp. 213–41.

THE WIT OF SAUL STEINBERG. First published in *Art Journal*, Winter 1983, pp. 377–80.

A MASTER OF POSTER DESIGN: ABRAM GAMES. Foreword to an exhibition catalogue, Howard Gardens Gallery, South Glamorgan Institute of Higher Education, March 1990, pp. 9–10.

THE PHOTOGRAPHER AS ARTIST: HENRI CARTIER-BRESSON. Introduction to a Scottish Arts Council Exhibition arranged in association with the Victoria and Albert Museum, London, 1978, pp. 5–10.

Index